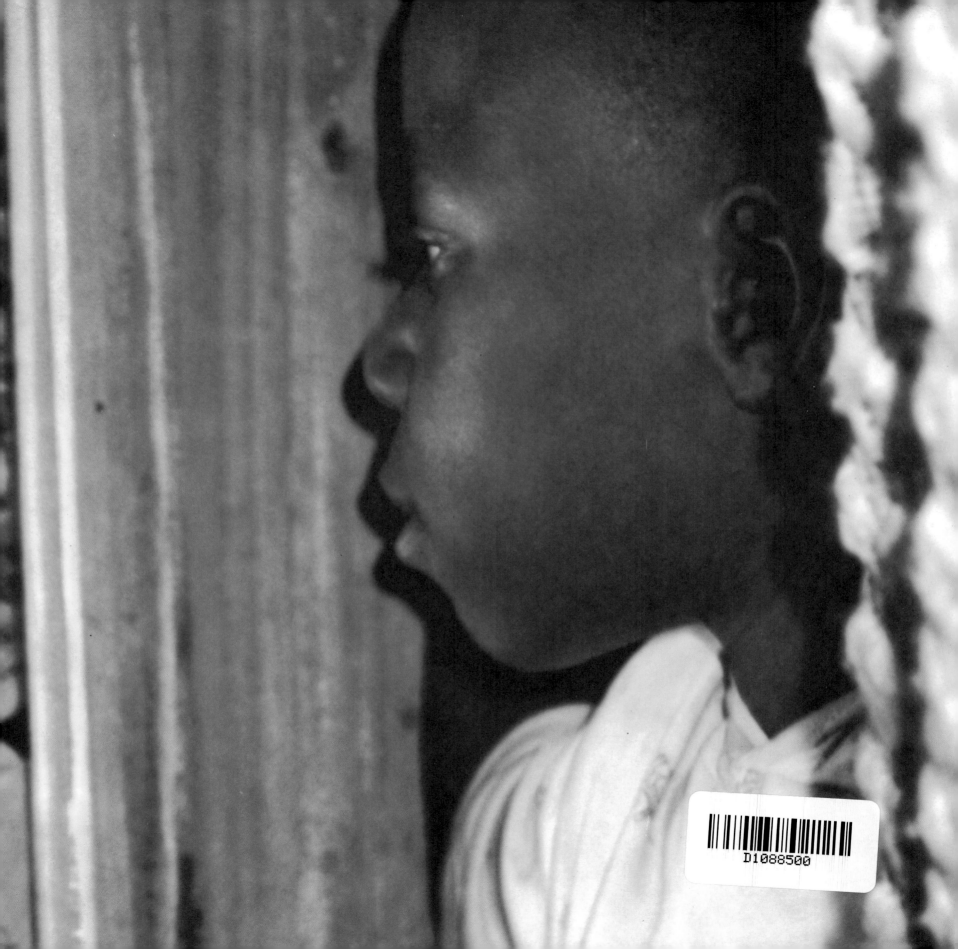

SHOOTBACK

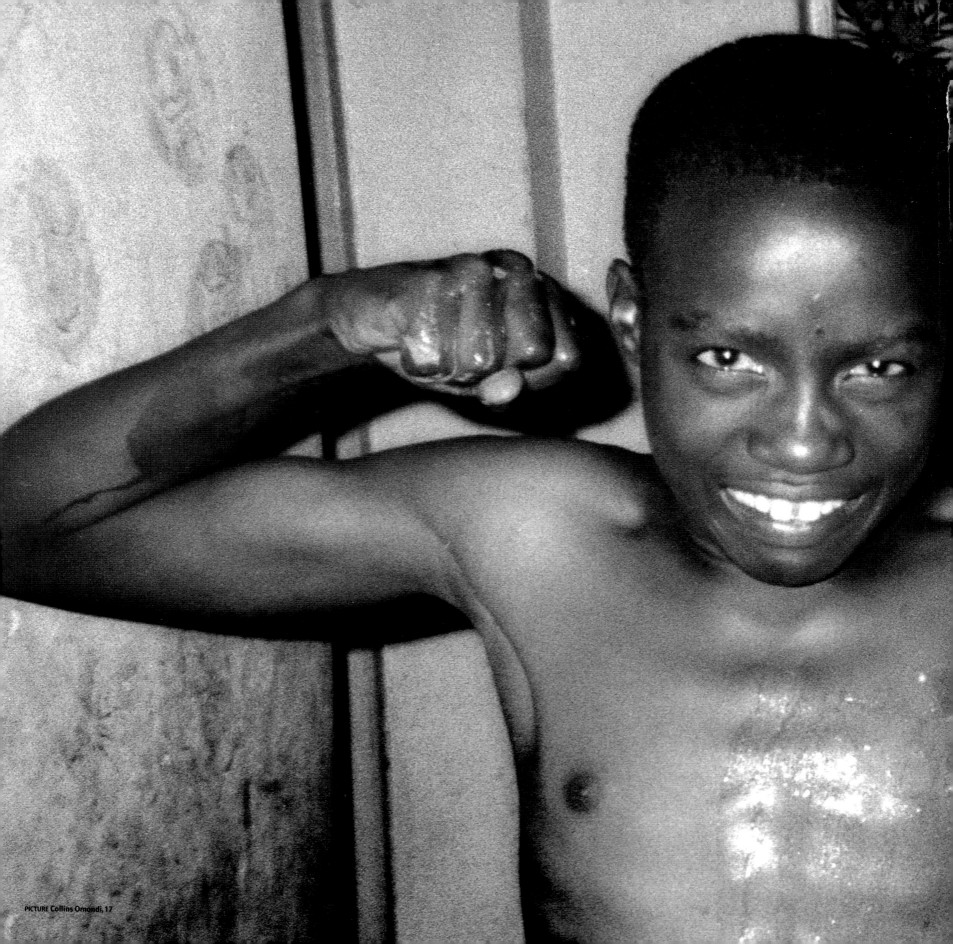

PICTURE Collins Omondi, 17

# SHOOTBACK

photos by kids from the Nairobi slums

BOOTH-CLIBBORN
EDITIONS

The photographs in this book were taken by the Shootback Team, a group of 31 kids, aged twelve to seventeen, from Nairobi, Kenya. They live in Mathare, one of the largest and poorest slums in Africa.

Two years ago, these kids had never held a camera. Today, their photographs are exhibited, published and collected around the world.

Equipped with $30 plastic cameras, the Shootback Team has been photographing their lives, and writing about them since September 1997. Through their own words and pictures, this book tells their story.

Lana Wong, Shootback Team Leader

**THE . DREAM**
*It was a dream at midnight minus one.*

**I DREAMED THAT I WAS TRAINING IN PHOTOGRAPHY. ONE DAY I STARTED TO PHOTO WHERE I CAN PHOTO ABOUT SLUMS, BEAUTIFULNESS, FRIENDS, THINGS THAT I DON'T LIKE AND THINGS THAT I LIKE.**

**AFTER 3 TO 4 MONTHS, I KNEW HOW TO PHOTO. I CONTINUED LIKE THAT AND GREW UP AS A MAN. I OPENED MY STUDIO, AND PEOPLE STARTED TO COME. THEY LOVED MY PICTURES VERY MUCH.**

**I STARTED TO TRAVEL COUNTRY TO COUNTRY, THEN TO OTHER CONTINENTS, TO PHOTO THINGS WHICH ARE GOOD AND THINGS WHICH ARE BAD.**

Peter Ndolo, 13

PICTURE Edith Awuor, 14

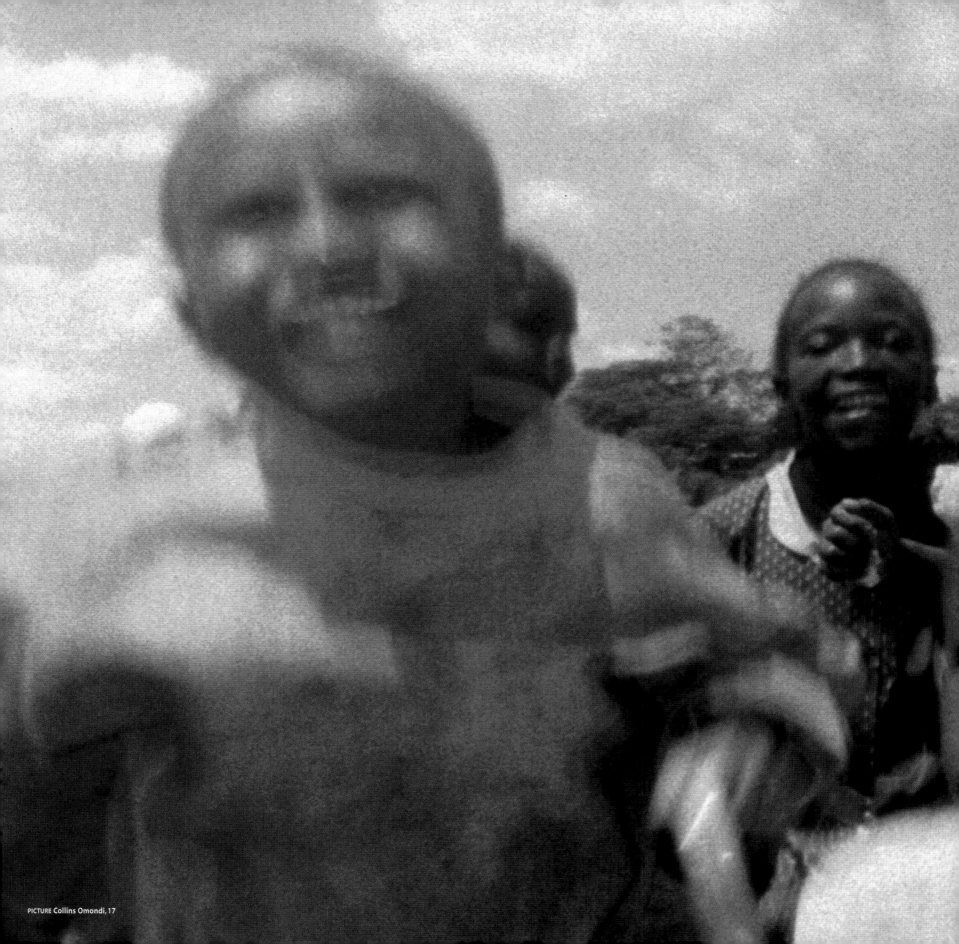

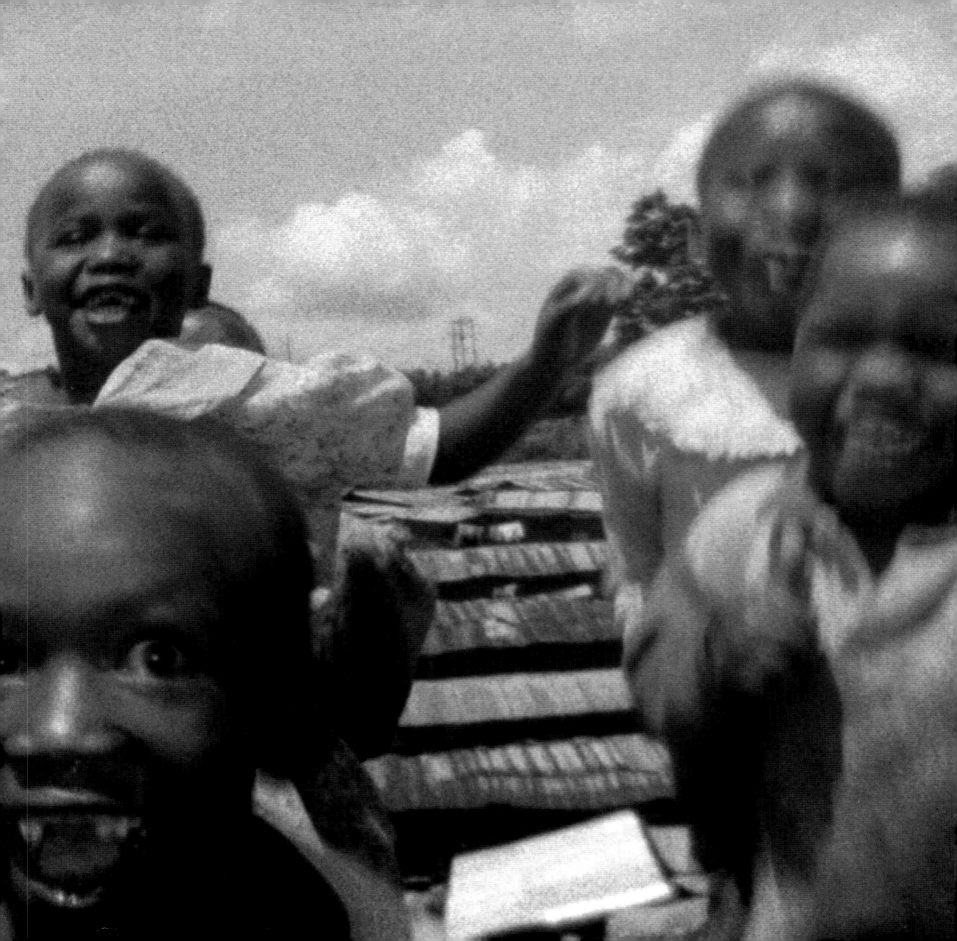

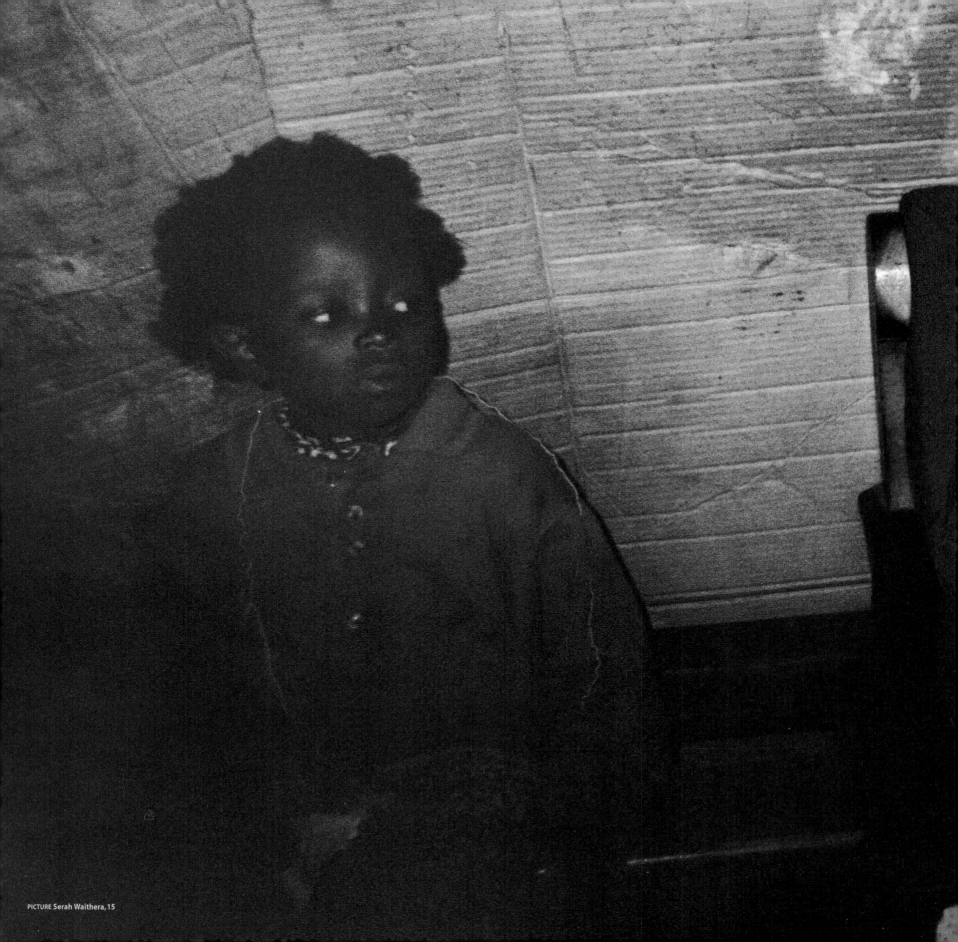

PICTURE Serah Waithera, 15

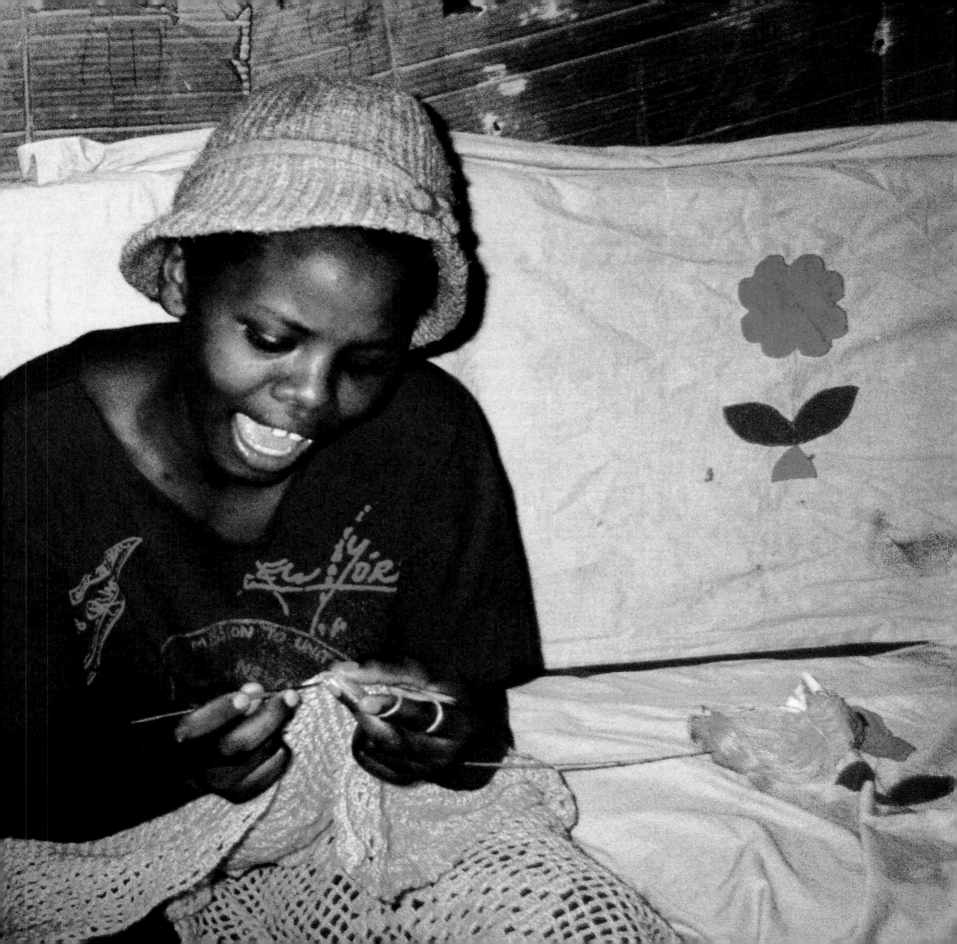

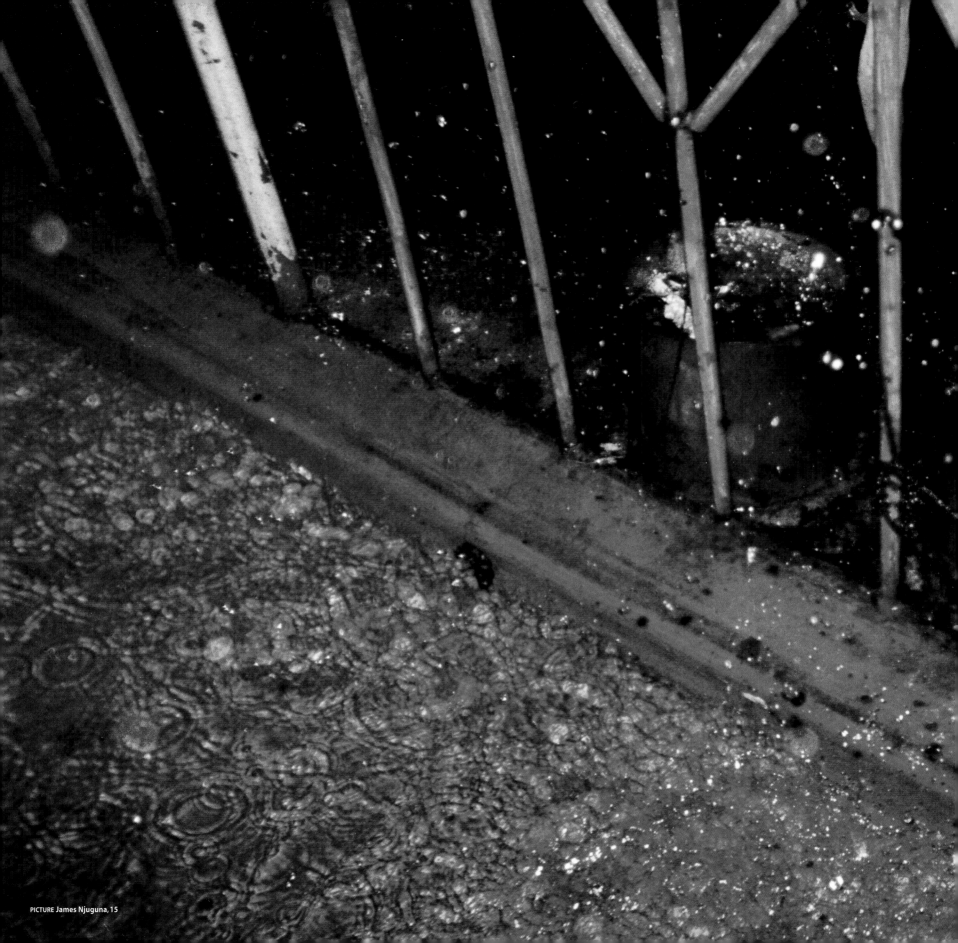

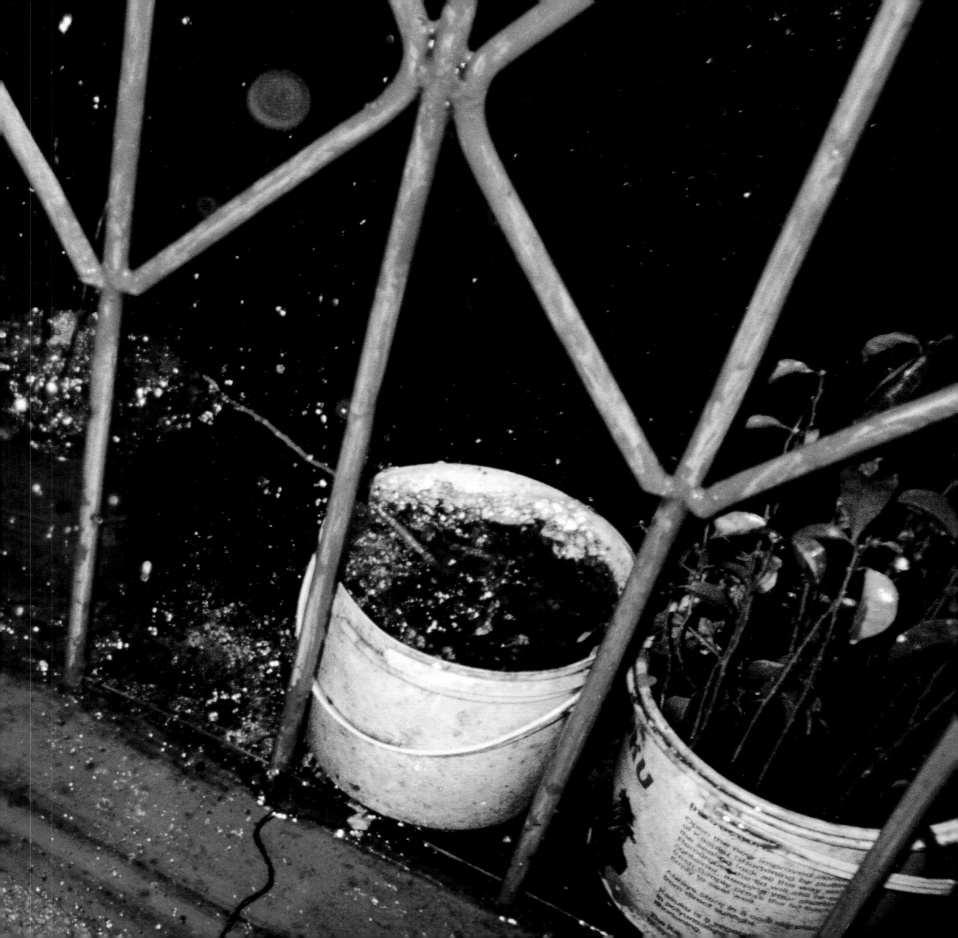

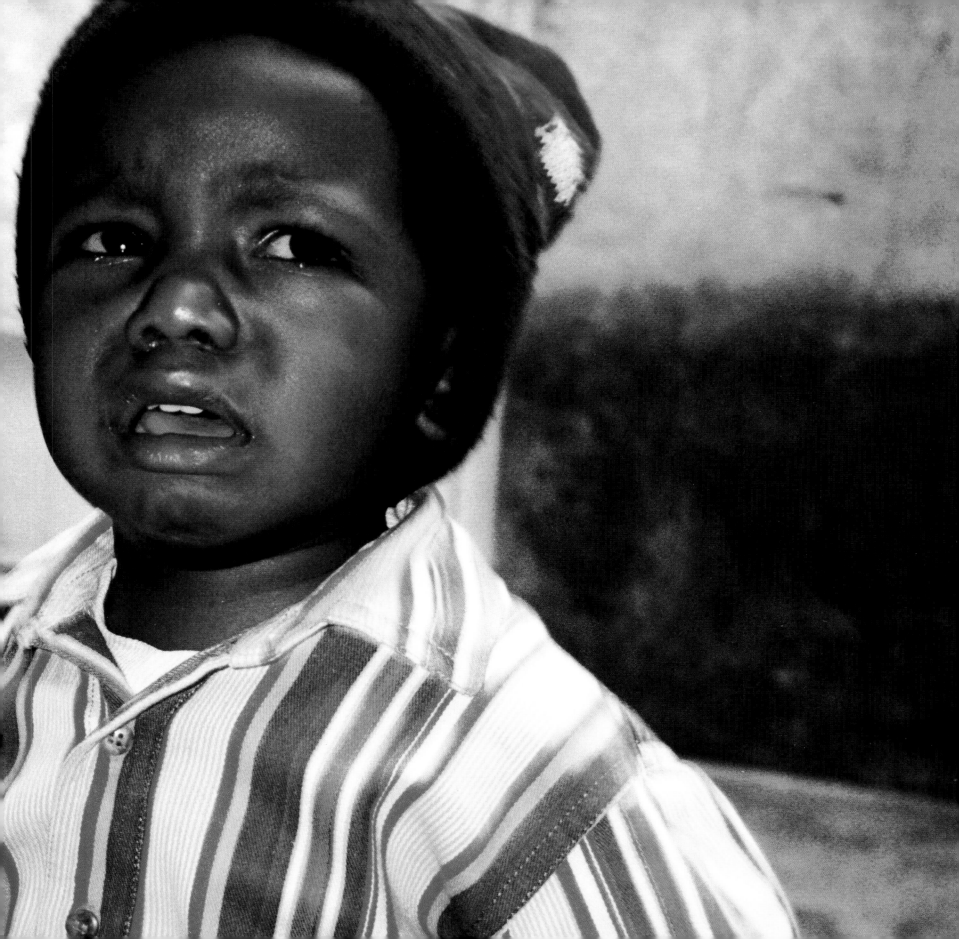

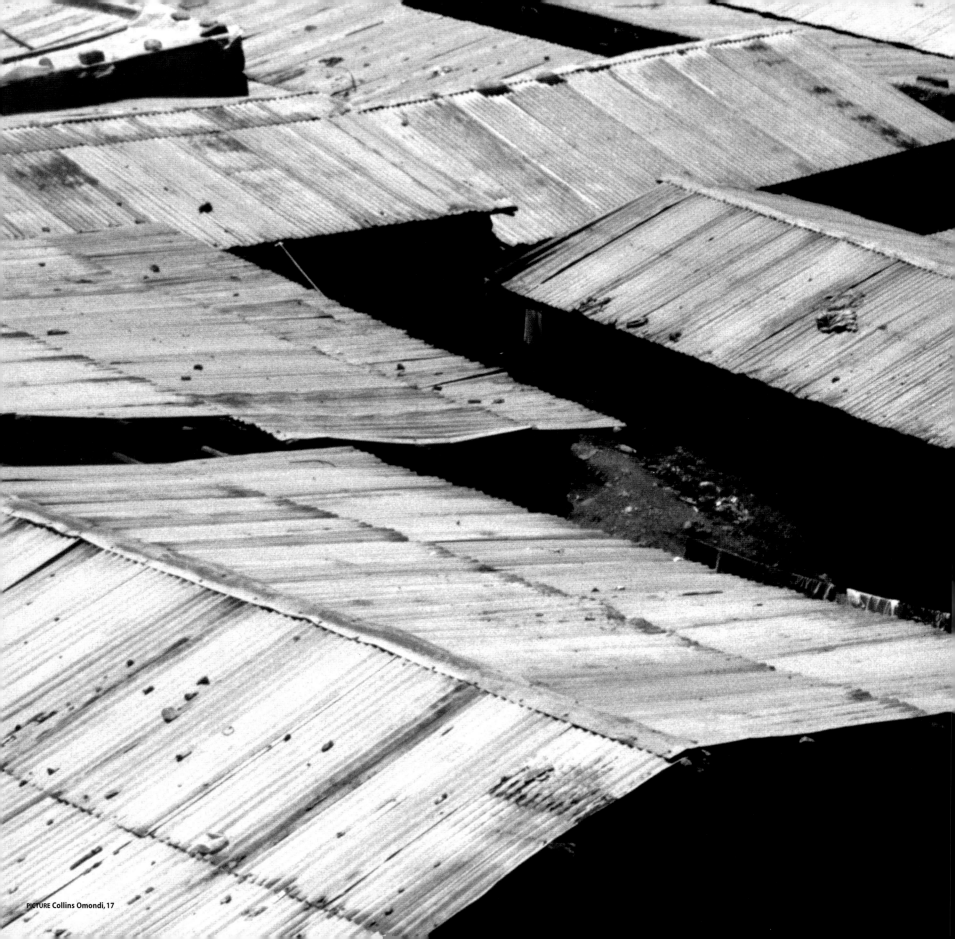

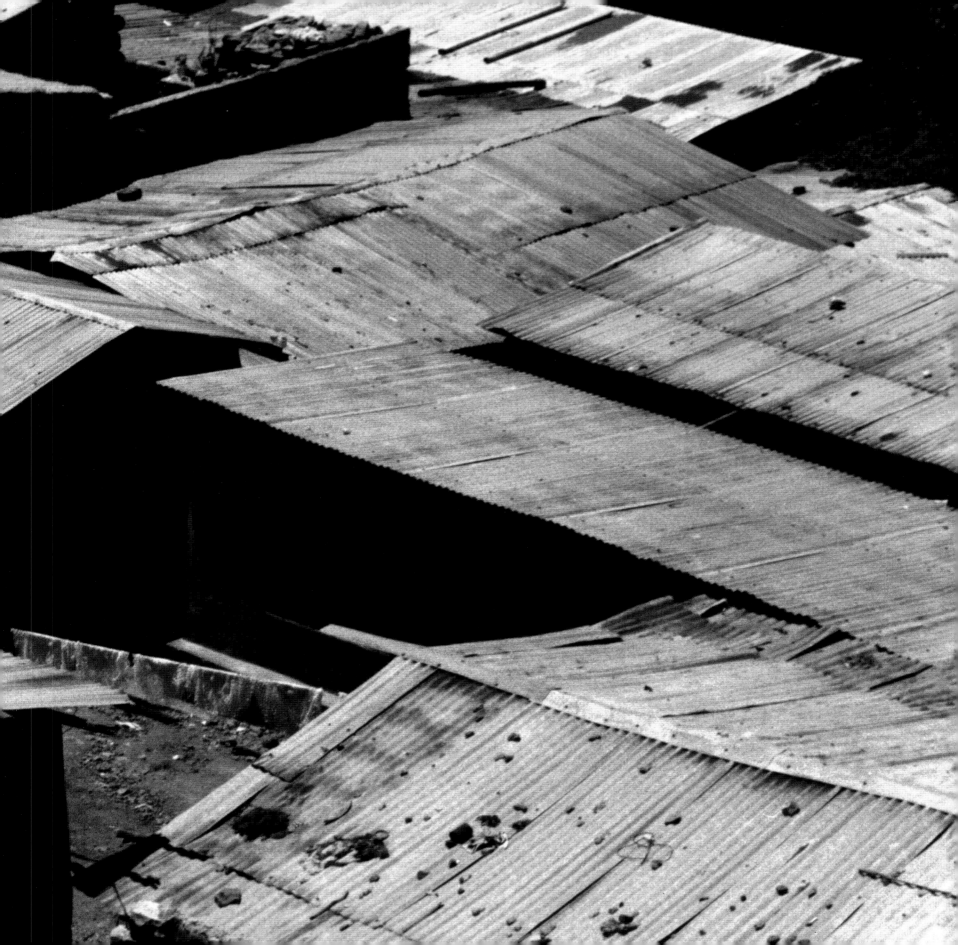

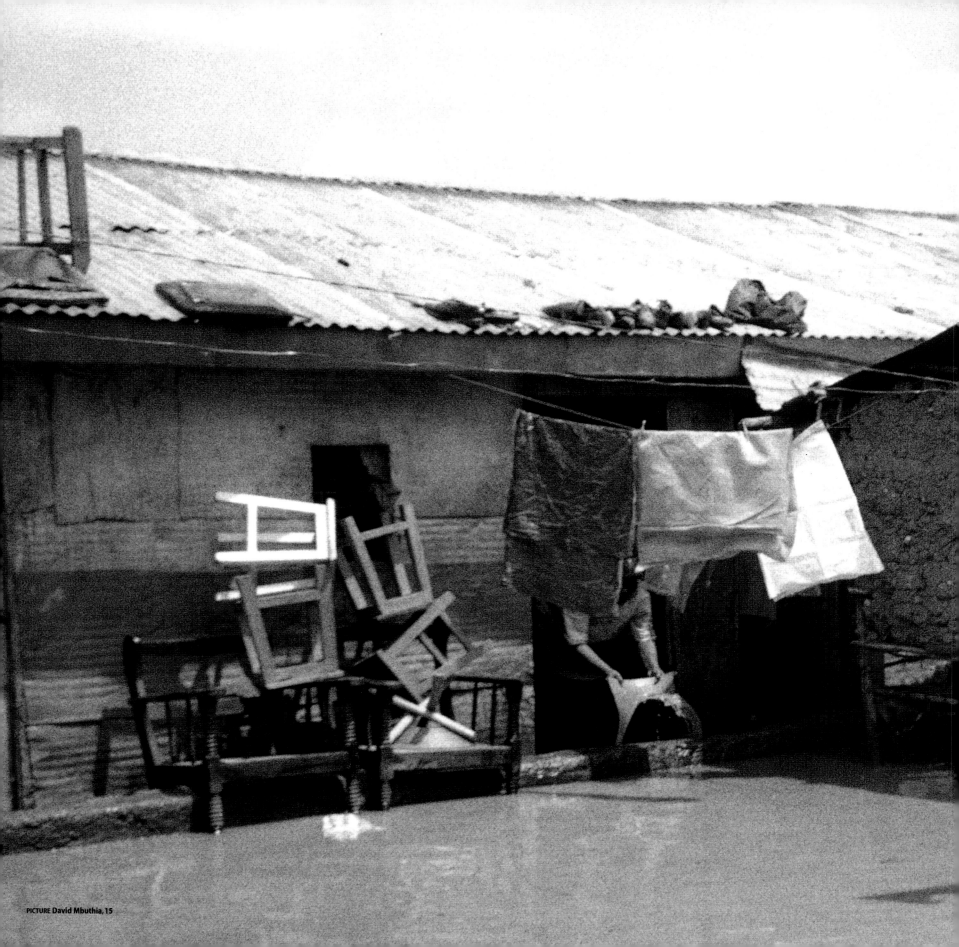

PICTURE David Mbuthia, 15

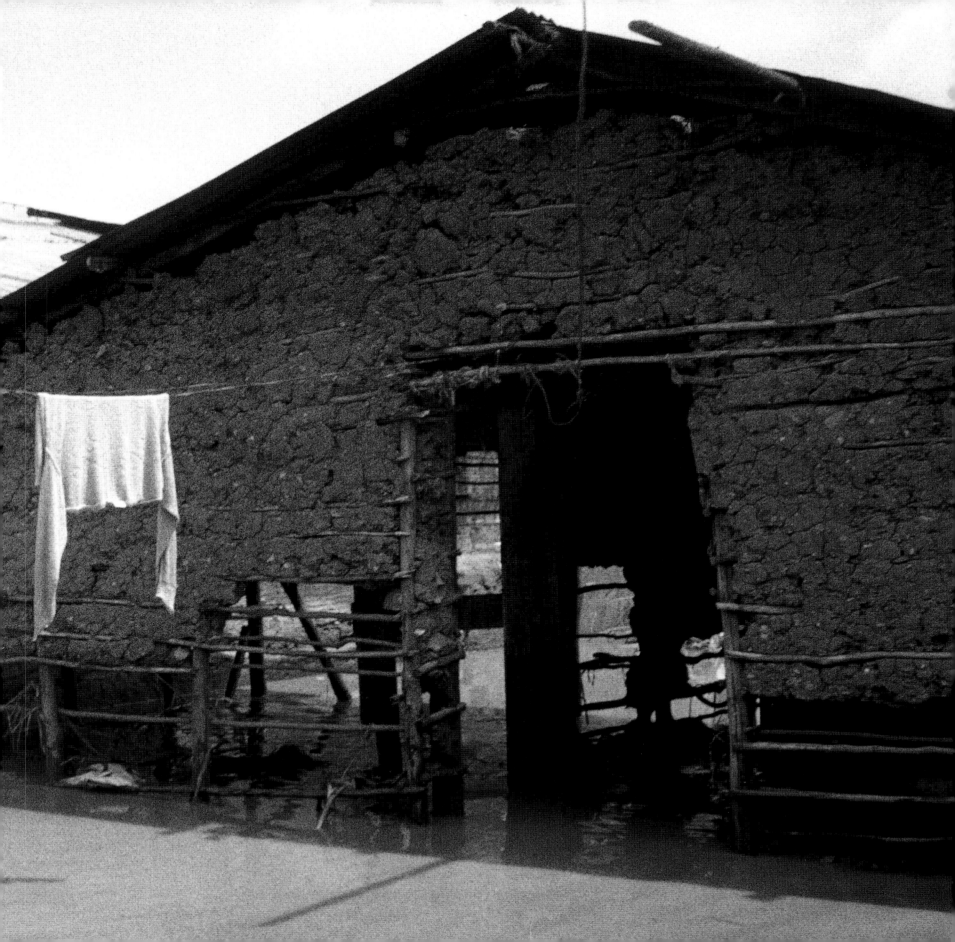

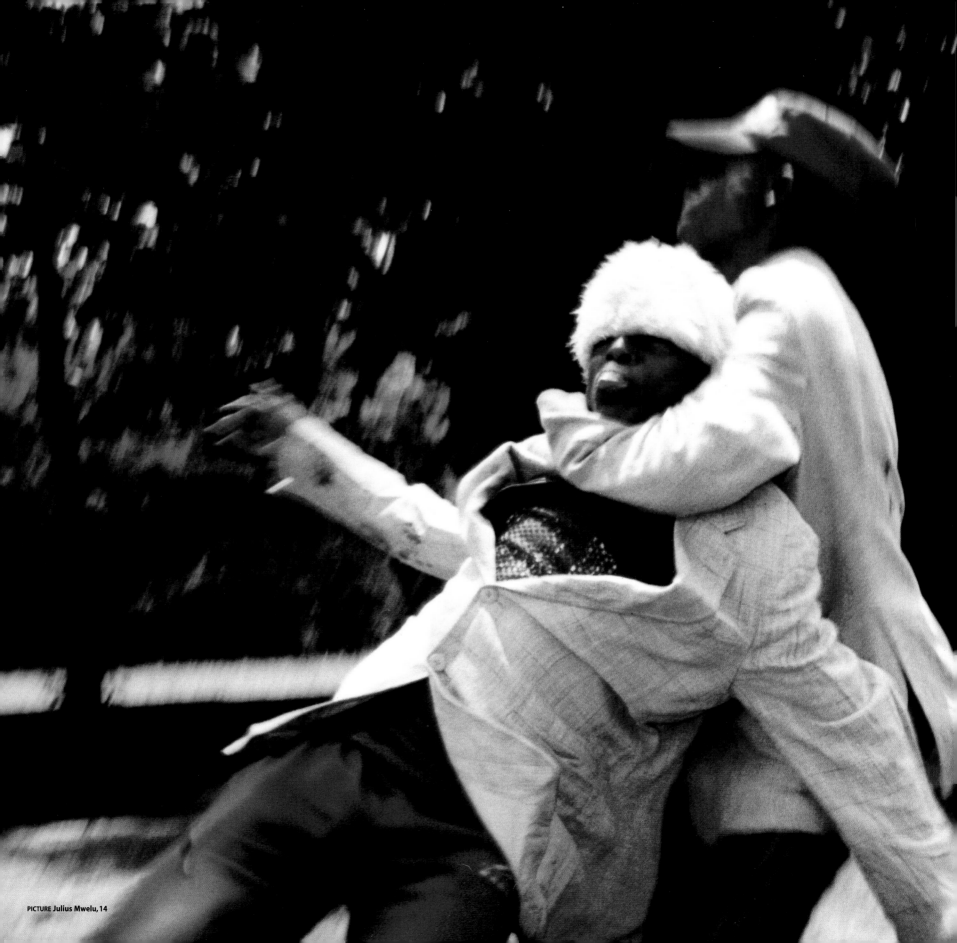

PICTURE Julius Mwelu, 14

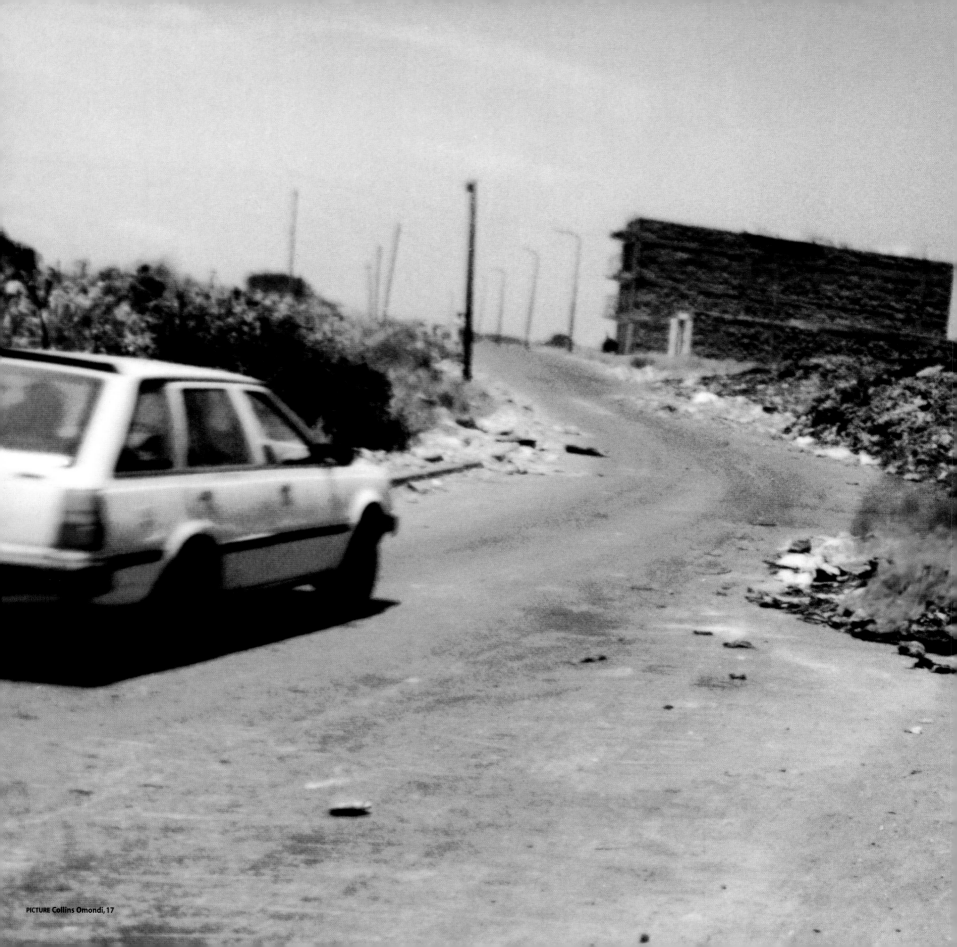

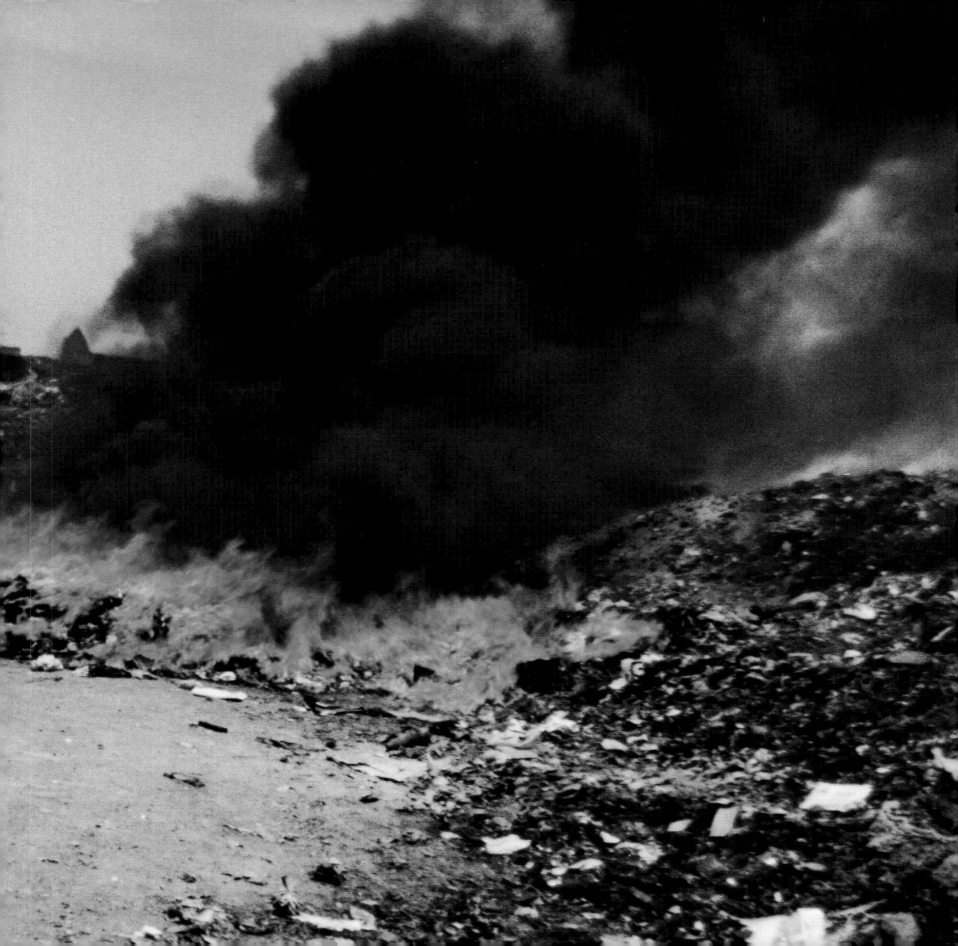

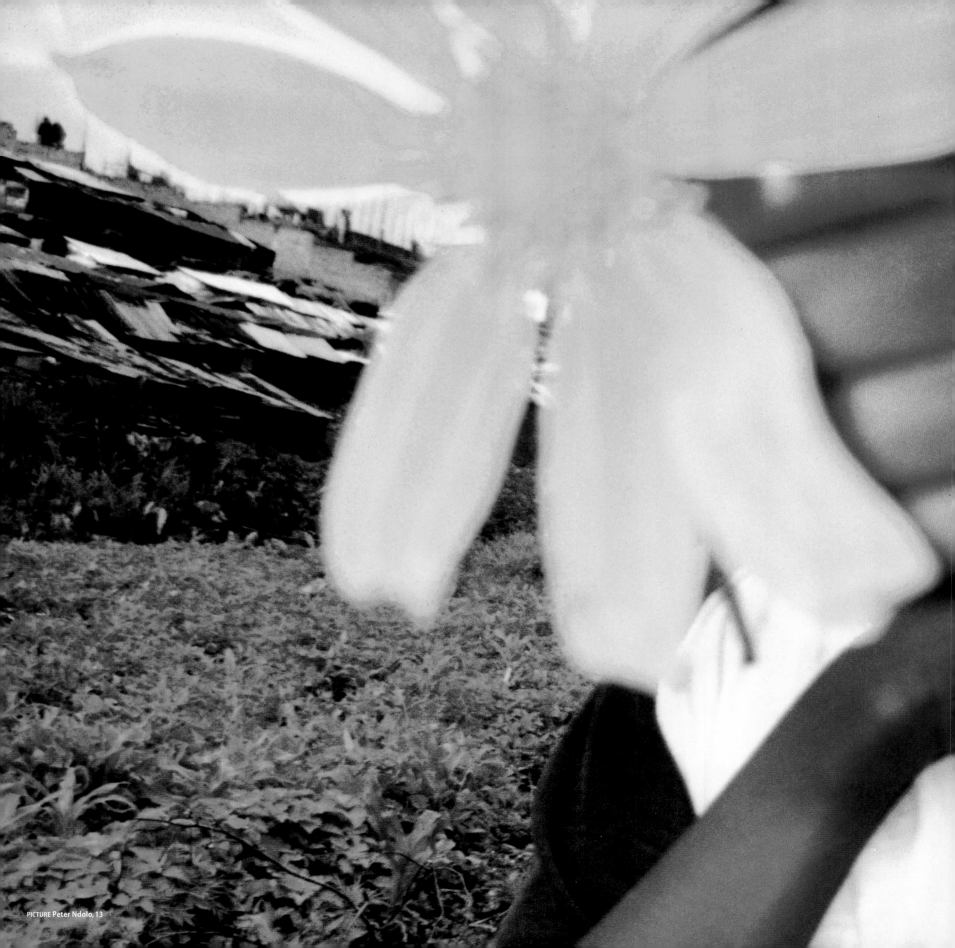

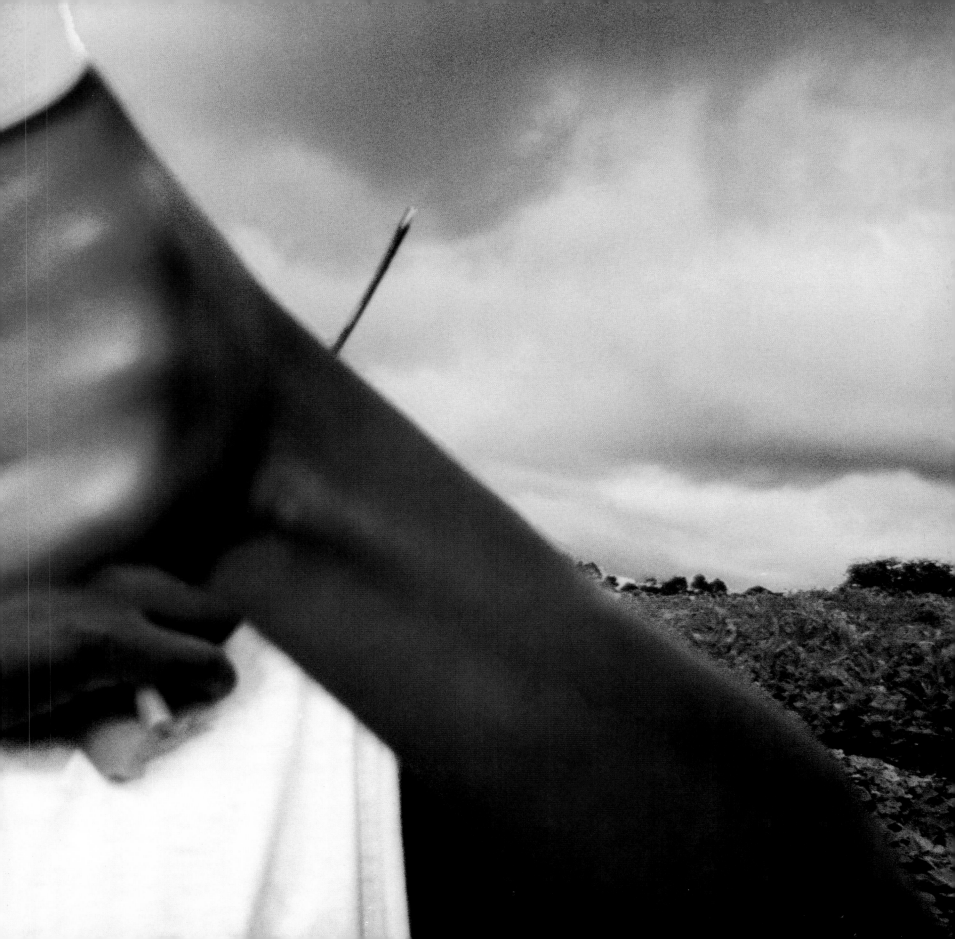

SHOOTBACK SHARPSHOOTERS ARE OUT TO SHOOT ANYTHING WORTH SHOOTING RELATING TO OUR DAY TO DAY LIVES.

IN THE EXHIBIT WERE PICTURES FROM THE SHOOTBACK CAFETERIA. WE WERE SERVING A BUFFET RANGING FROM COMEDY TO HORROR.

THE PICTURES ON DISPLAY WERE FOR SALE AT A THROW AWAY PRICE BUT OUR MAIN AIM WAS TO TRY TO TAKE PEOPLE PLACES WHERE THEY HAVE NEVER BEEN...

Collins Omondi, 17

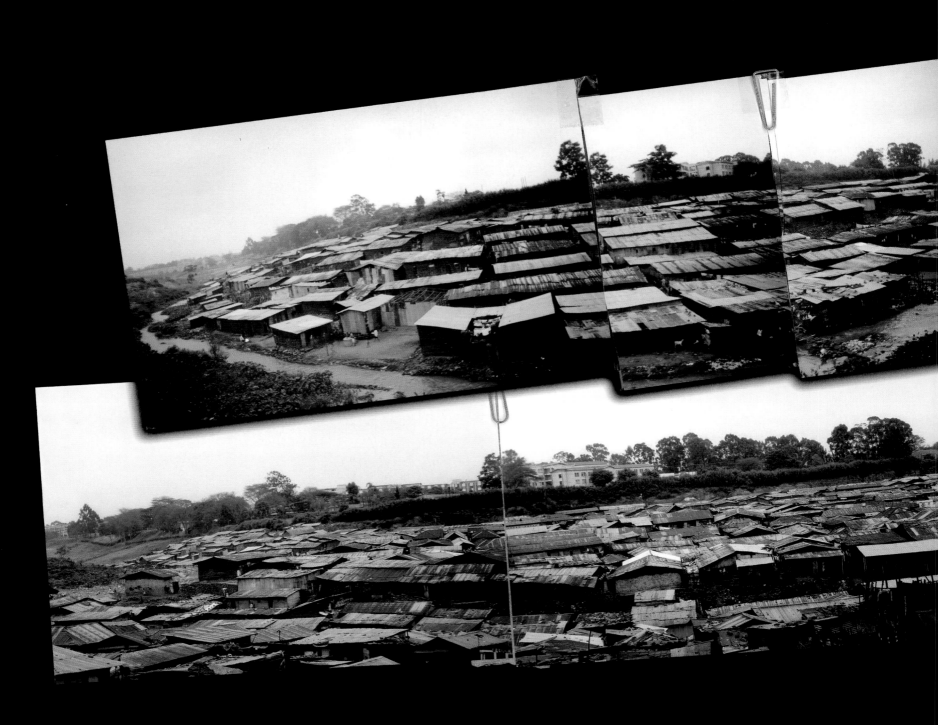

PICTURES Beldine Achieng, 14 & Peter Ndolo, 13  WORDS Peter Ndolo, 13; Saidi Hamisi, 15; Charles Odhiambo, 15; David Mbuthia, 15; Collins Omondi, 17

# A slum eye view

SOMETIMES YOU MIGHT THINK YOU ARE ON MARS OR
VENUS BUT ALL THE SAME YOU ARE STILL ON EARTH.

YOU CAN SEE SO MANY HOUSES SQUEEZED AND
THERE IS NO SPACE FOR YOUNG CHILDREN TO PLAY.

VERY FEW CHILDREN GO TO SCHOOL BECAUSE EDUCATION
FEES ARE VERY EXPENSIVE COMPARED WITH THE JOBS
THAT THEIR PARENTS ARE DOING.

BUT WHATEVER YOU HAVE, THANK GOD. IF YOU DON'T
HAVE SHOES, THANK GOD BECAUSE THERE ARE
SOME PEOPLE WITHOUT LEGS.

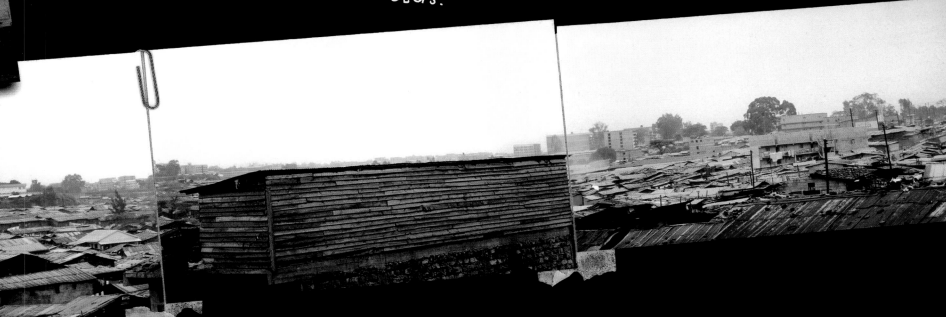

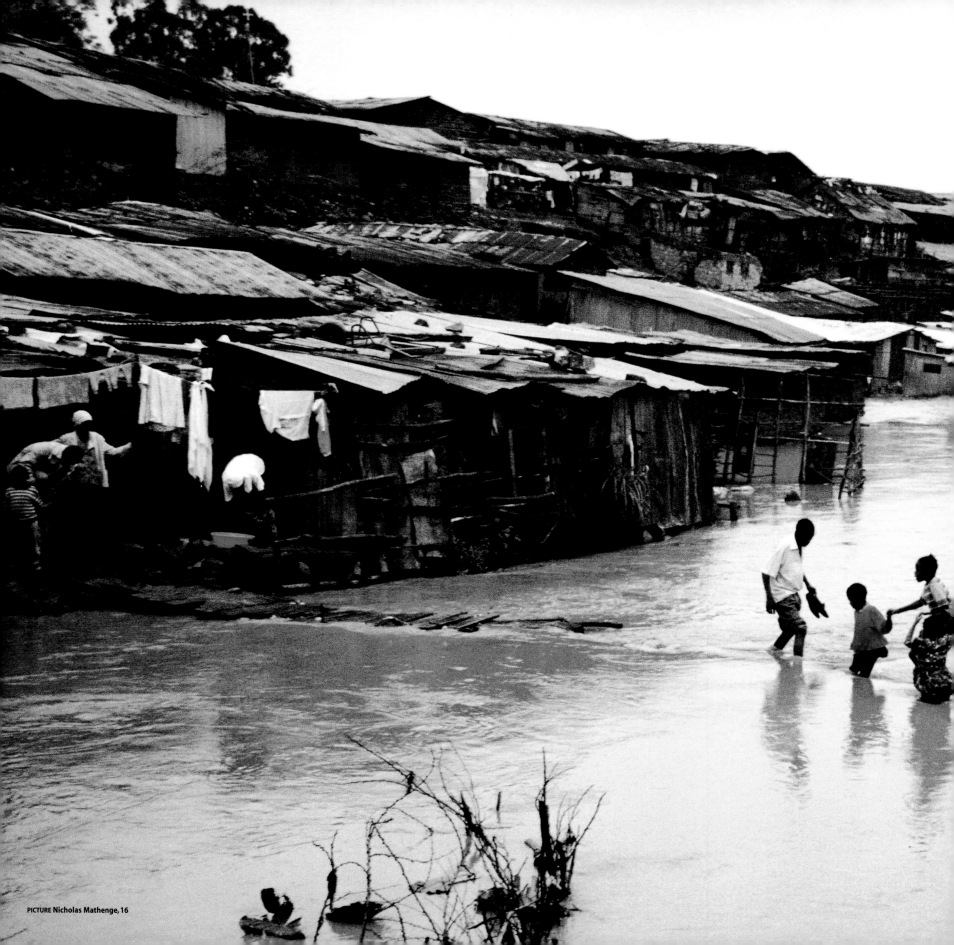

PICTURE Nicholas Mathenge, 16

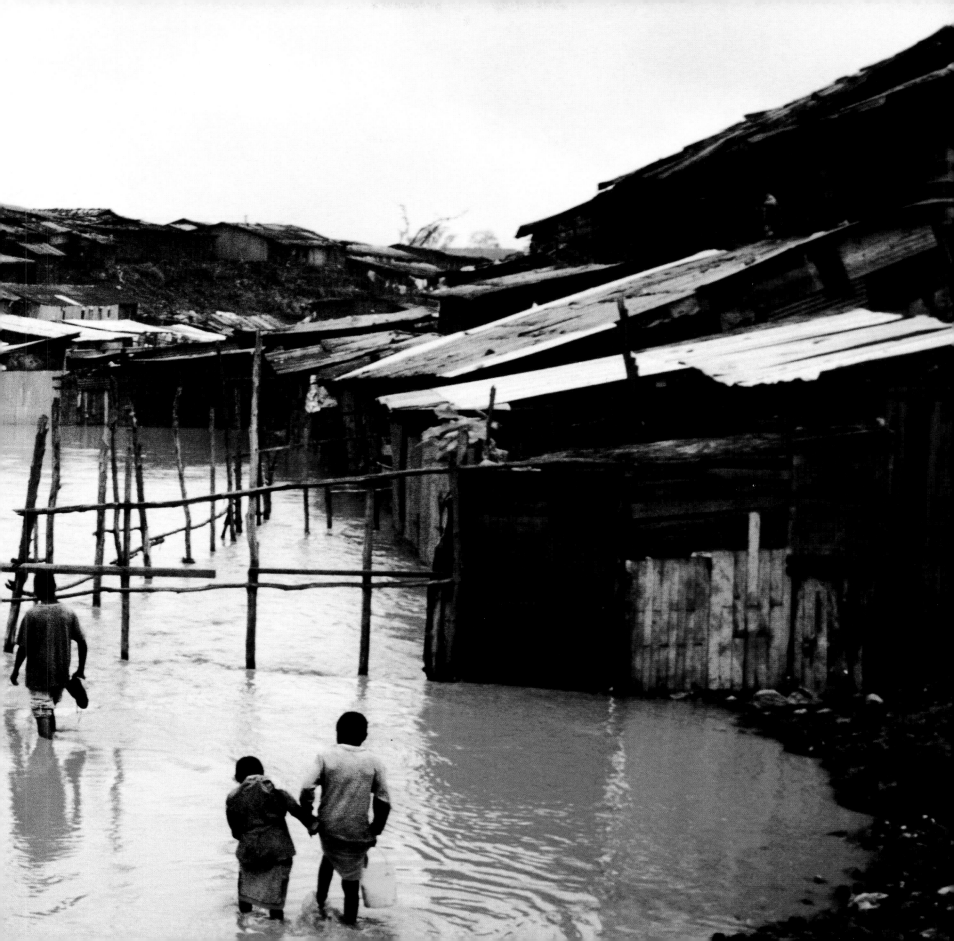

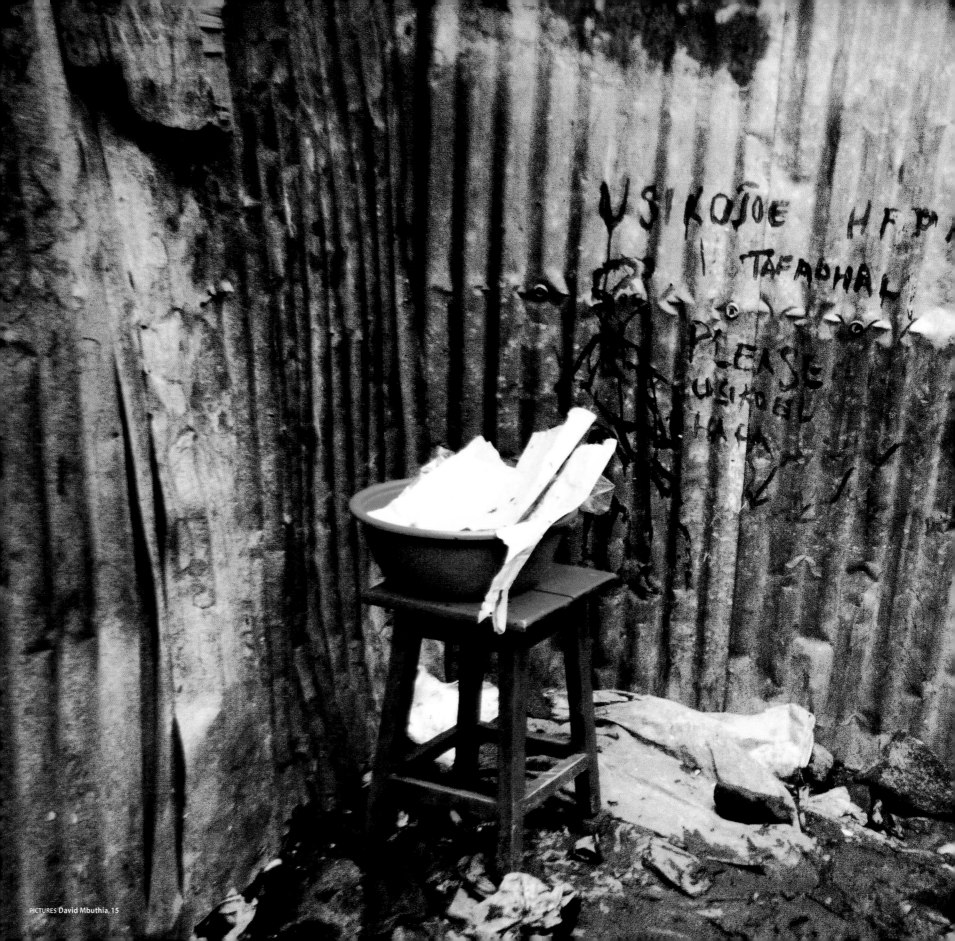

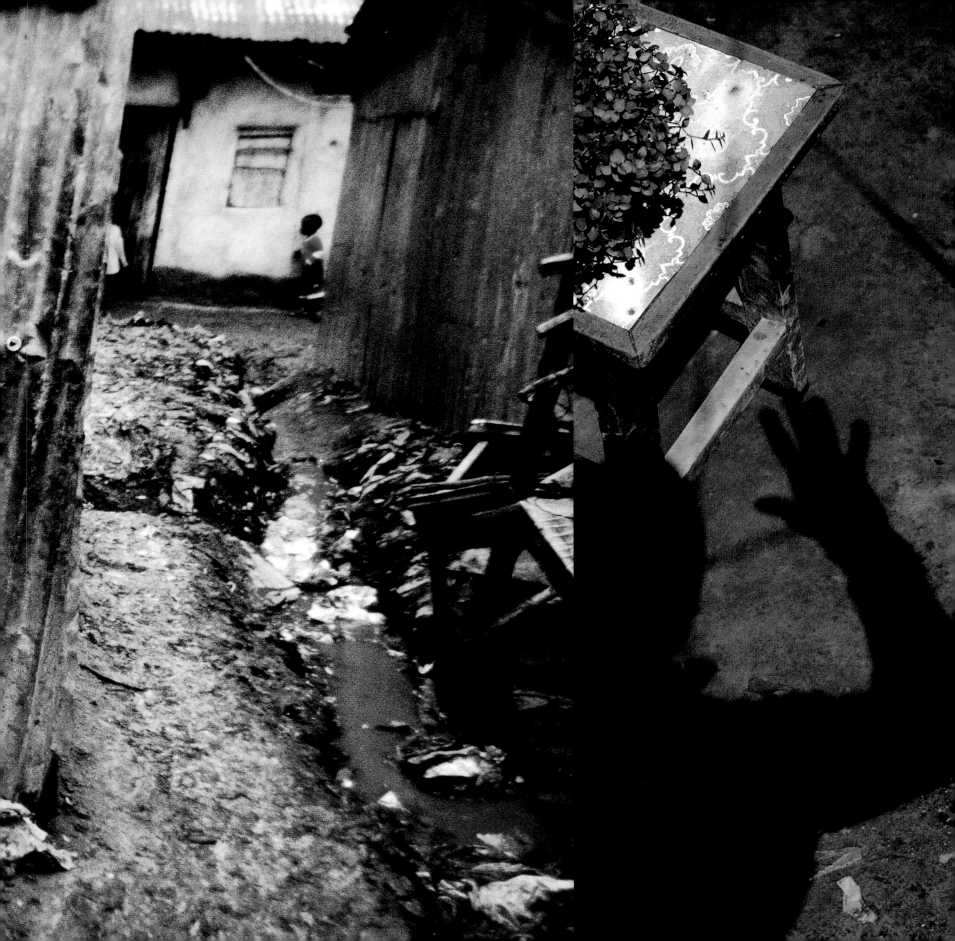

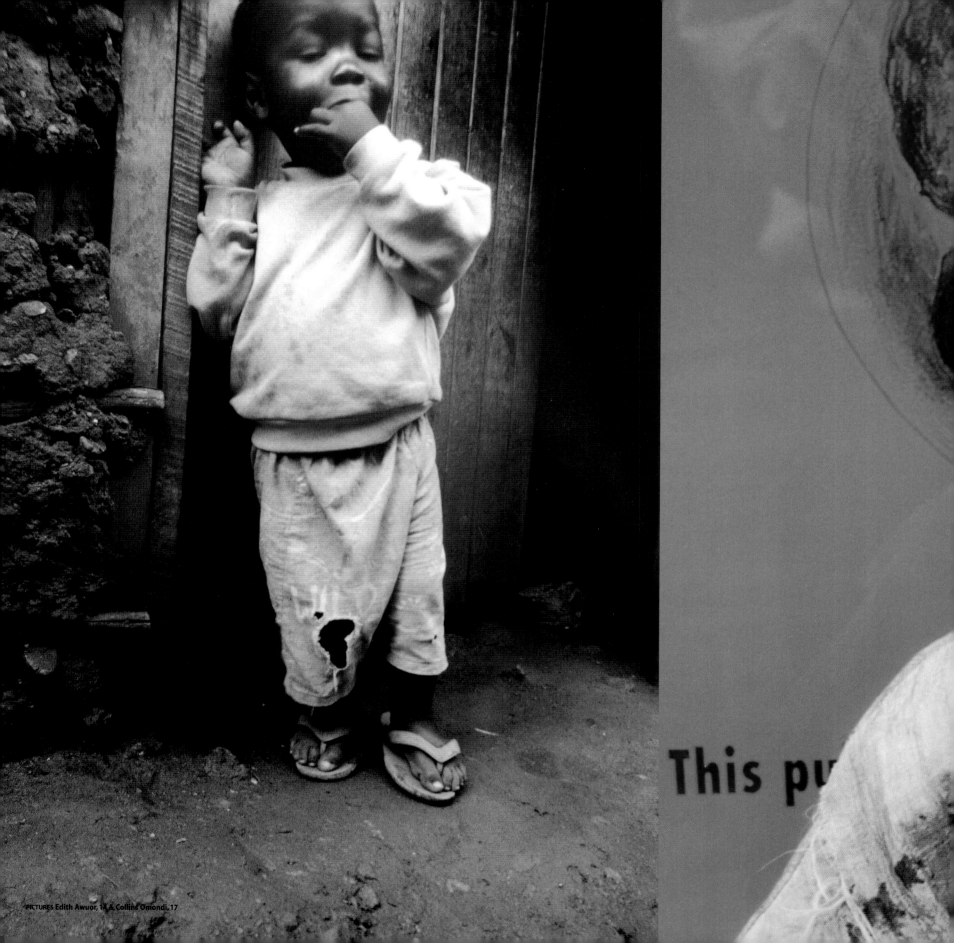

PICTURES Edith Awuor, 14 & Collins Omondi, 17

This pu

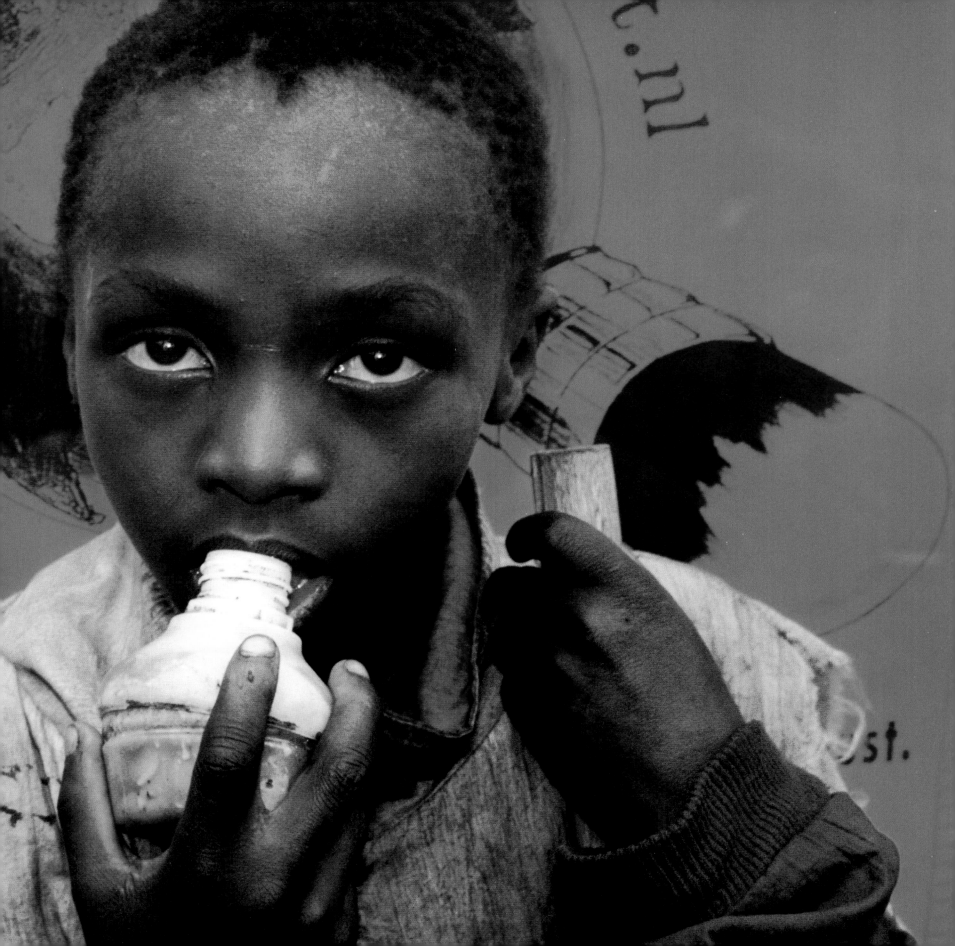

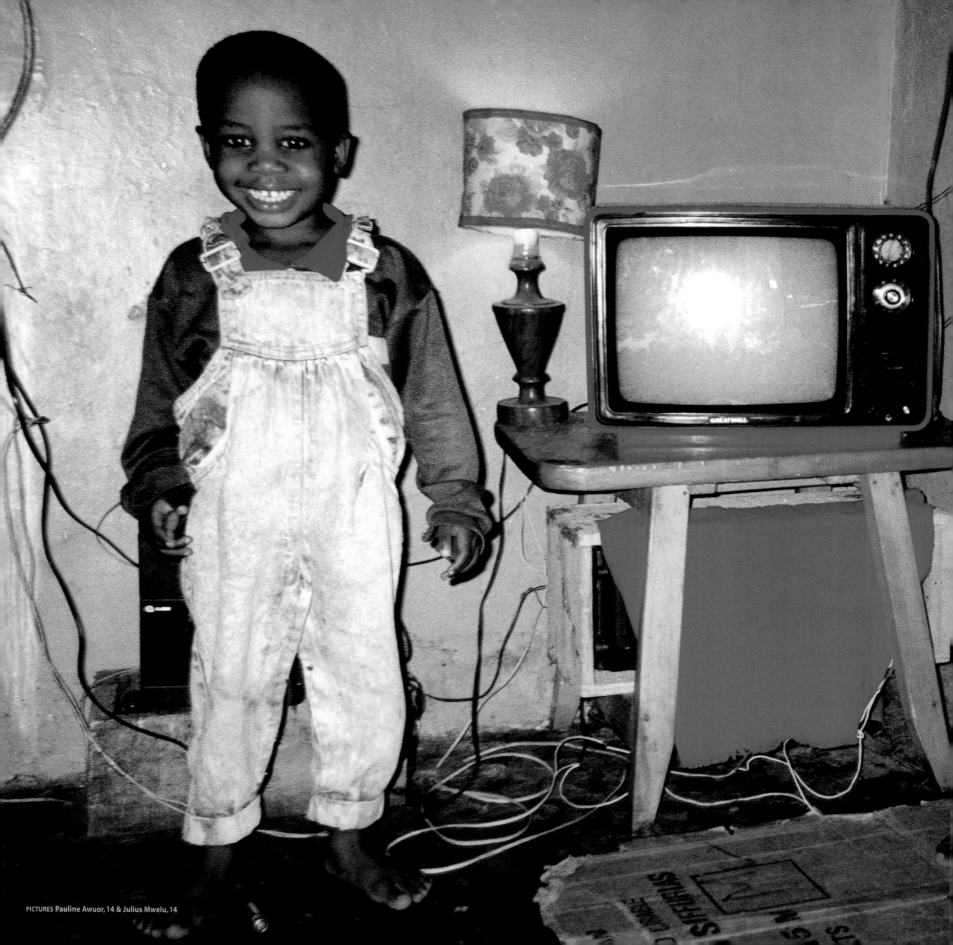

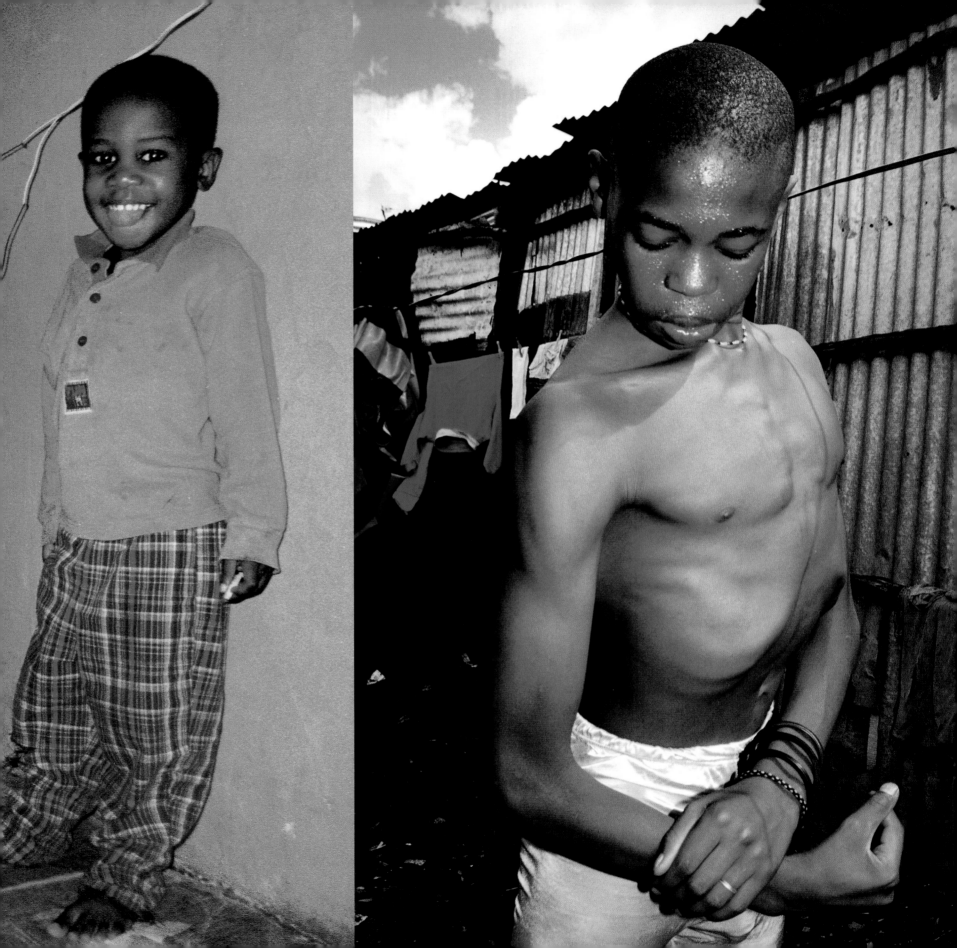

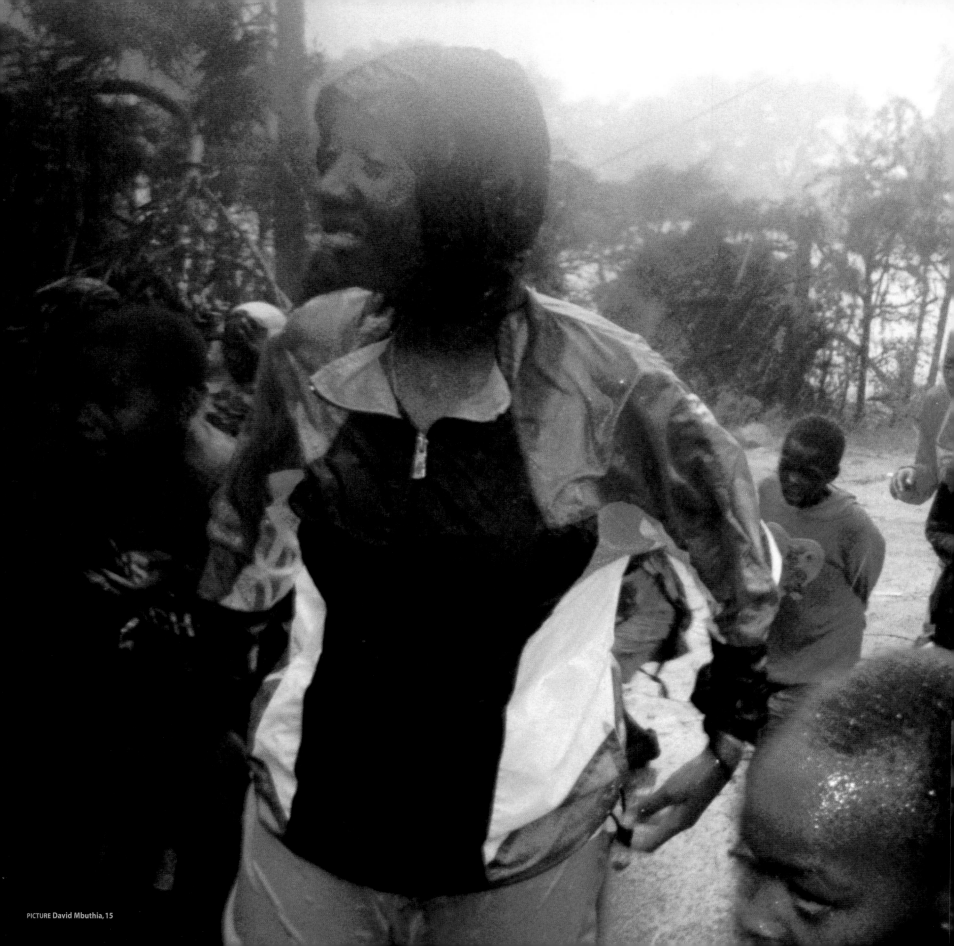

PICTURE David Mbuthia, 15

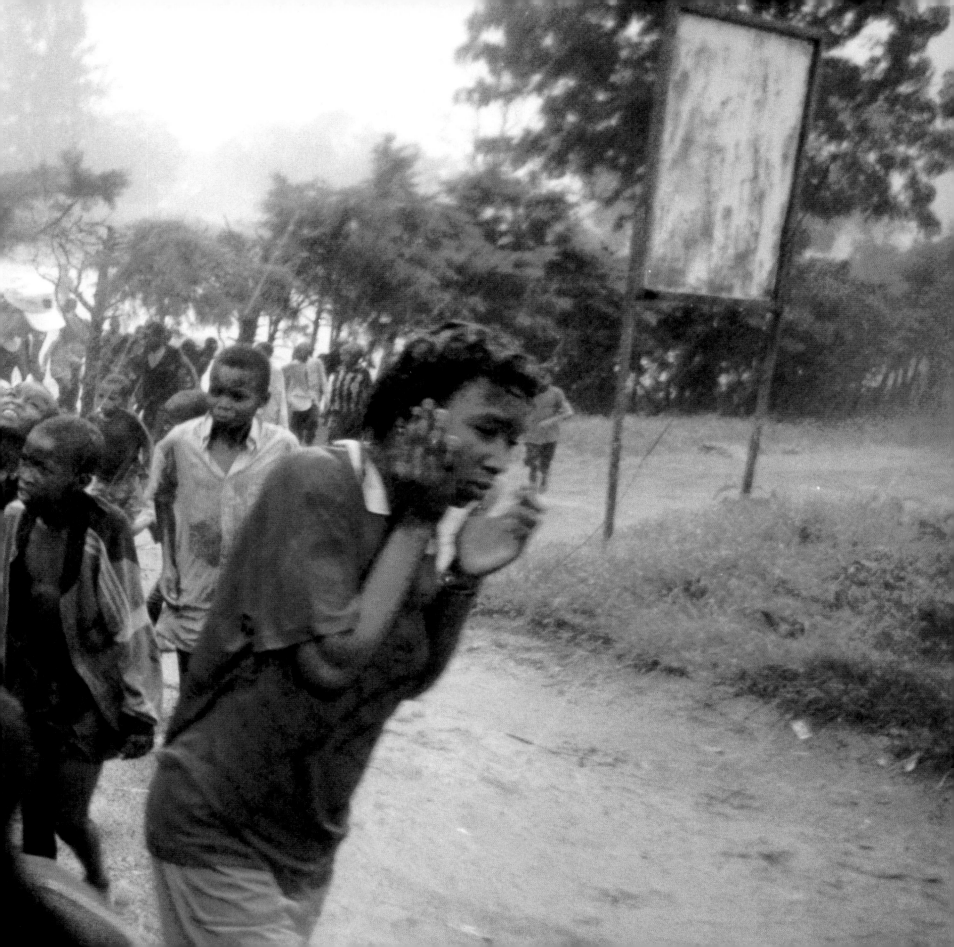

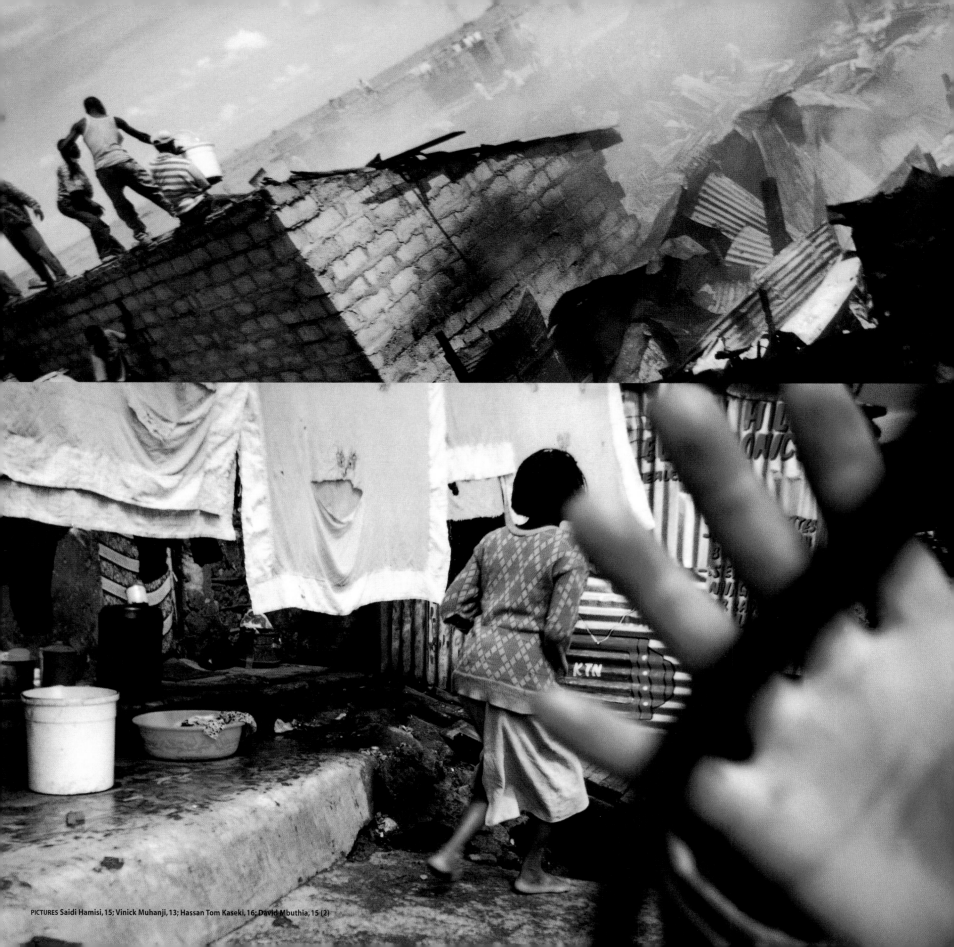

PICTURES Saidi Hamisi, 15; Vinick Muhanji, 13; Hassan Tom Kaseki, 16; David Mbuthia, 15 (2)

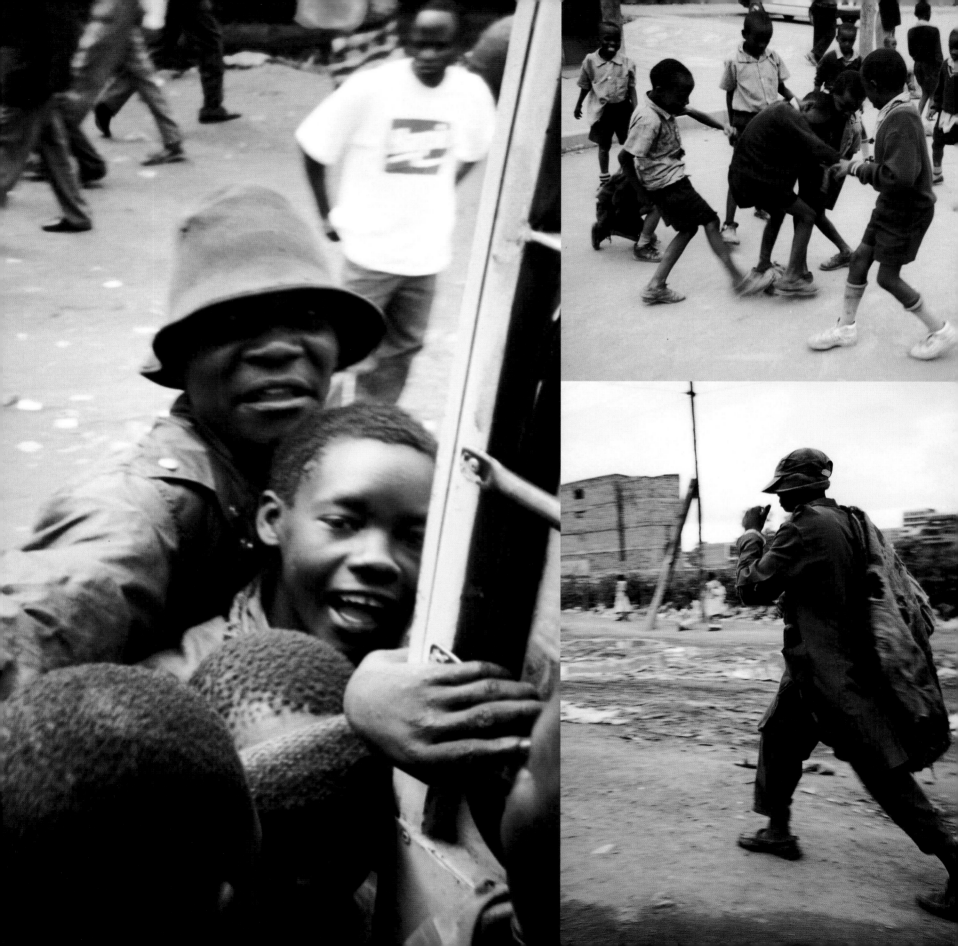

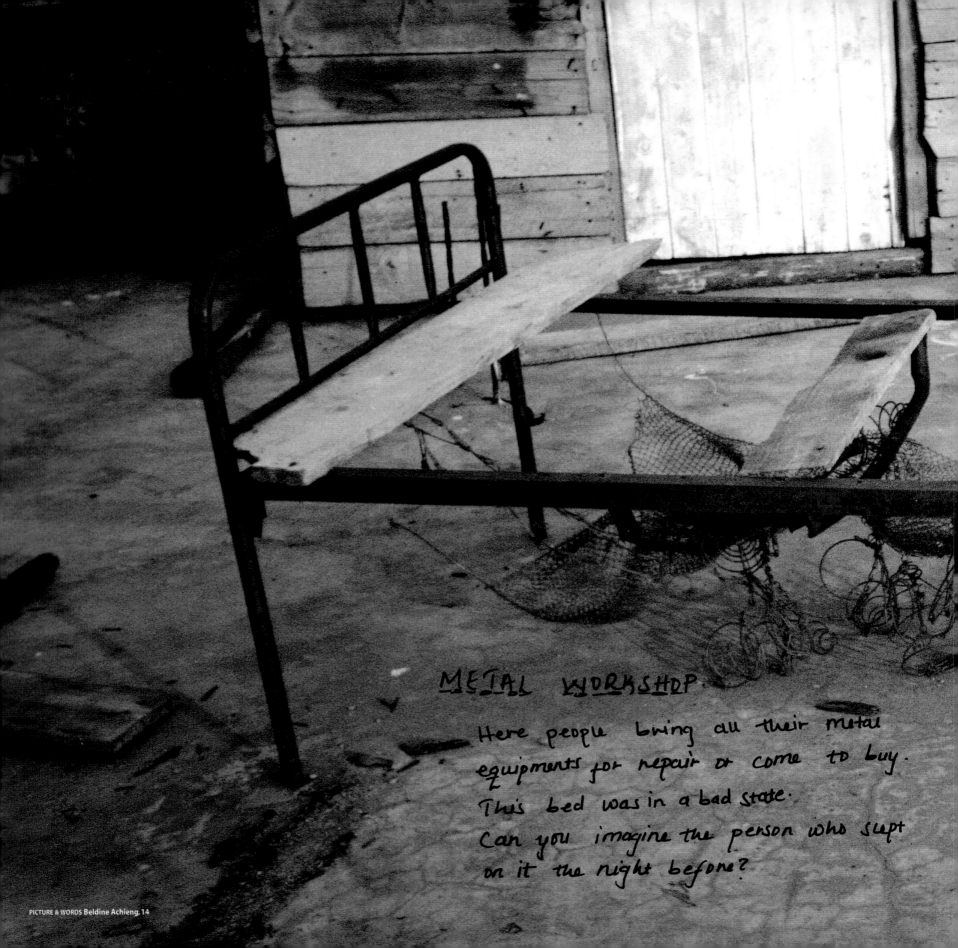

METAL WORKSHOP.

Here people bring all their metal
equipments for repair or come to buy.
This bed was in a bad state.
Can you imagine the person who slept
on it the night before?

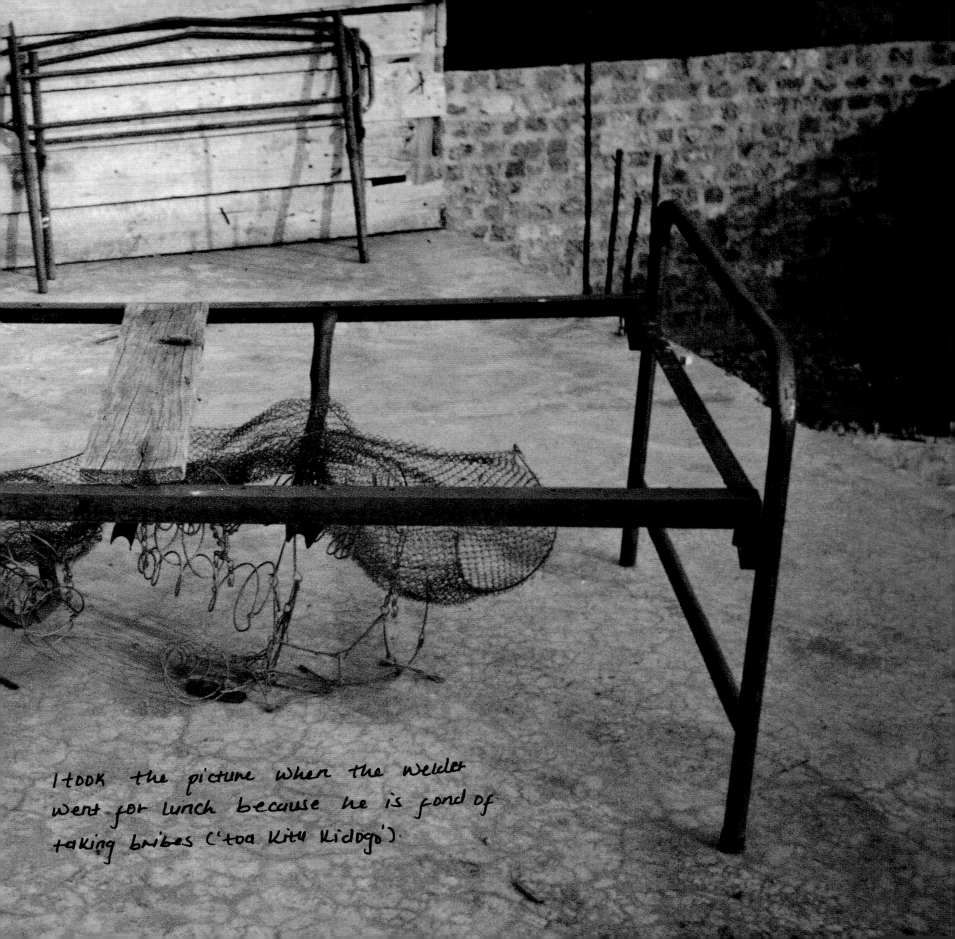

I took the picture when the welder
went for lunch because he is fond of
taking bribes ('toa kitu kidogo').

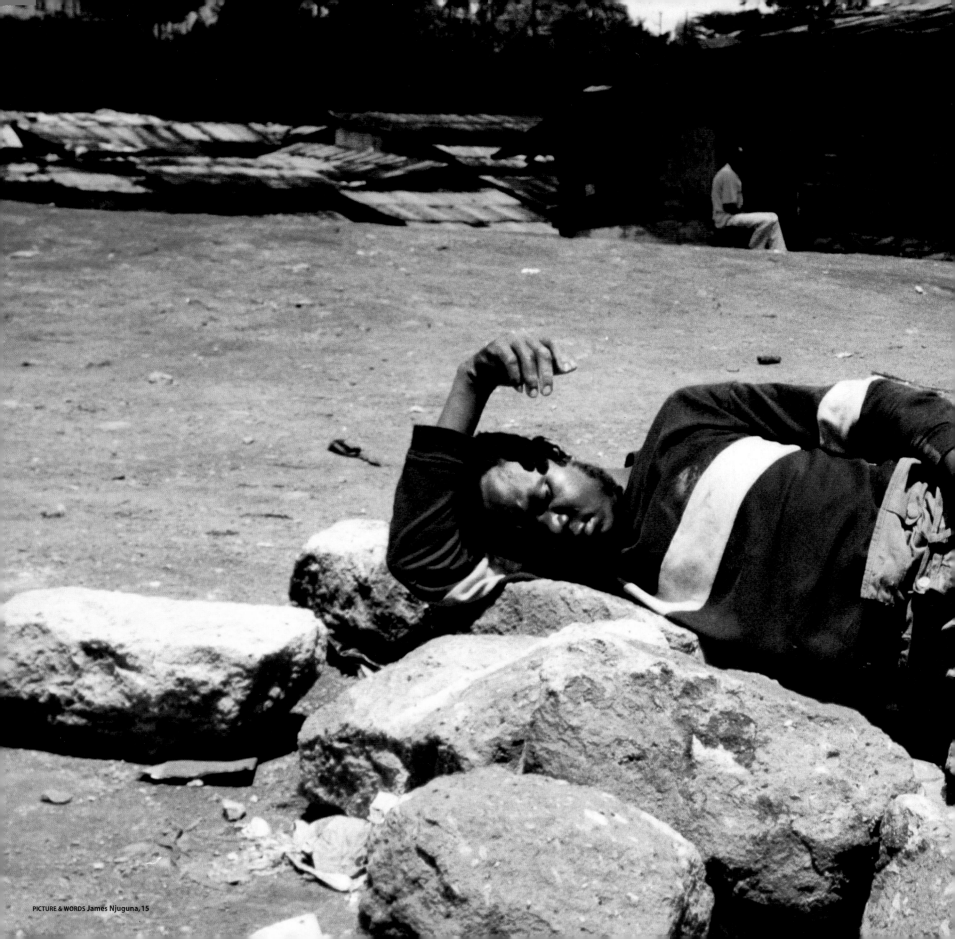

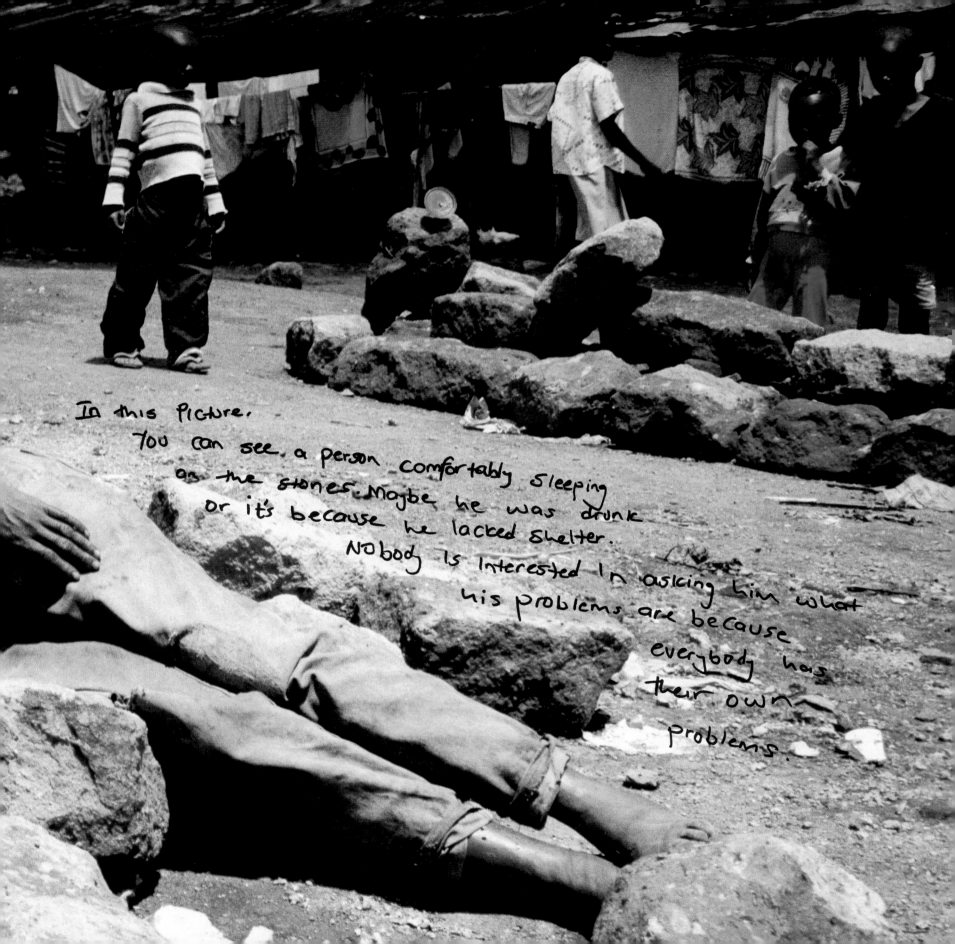

In this picture,
You can see a person comfortably sleeping
on the stones. Maybe he was drunk
or it's because he lacked shelter.
Nobody is interested in asking him what
his problems are because
everybody has
their own
problems.

Relaxing time –
This child lying on the garbage
seems to be very tired from playing
and needs to rest.

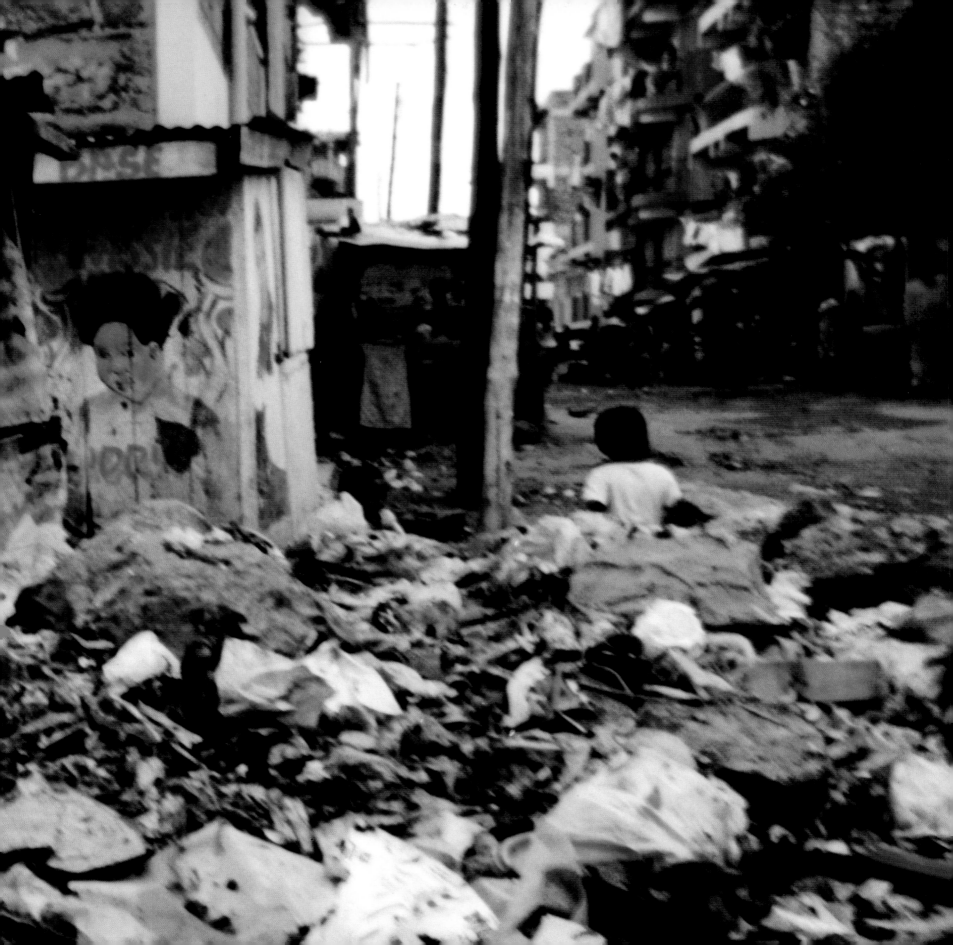

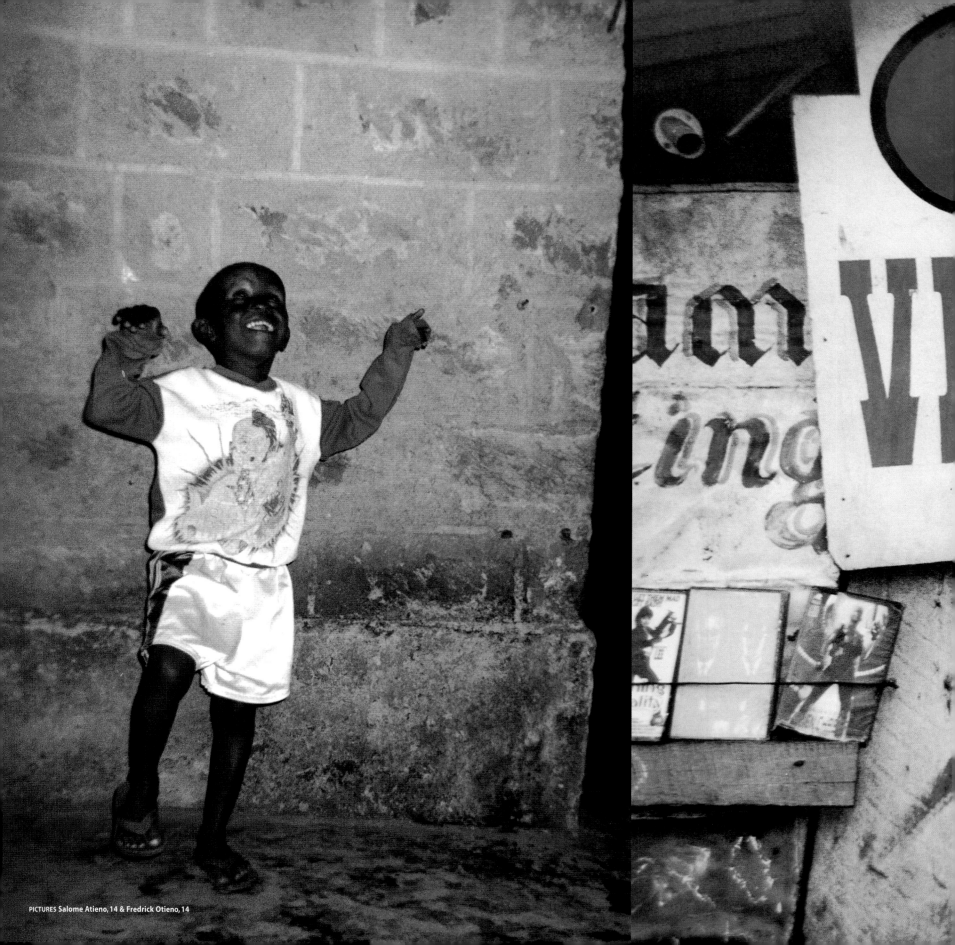

PICTURES Salome Atieno, 14 & Fredrick Otieno, 14

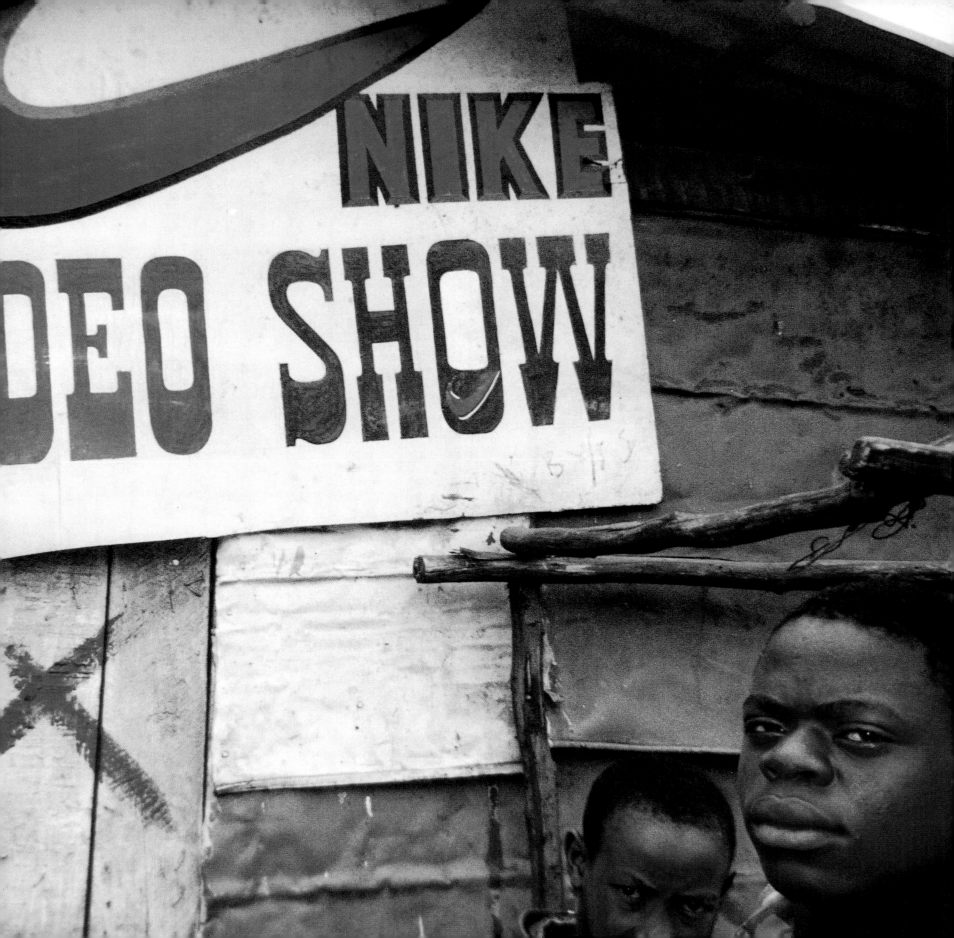

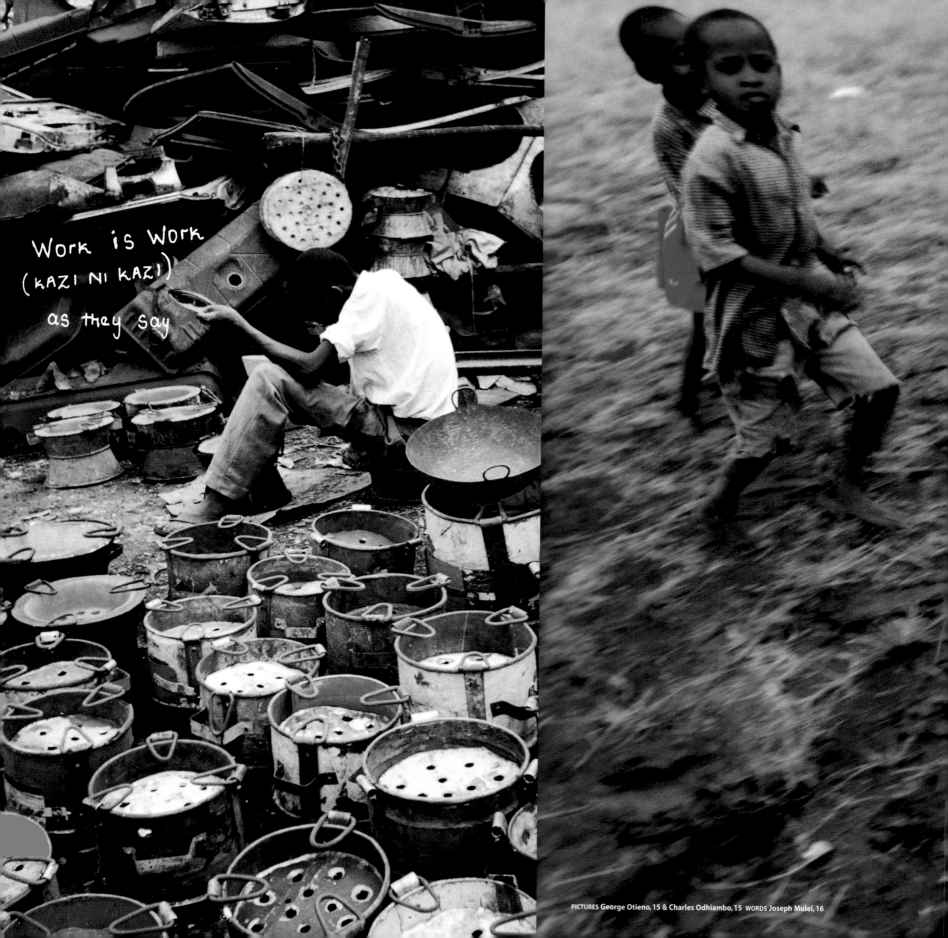

Work is Work
(KAZI NI KAZI)

as they say

PICTURES George Otieno, 15 & Charles Odhiambo, 15  WORDS Joseph Mulei, 16

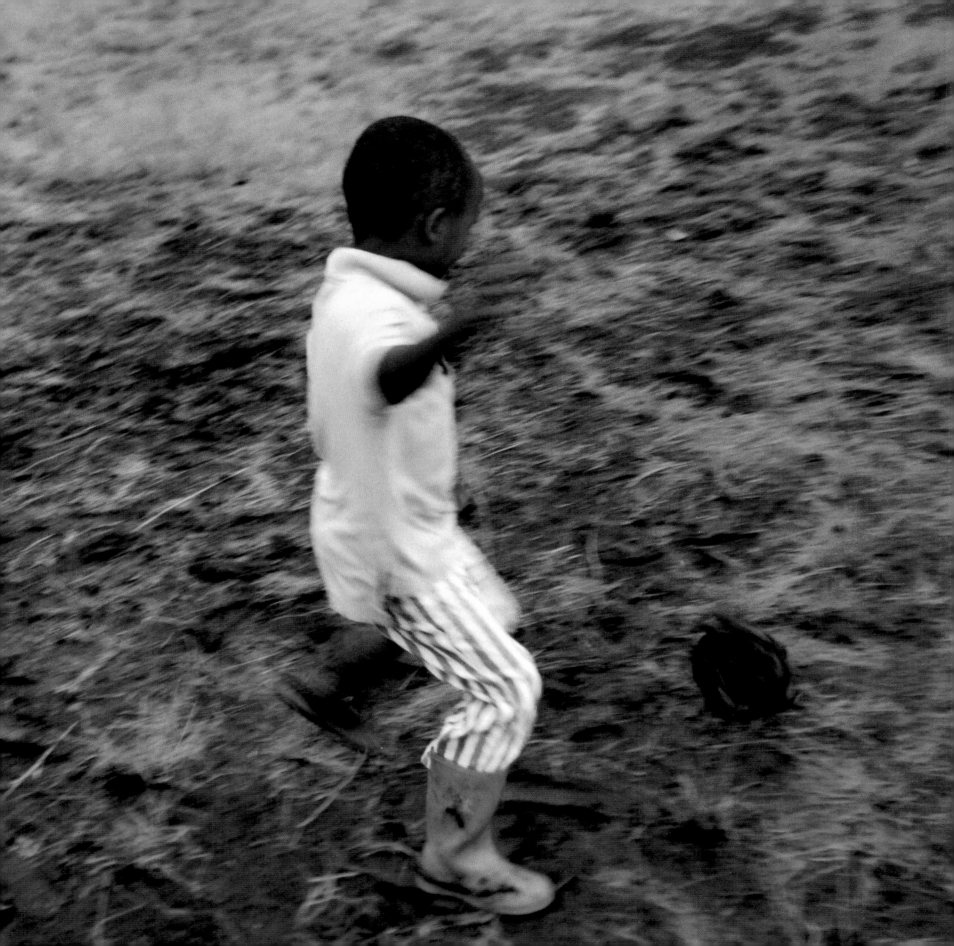

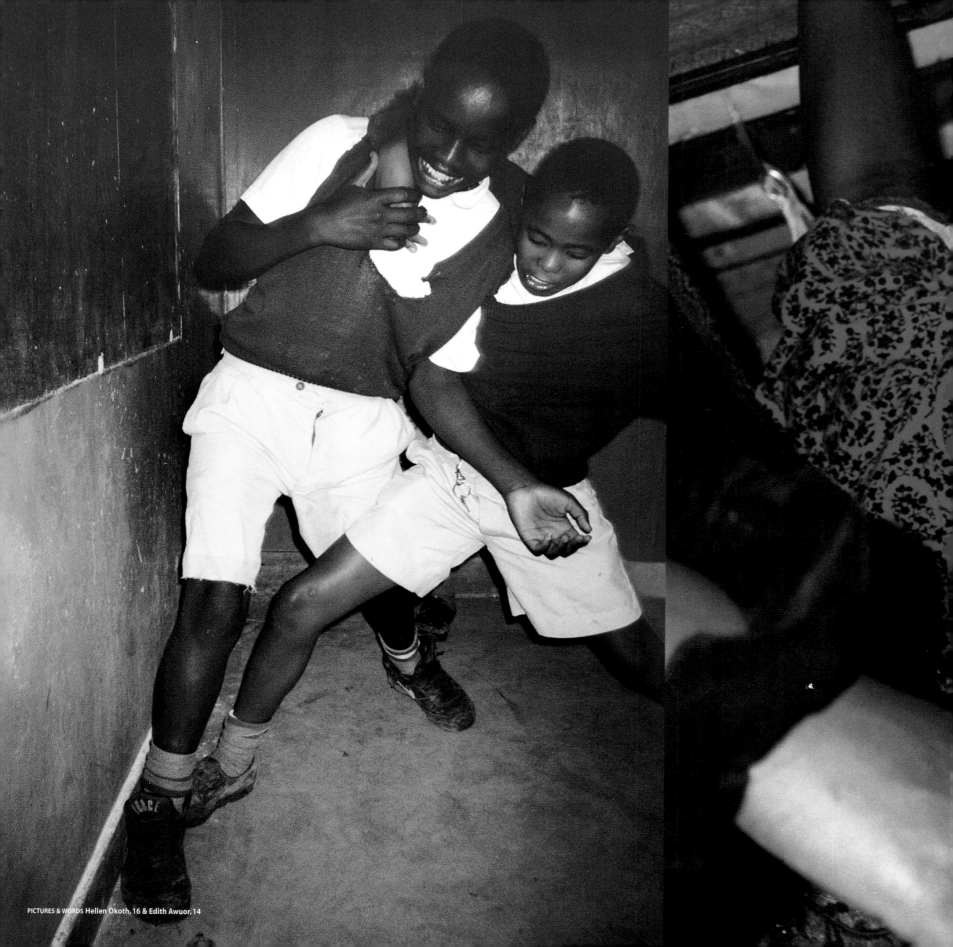

PICTURES & WORDS Hellen Okoth, 16 & Edith Awuor, 14

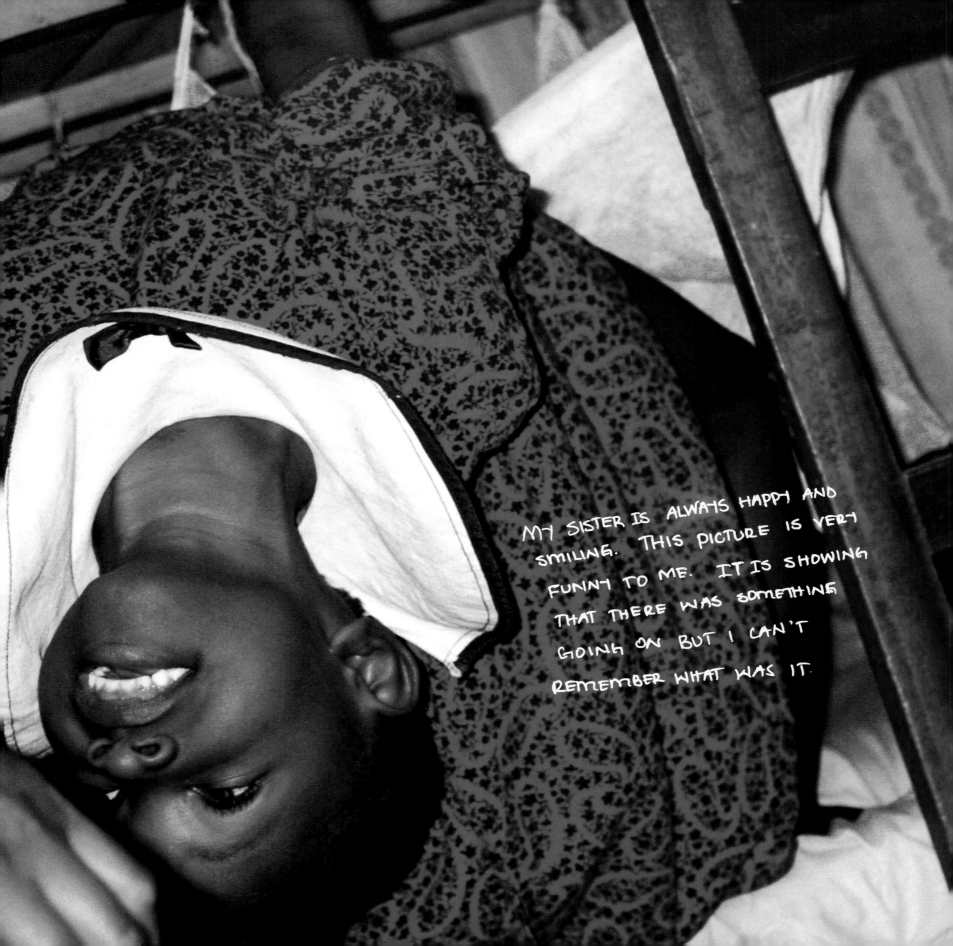

MY SISTER IS ALWAYS HAPPY AND SMILING. THIS PICTURE IS VERY FUNNY TO ME. IT IS SHOWING THAT THERE WAS SOMETHING GOING ON BUT I CAN'T REMEMBER WHAT WAS IT.

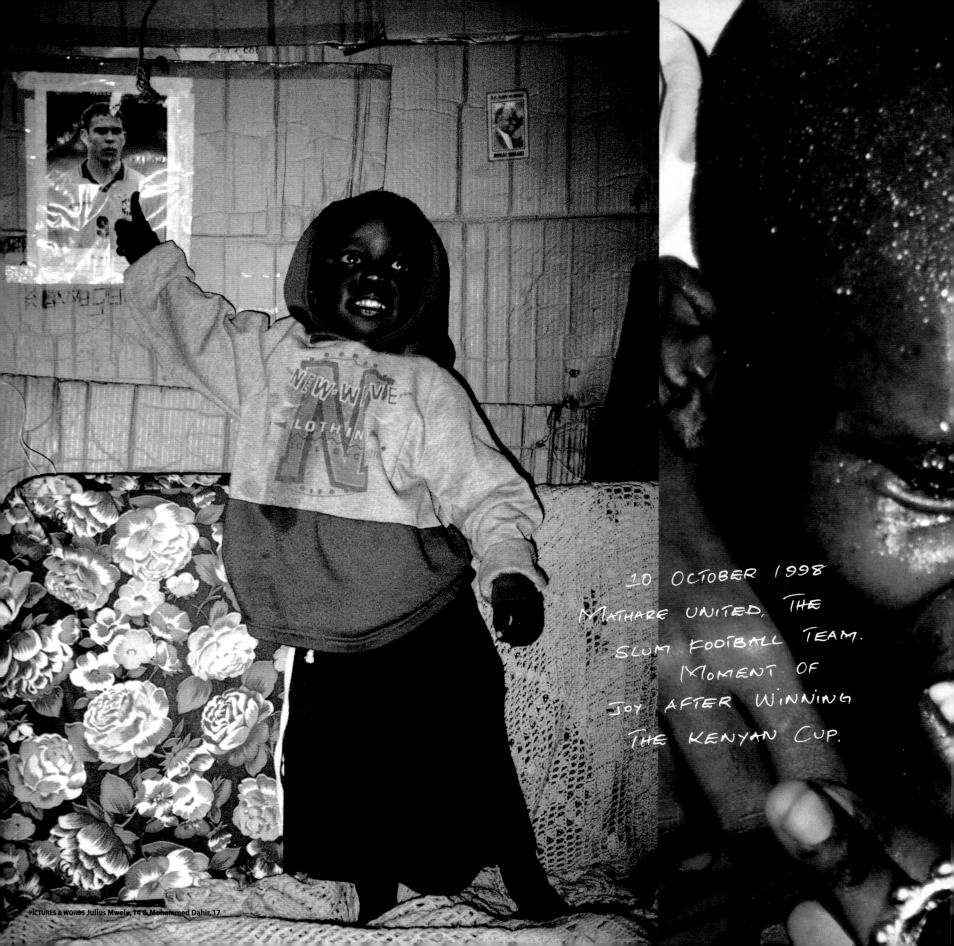

10 OCTOBER 1998
MATHARE UNITED, THE
SLUM FOOTBALL TEAM.
MOMENT OF
JOY AFTER WINNING
THE KENYAN CUP.

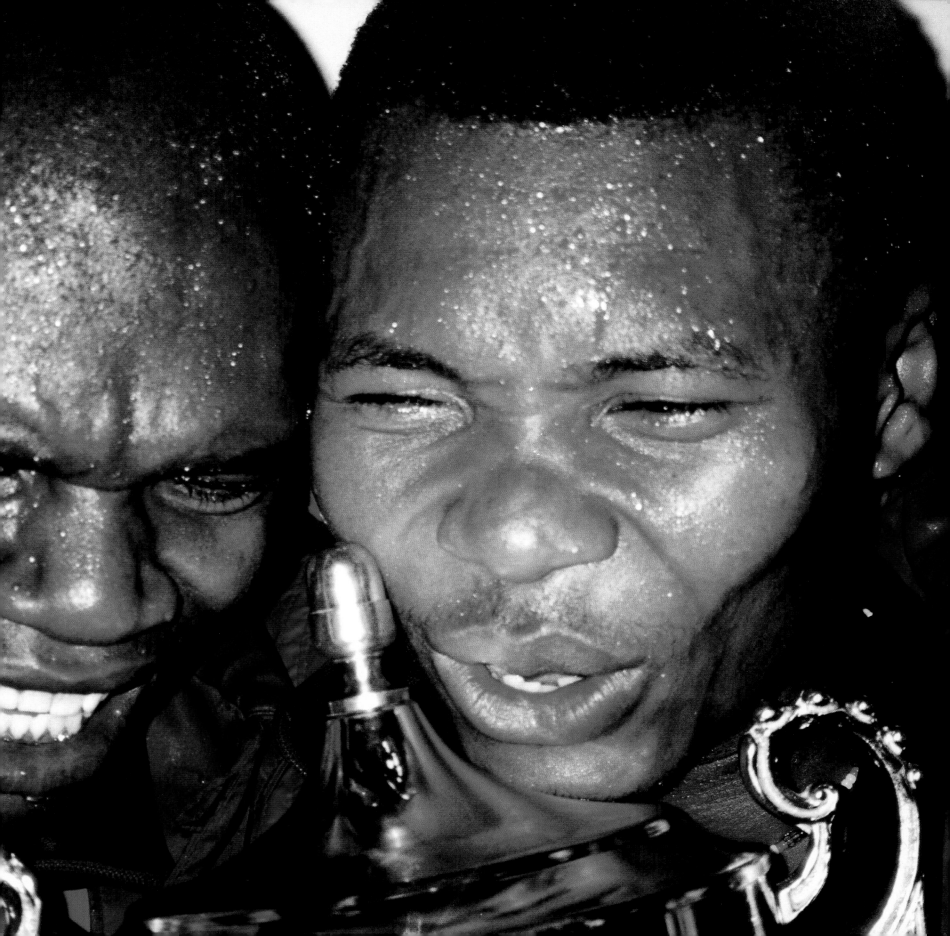

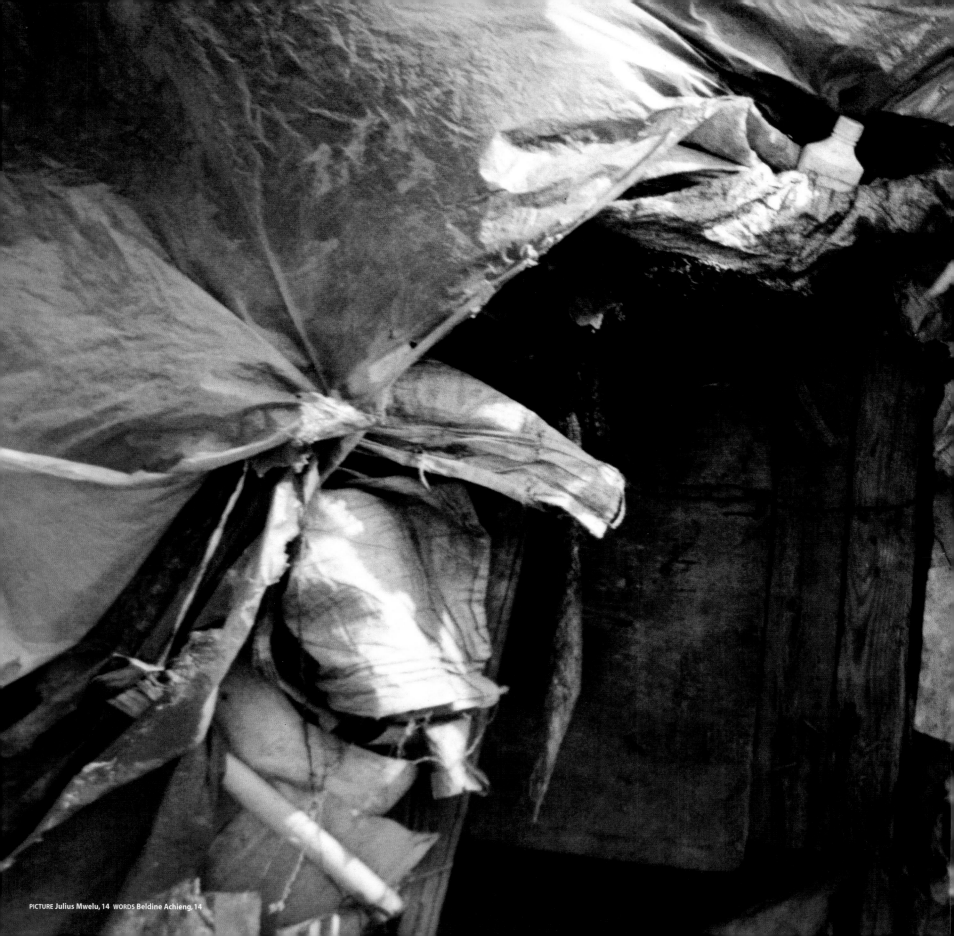

PICTURE Julius Mwelu, 14  WORDS Beldine Achieng, 14

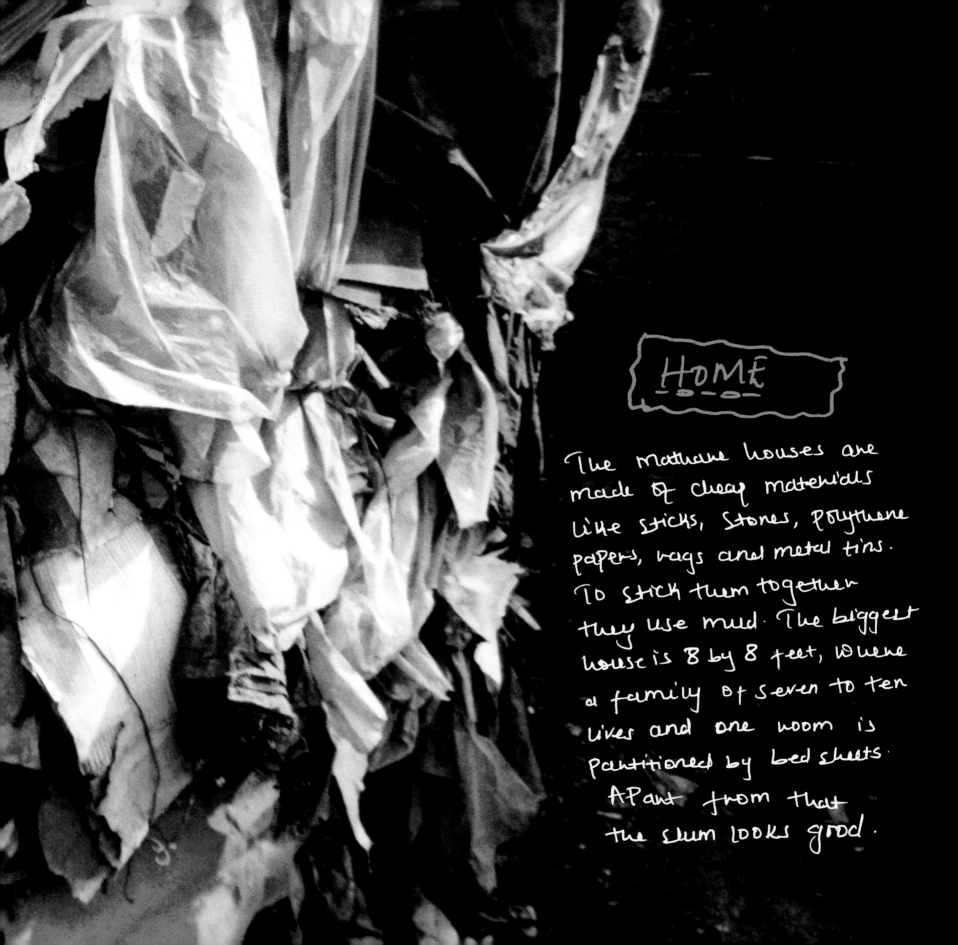

## HOME

The Mathare houses are made of cheap materials like sticks, stones, polythene papers, rags and metal tins. To stick them together they use mud. The biggest house is 8 by 8 feet, where a family of seven to ten lives and one room is partitioned by bed sheets. Apart from that the slum looks good.

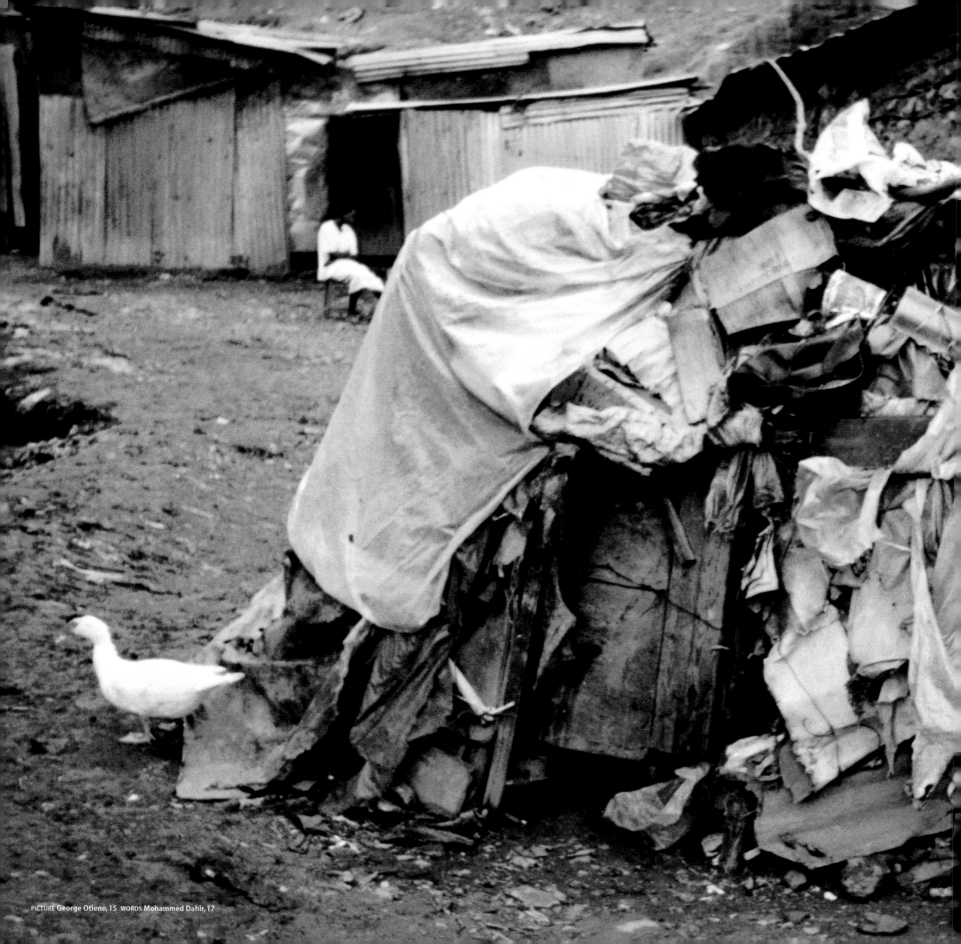

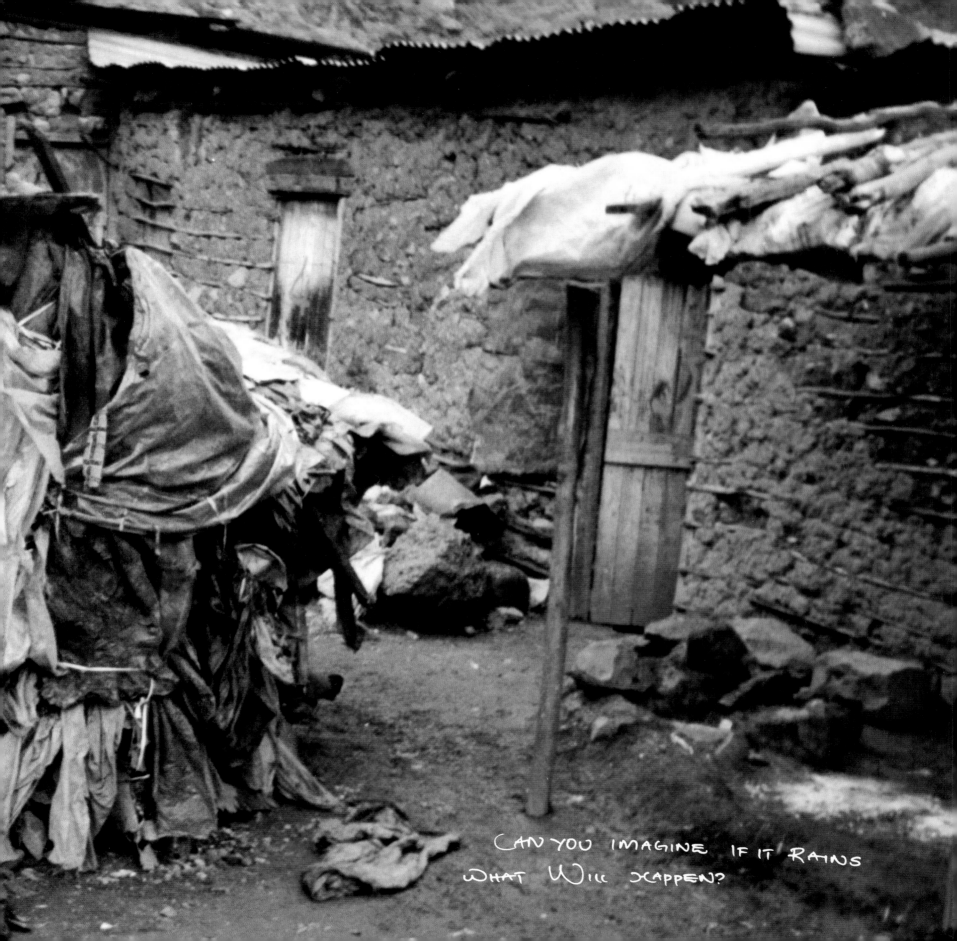

CAN YOU IMAGINE IF IT RAINS
WHAT WILL HAPPEN?

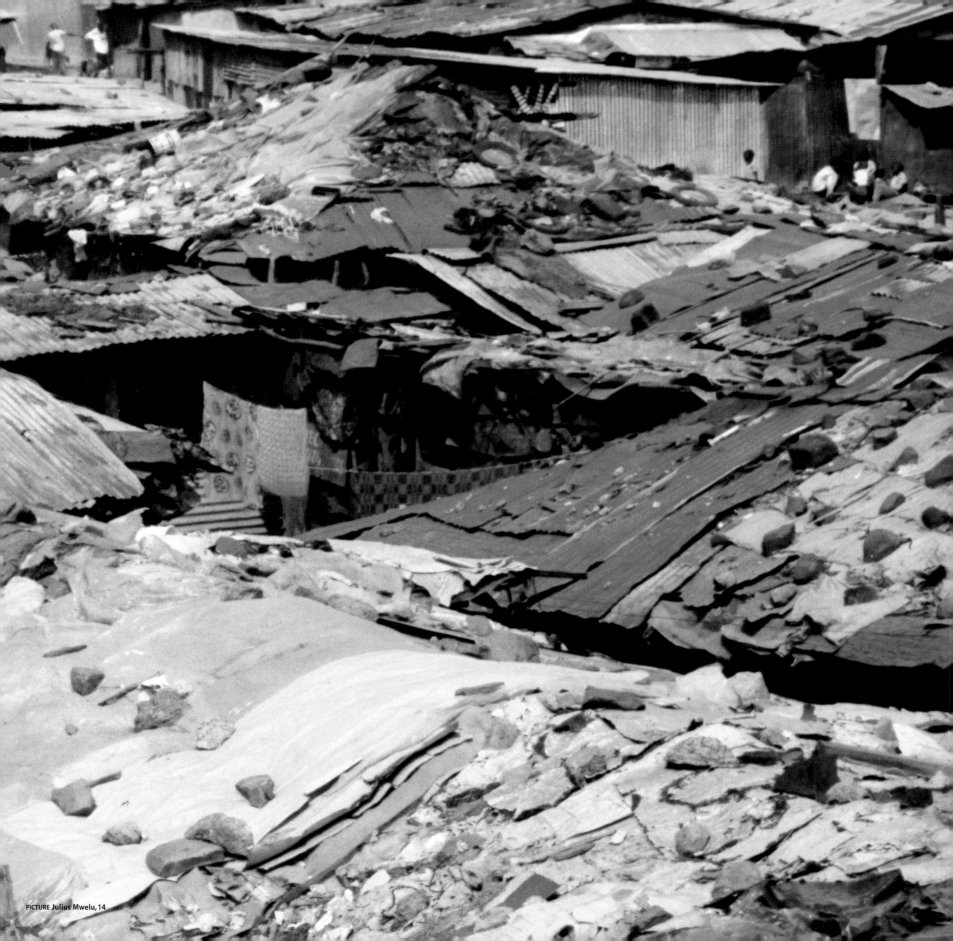

PICTURE Julius Mwelu, 14

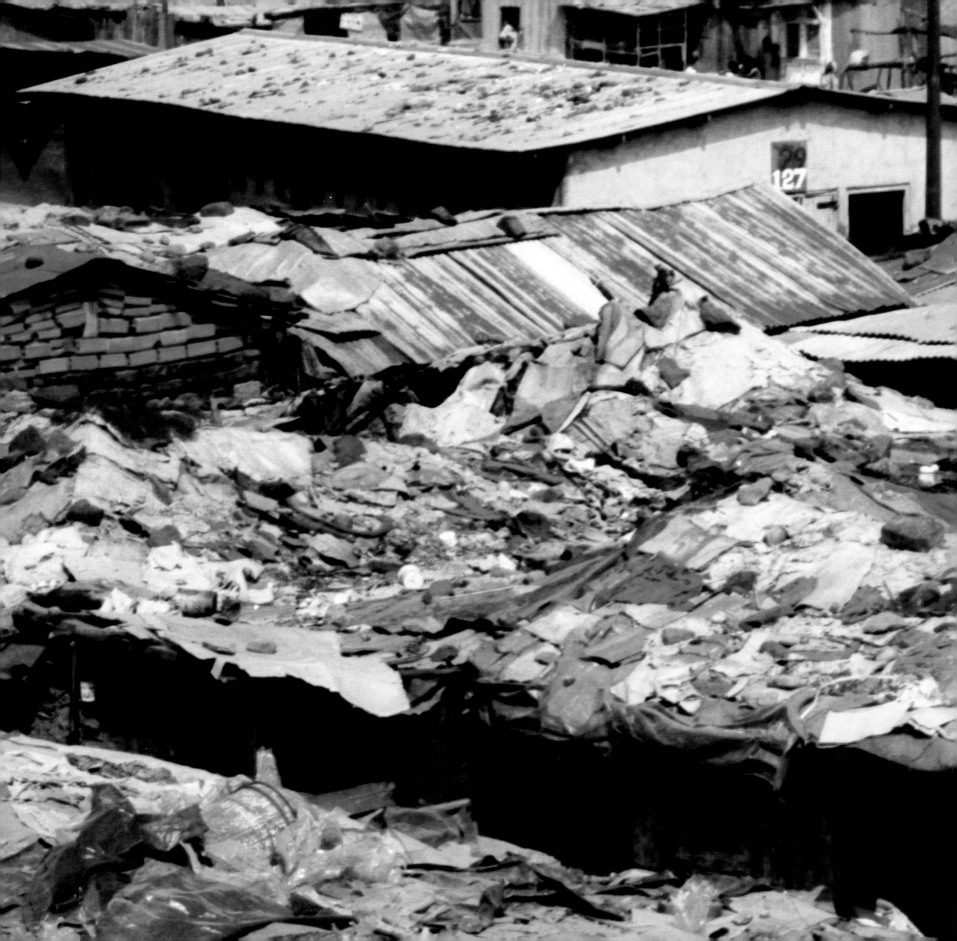

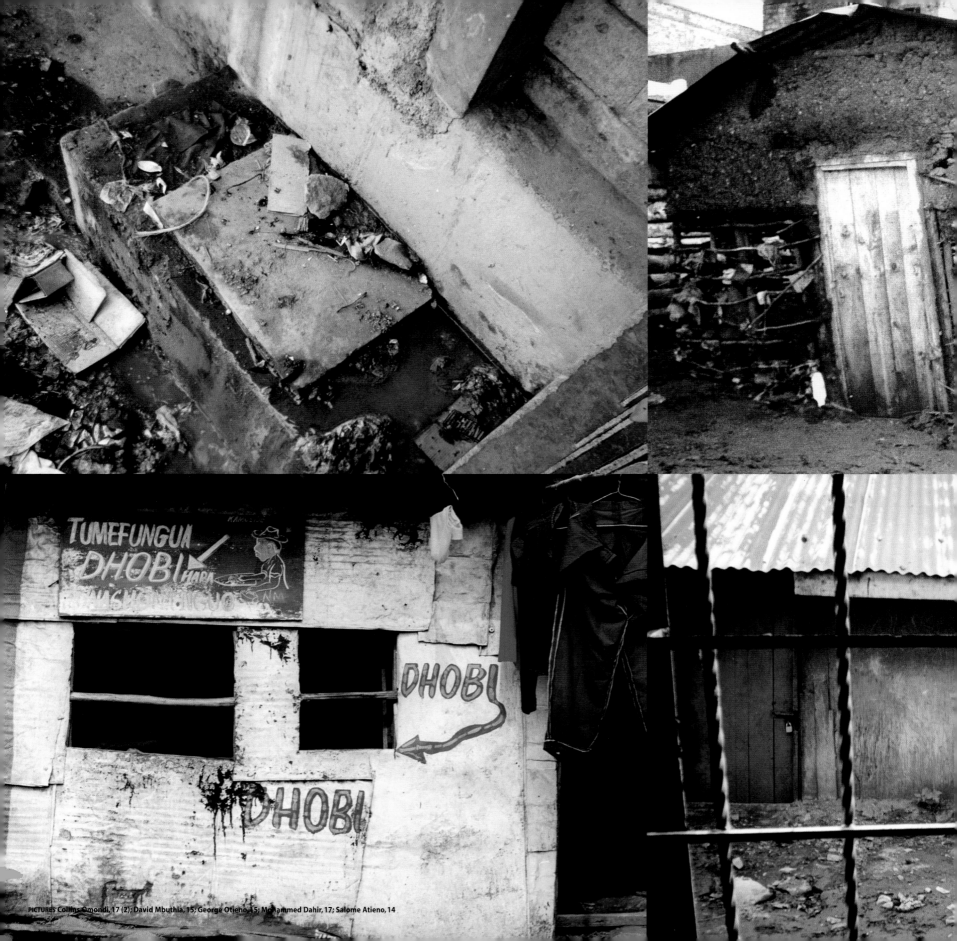

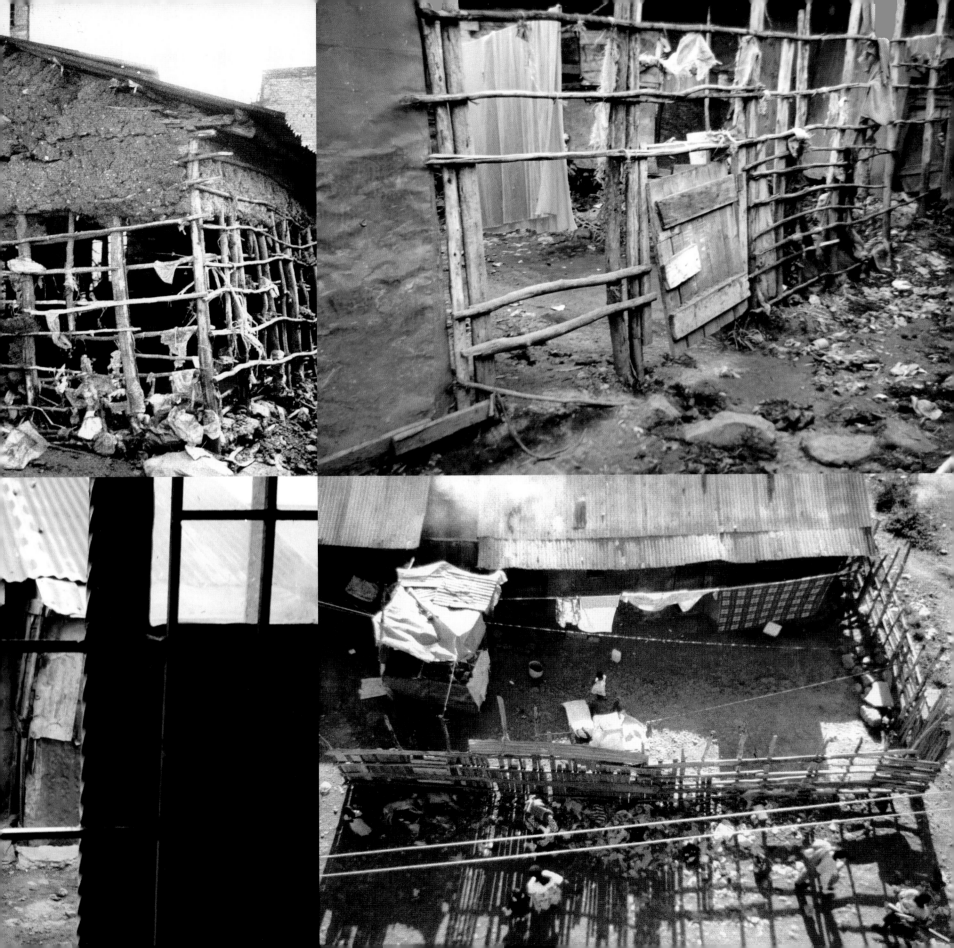

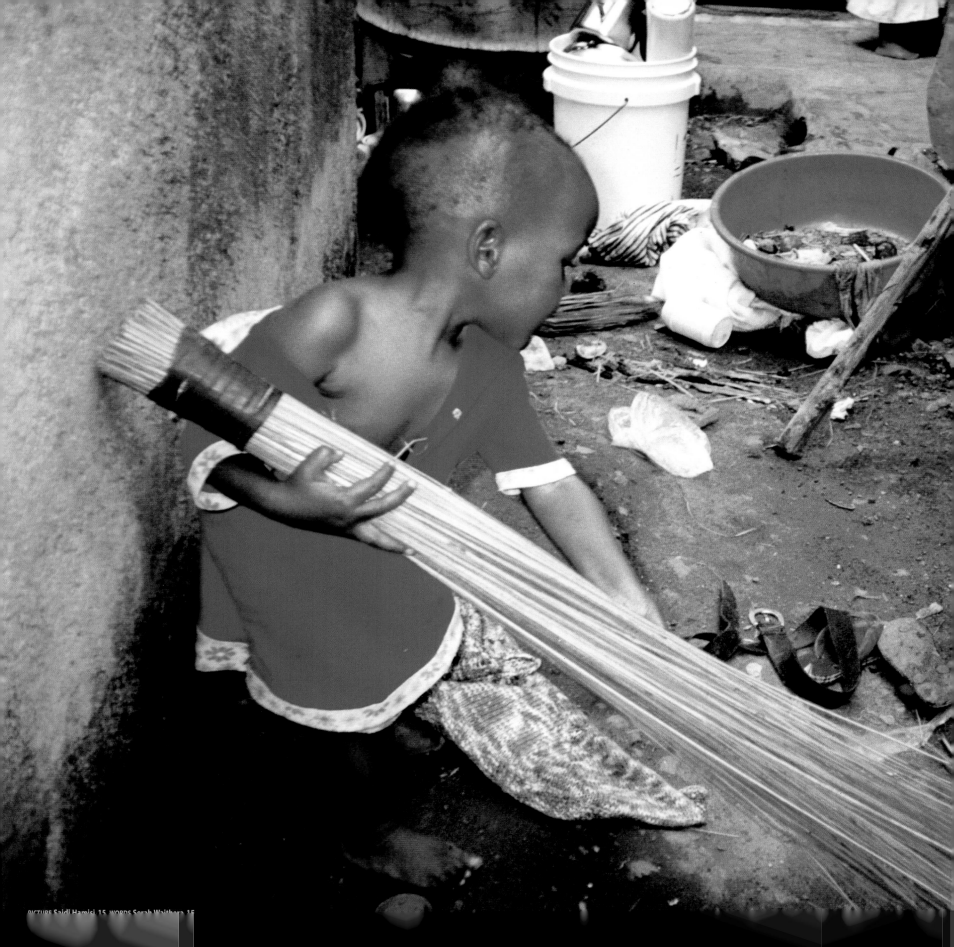

PICTURE Saidi Hamisi, 15. WORDS Sarah Waithera, 15

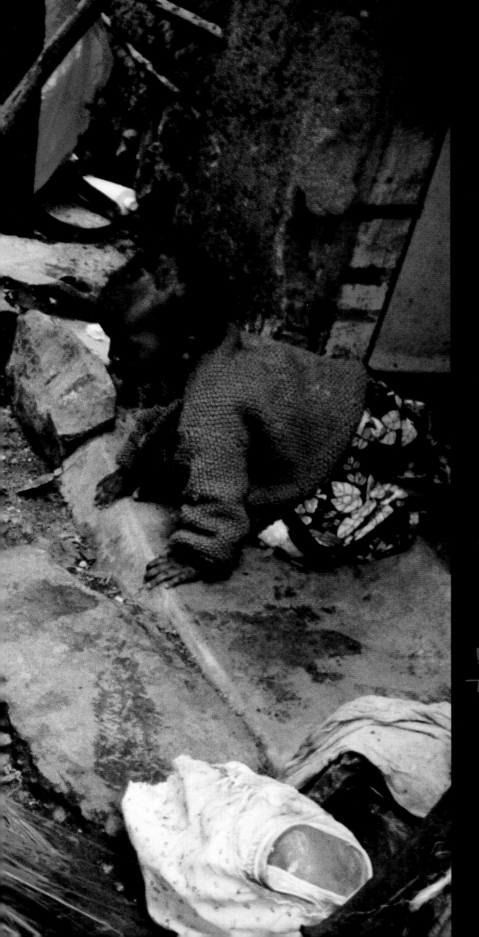

FIRST WHEN YOU WAKE UP
IN THE MORNING THE IMPORTANT
THING TO DO FIRST IS
TO FIND OUT WHERE ARE YOUR
SHOES SO THAT YOU CAN DO
THE REST OF YOUR WORK.

WHY SHOES ARE ~~IMPORTANT~~
USEFUL: WHEN YOU WALK
WITHOUT THEM YOUR LEGS CAN
GET INJURED BY ANYTHING
DANGEROUS LIKE BONES,
THORNS AND MANY OTHERS.

SO I WILL SUGGEST THAT
SHOES ARE THE MOST USEFUL
OBJECT IN OUR HOME.

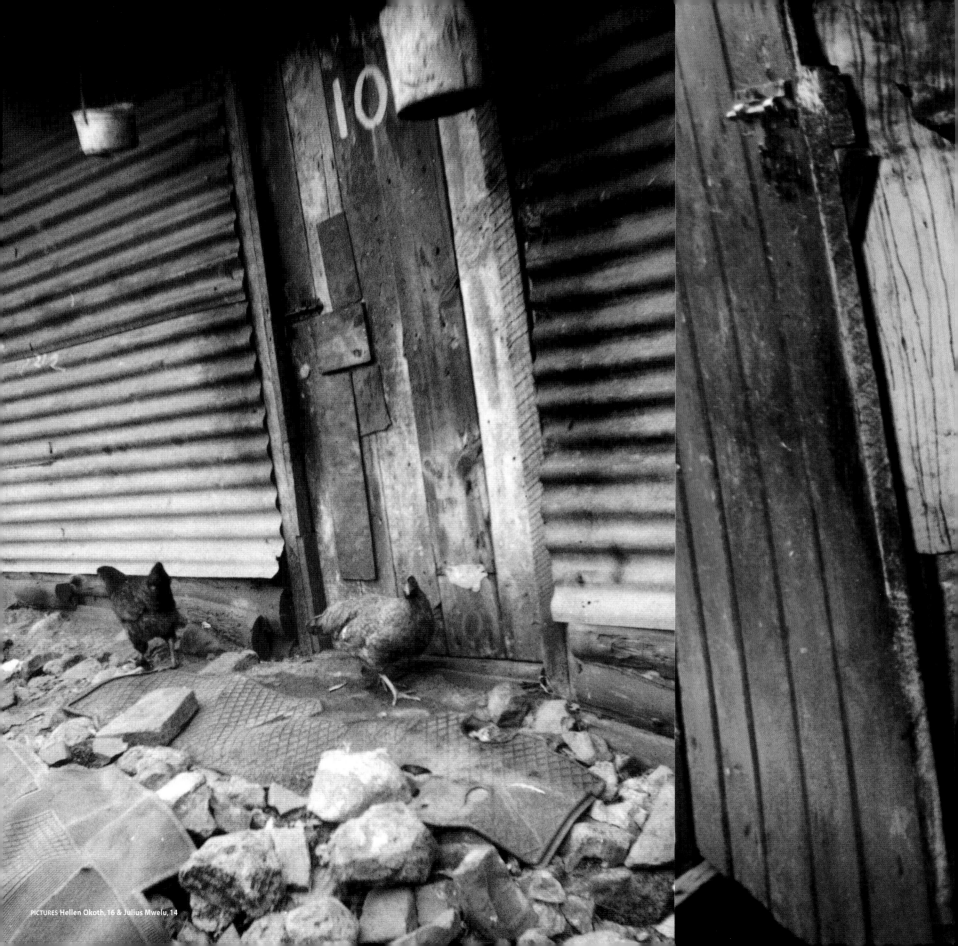

PICTURES Hellen Okoth, 16 & Julius Mwelu, 14

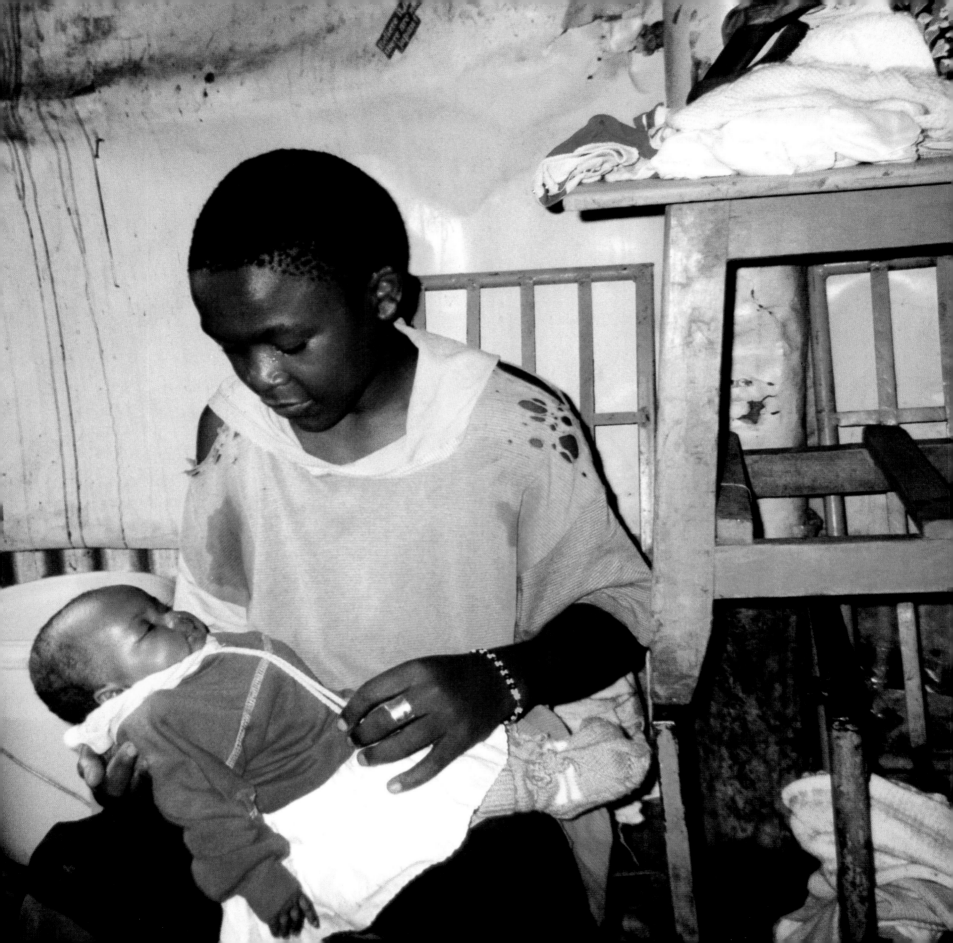

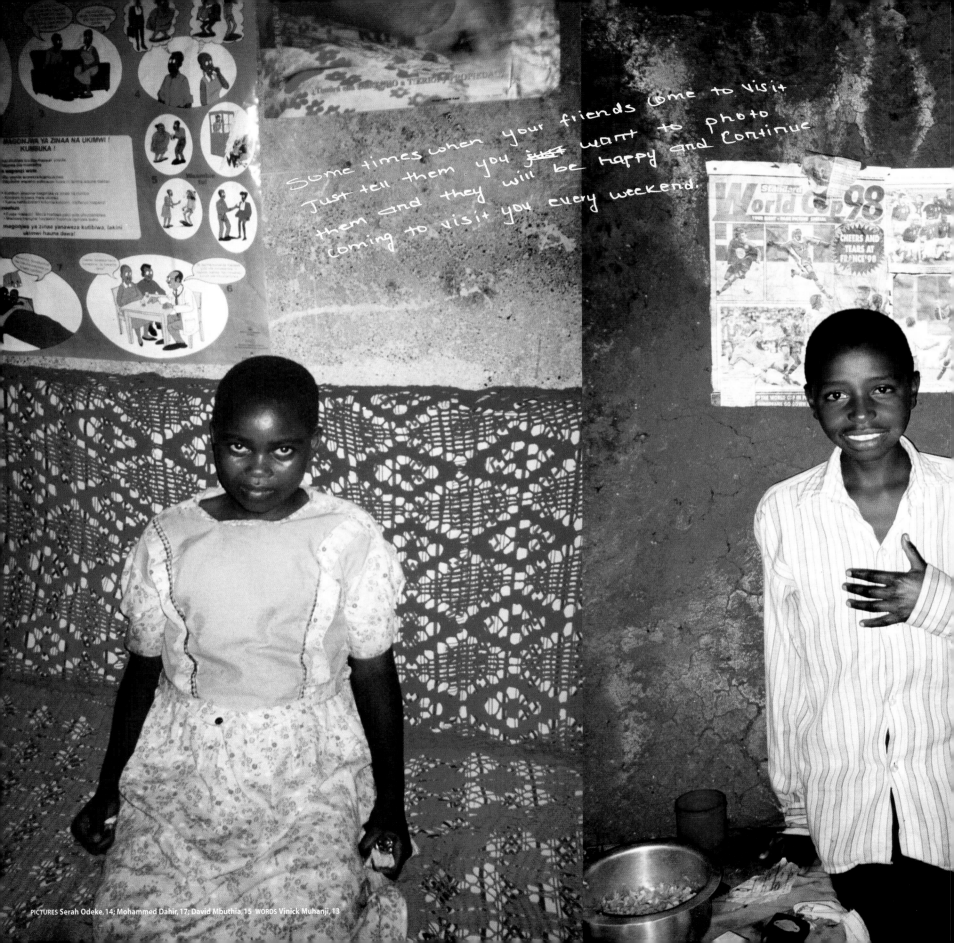

Some times when your friends come to visit
Just tell them you ~~just~~ want to photo
them and they will be happy and Continue
coming to visit you every weekend.

PICTURES Serah Odeke, 14; Mohammed Dahir, 17; David Mbuthia, 15 WORDS Vinick Muhanji, 13

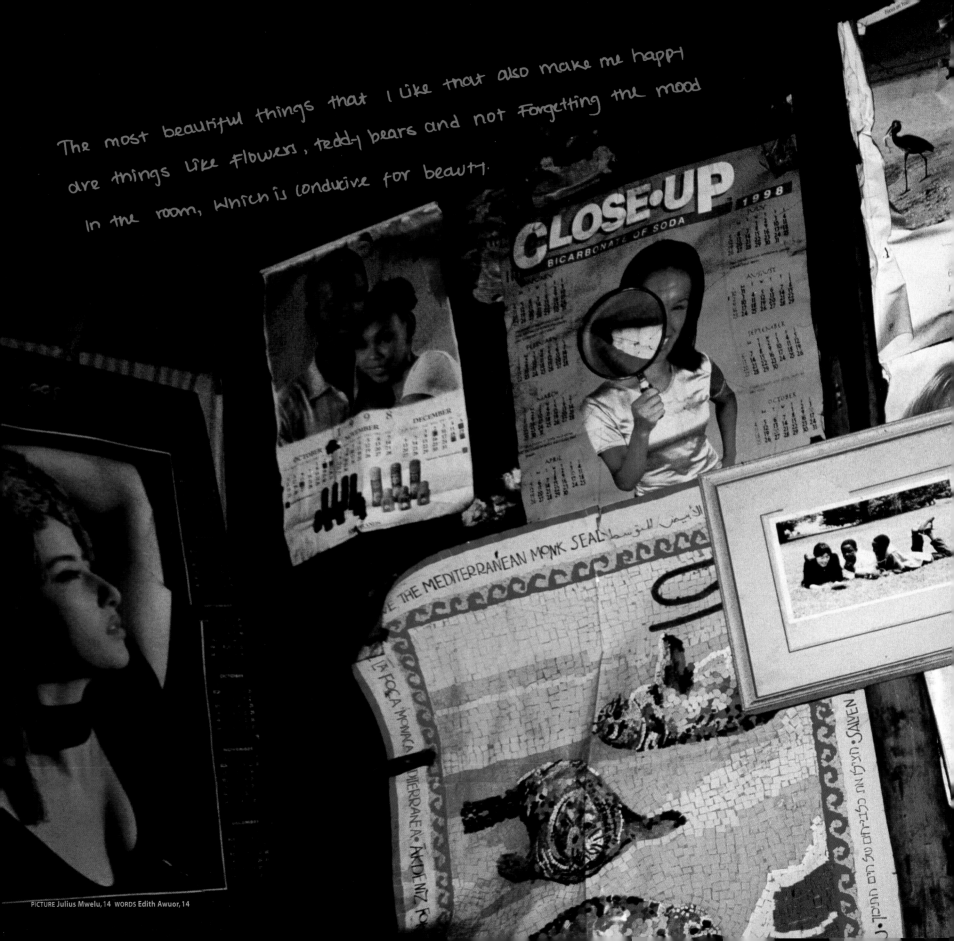

The most beautiful things that I like that also make me happy are things like flowers, teddy bears and not forgetting the mood in the room, which is conducive for beauty.

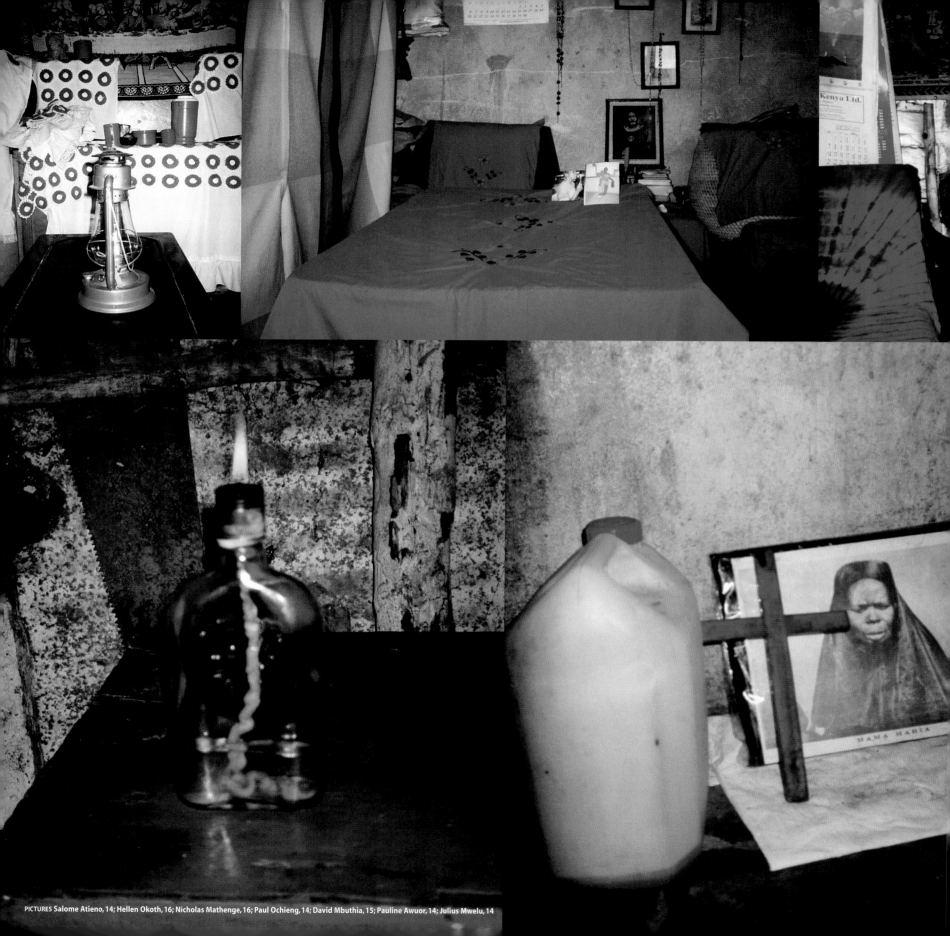

PICTURES Salome Atieno, 14; Hellen Okoth, 16; Nicholas Mathenge, 16; Paul Ochieng, 14; David Mbuthia, 15; Pauline Awuor, 14; Julius Mwelu, 14

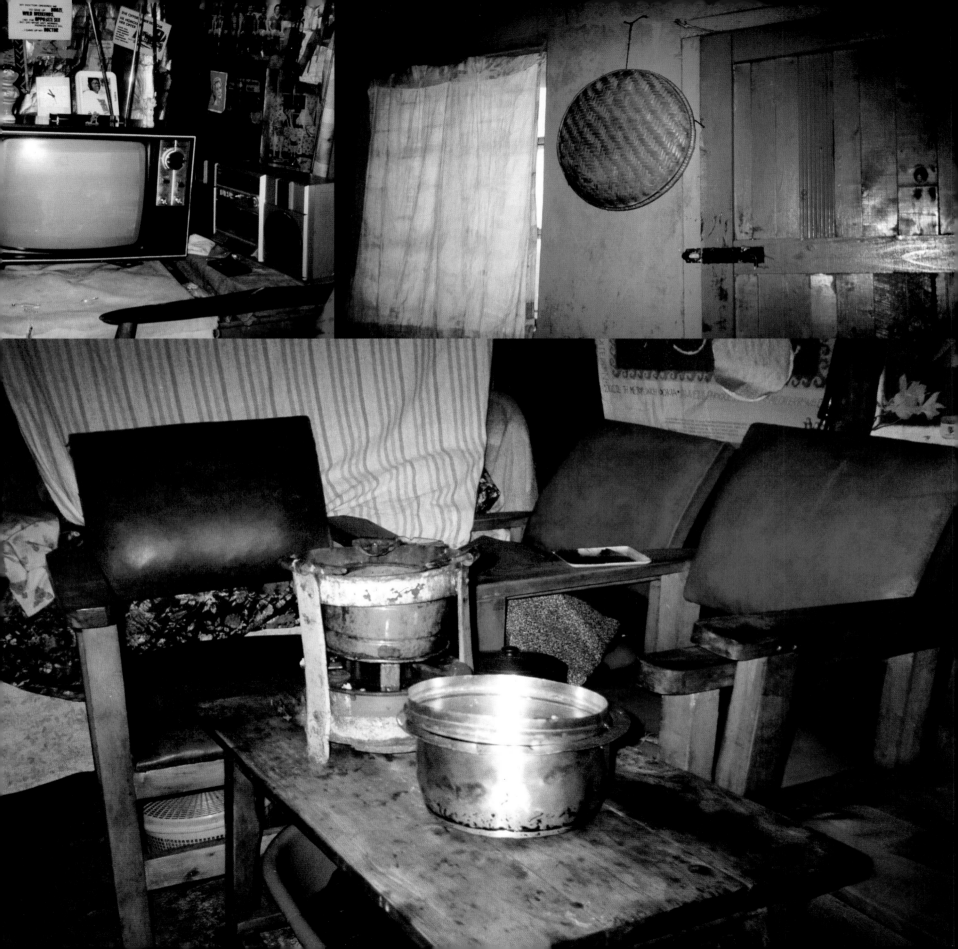

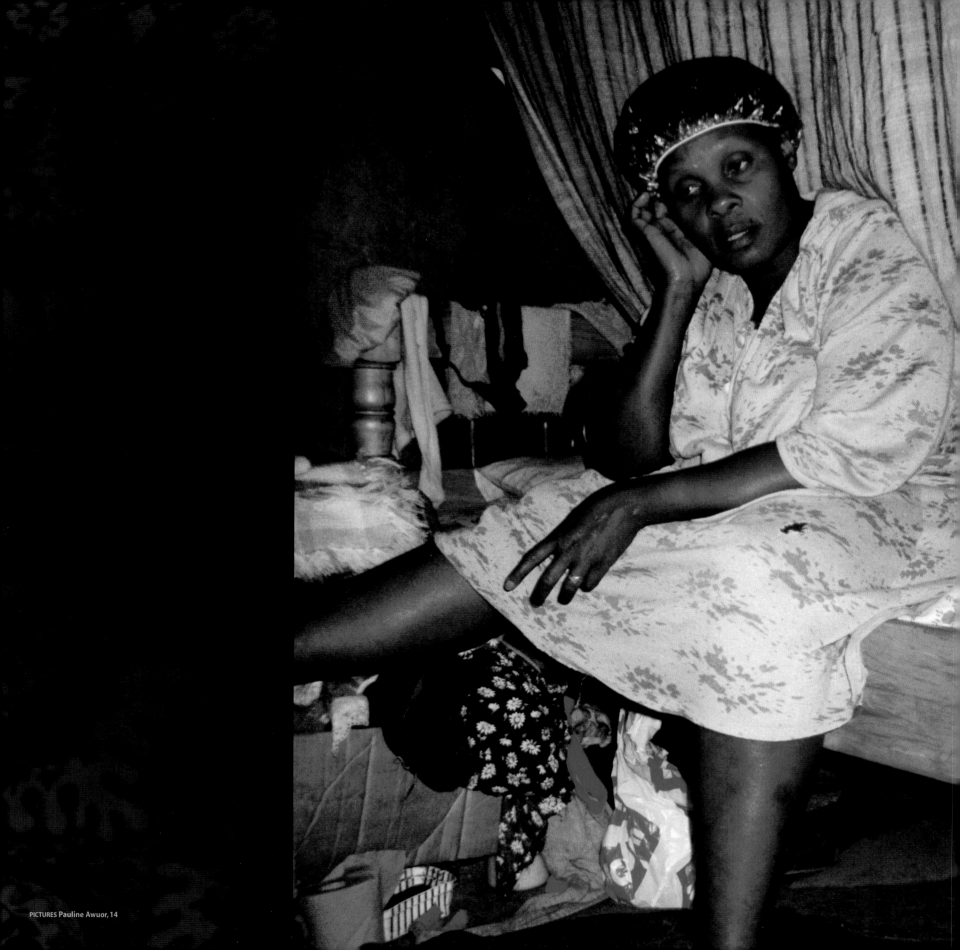

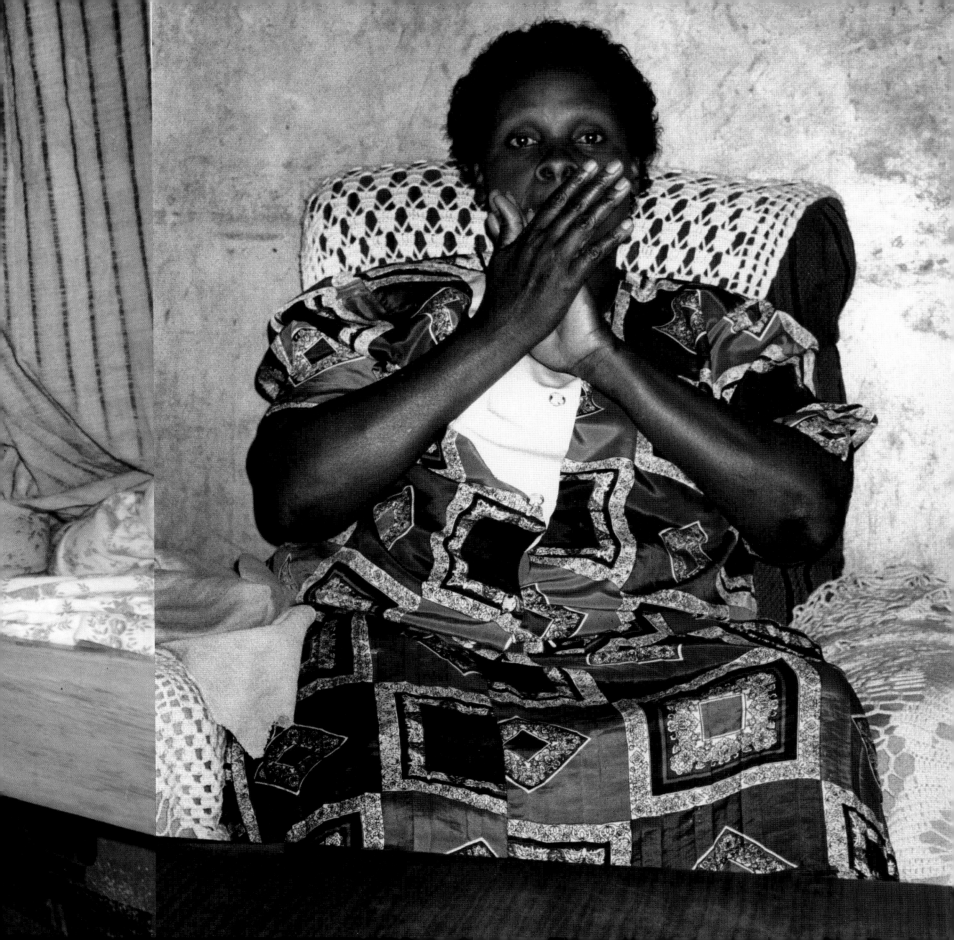

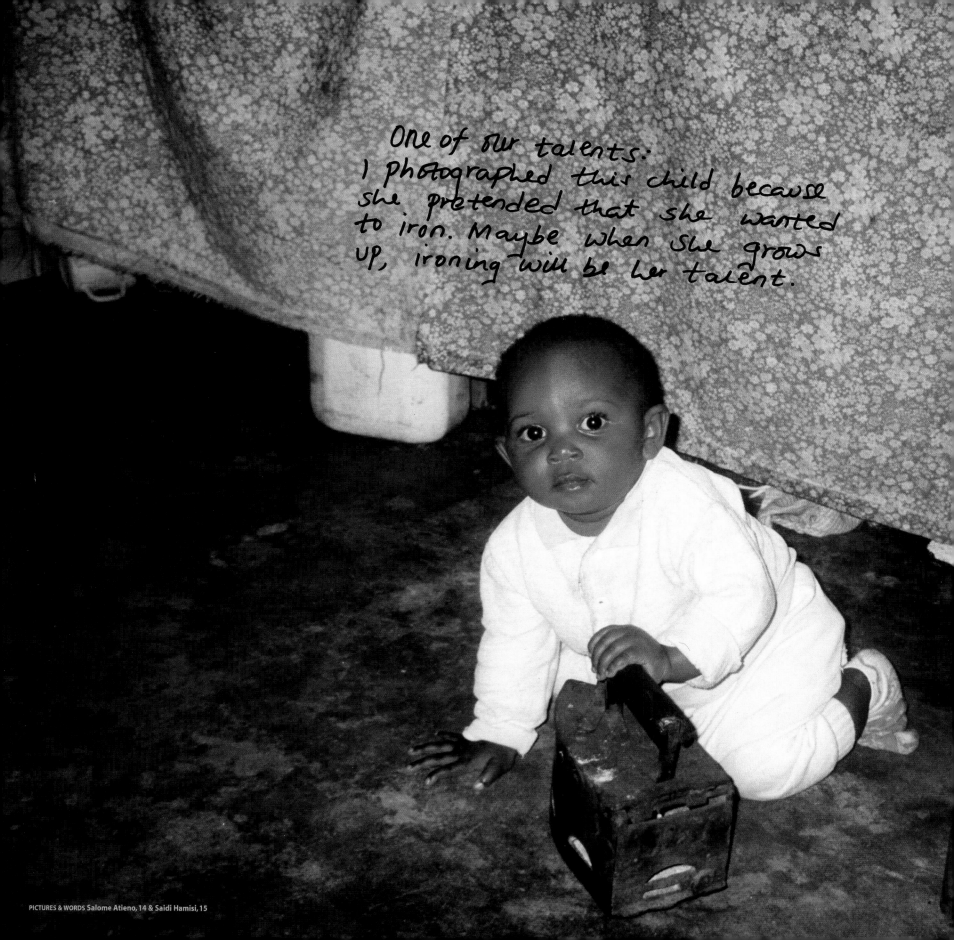

One of our talents:
I photographed this child because she pretended that she wanted to iron. Maybe when she grows up, ironing will be her talent.

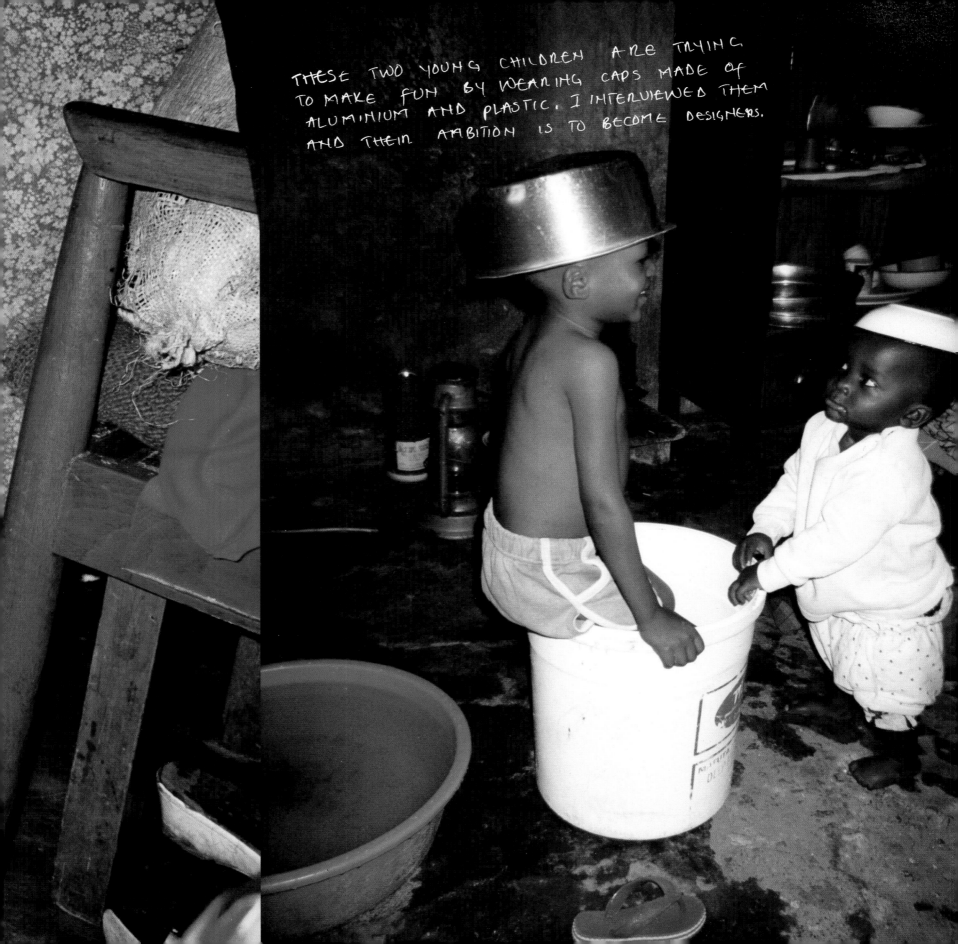

THESE TWO YOUNG CHILDREN ARE TRYING TO MAKE FUN BY WEARING CAPS MADE OF ALUMINIUM AND PLASTIC. I INTERVIEWED THEM AND THEIR AMBITION IS TO BECOME DESIGNERS.

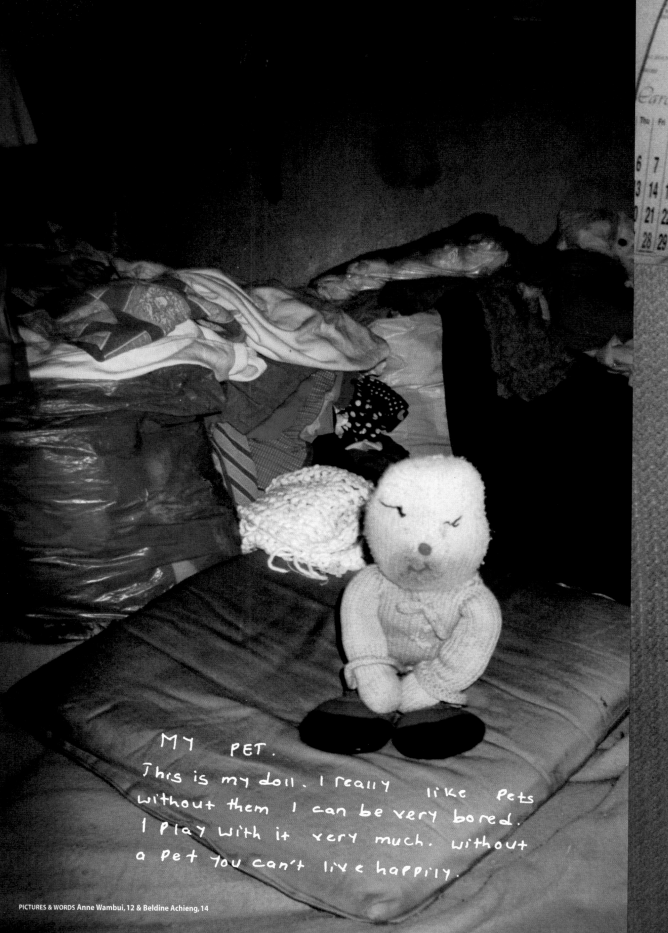

MY PET.
This is my doll. I really like pets
without them I can be very bored.
I play with it very much. Without
a pet you can't live happily.

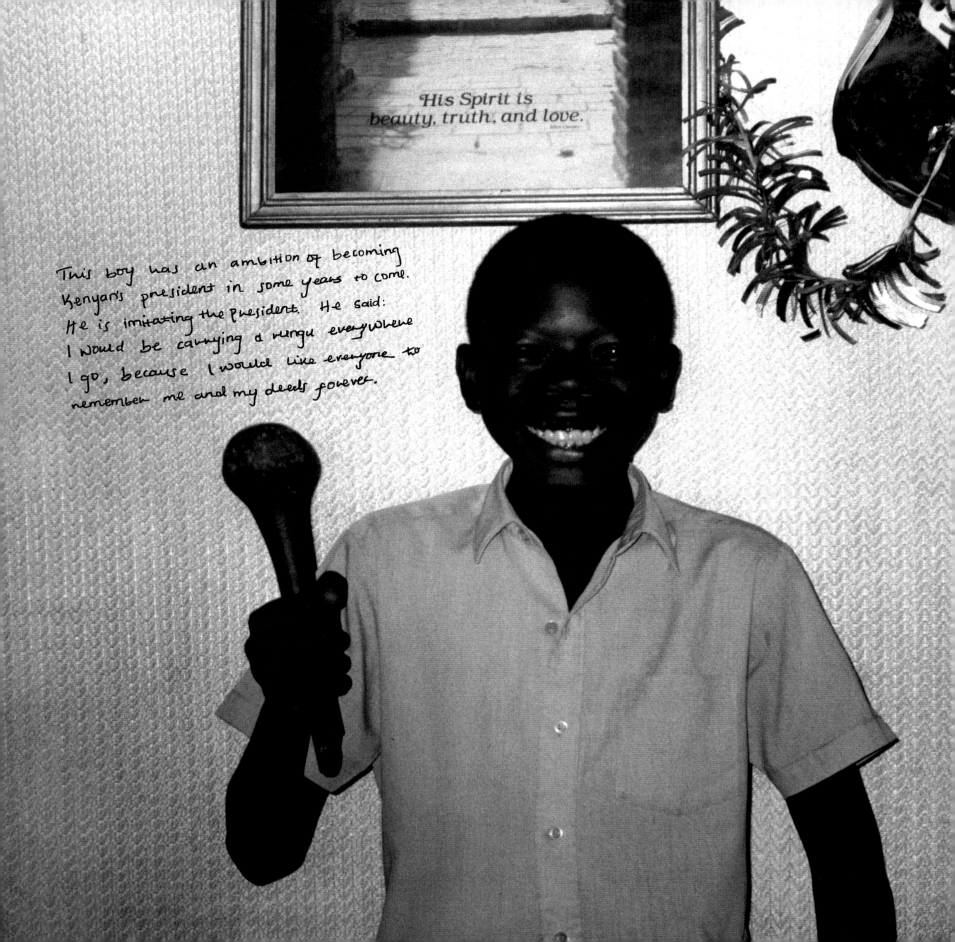

His Spirit is
beauty, truth, and love.

This boy has an ambition of becoming
Kenya's president in some years to come.
He is imitating the president. He said:
I would be carrying a rungu everywhere
I go, because I would like everyone to
remember me and my deeds forever.

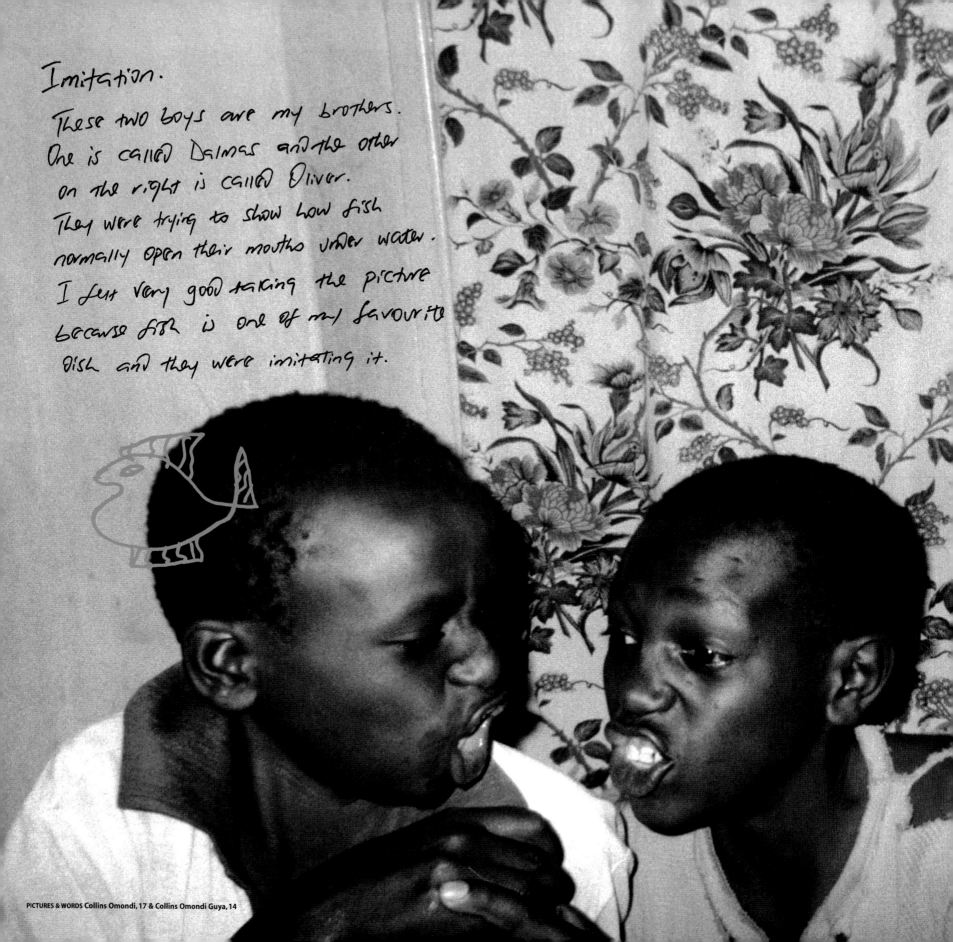

Imitation.

These two boys are my brothers.
One is called Dalmas and the other
on the right is called Oliver.
They were trying to show how fish
normally open their mouths under water.
I felt very good taking the picture
because fish is one of my favourite
dish and they were imitating it.

PICTURES & WORDS Collins Omondi, 17 & Collins Omondi Guya, 14

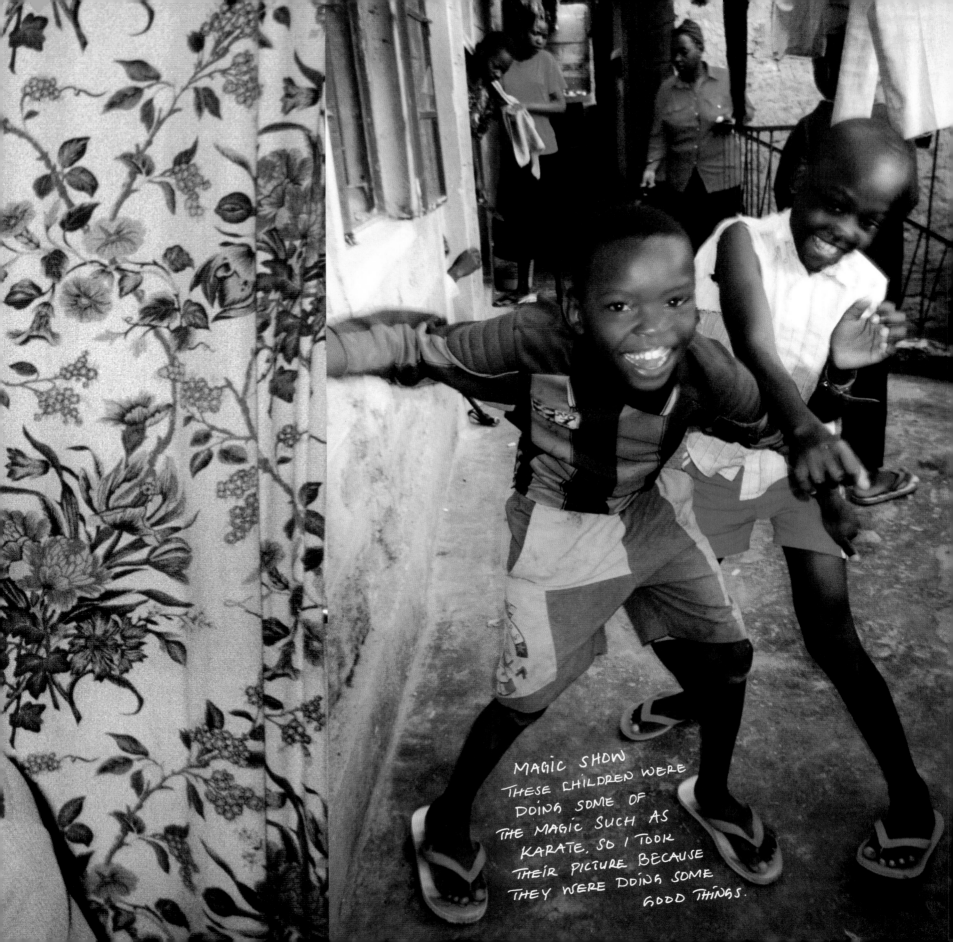

MAGIC SHOW
THESE CHILDREN WERE
DOING SOME OF
THE MAGIC SUCH AS
KARATE, SO I TOOK
THEIR PICTURE BECAUSE
THEY WERE DOING SOME
GOOD THINGS.

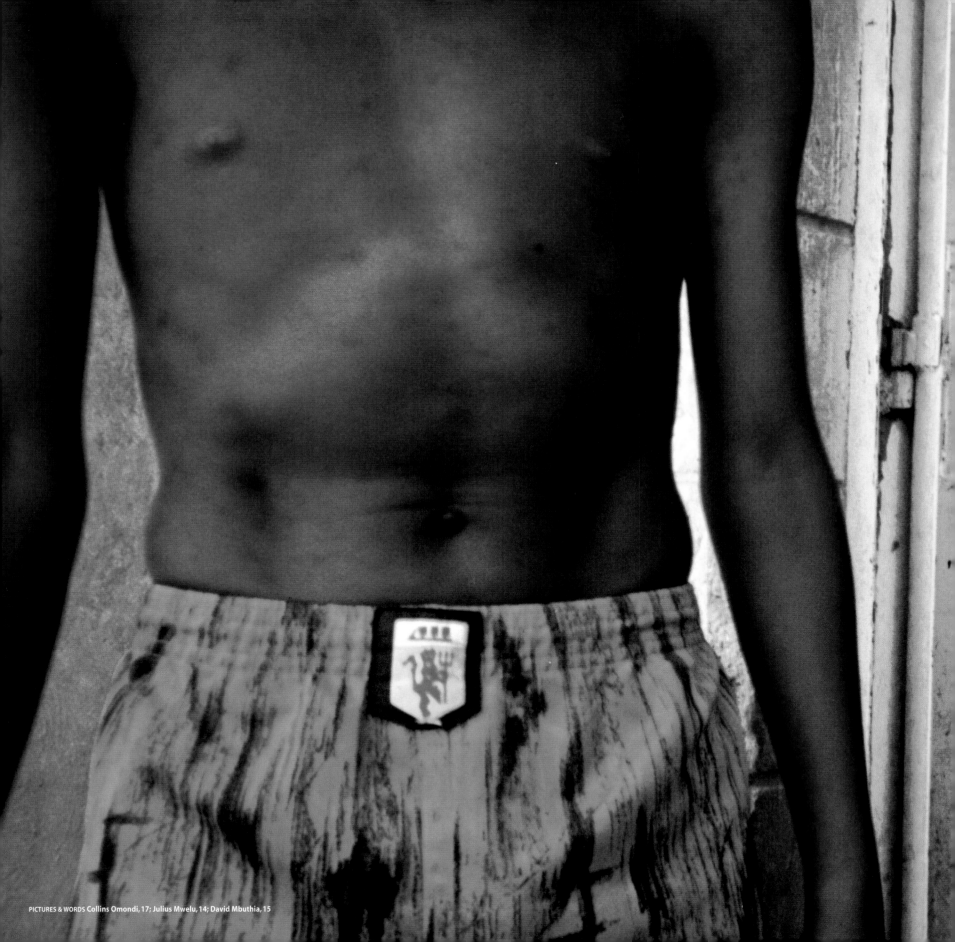

PICTURES & WORDS Collins Omondi, 17; Julius Mwelu, 14; David Mbuthia, 15

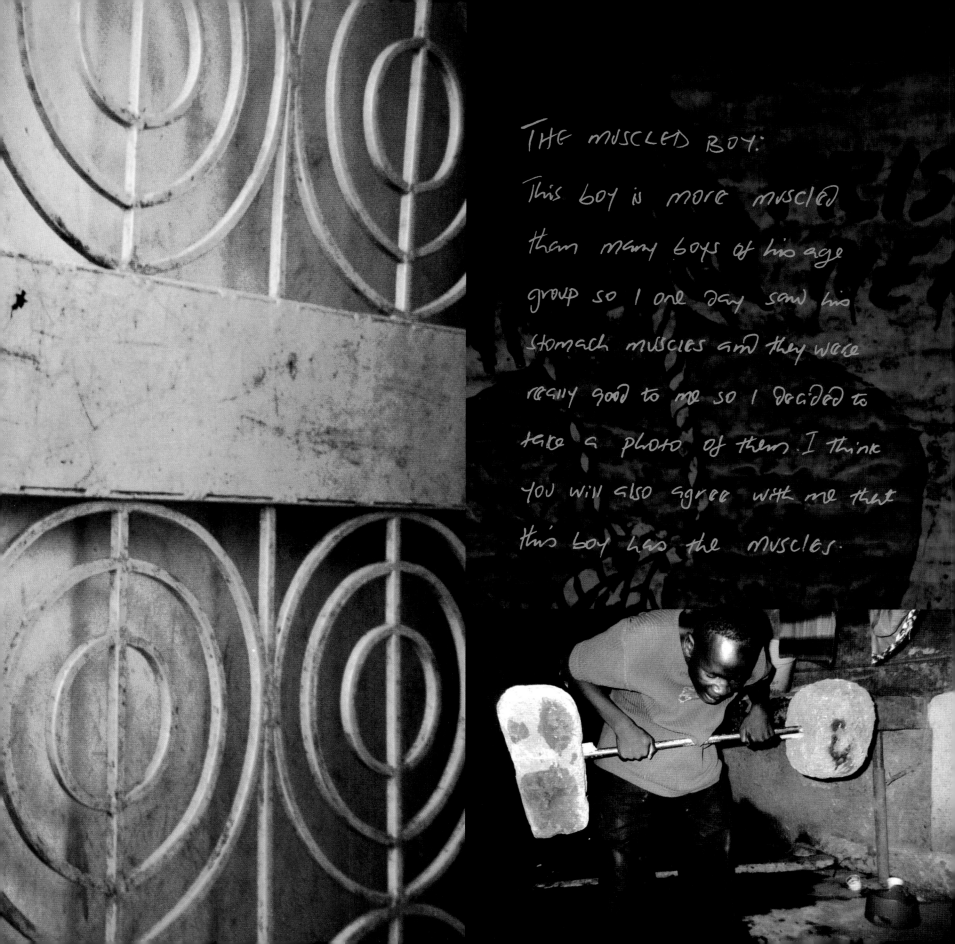

THE MUSCLED BOY:
This boy is more muscled than many boys of his age group so I one day saw his stomach muscles and they were really good to me so I decided to take a photo of them. I think you will also agree with me that this boy has the muscles.

LET SLEEPING DOGS LIE

The dogs are having a rest during the day time, without any disturbance. They are our night watch dogs at my residence. At midday is when they can have a rest, so no one bothers them since in the evening they have to resume their work and everyone understands.

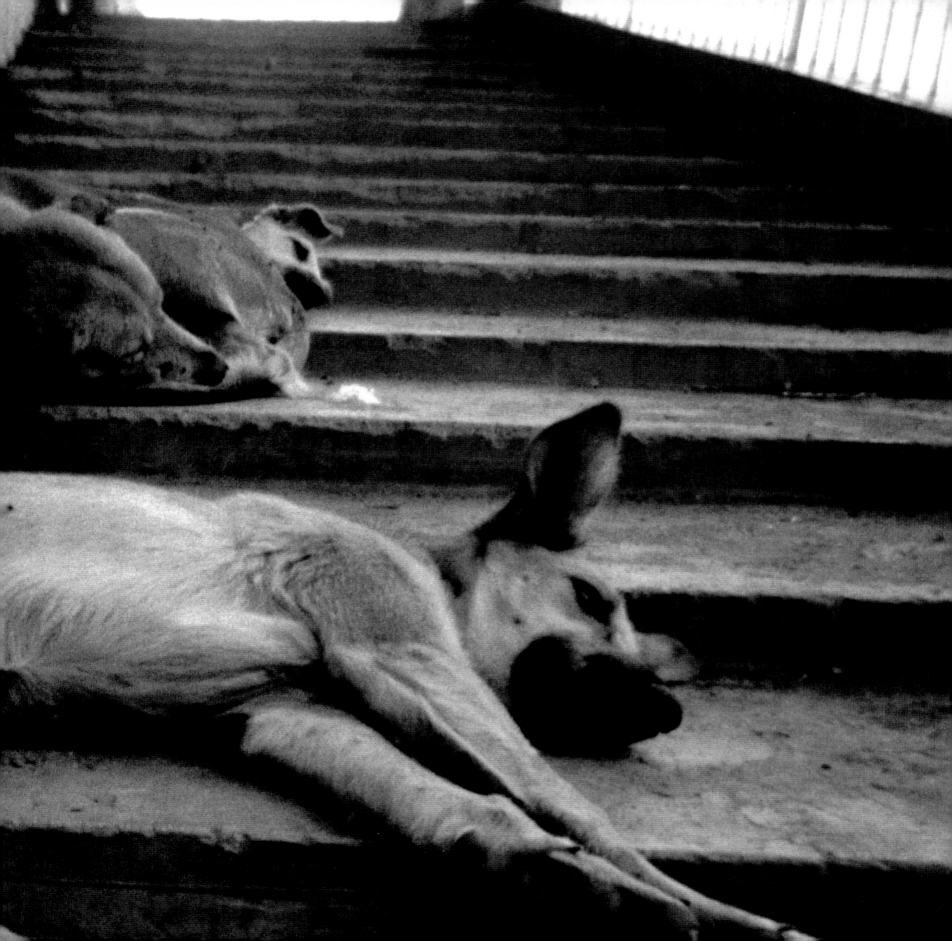

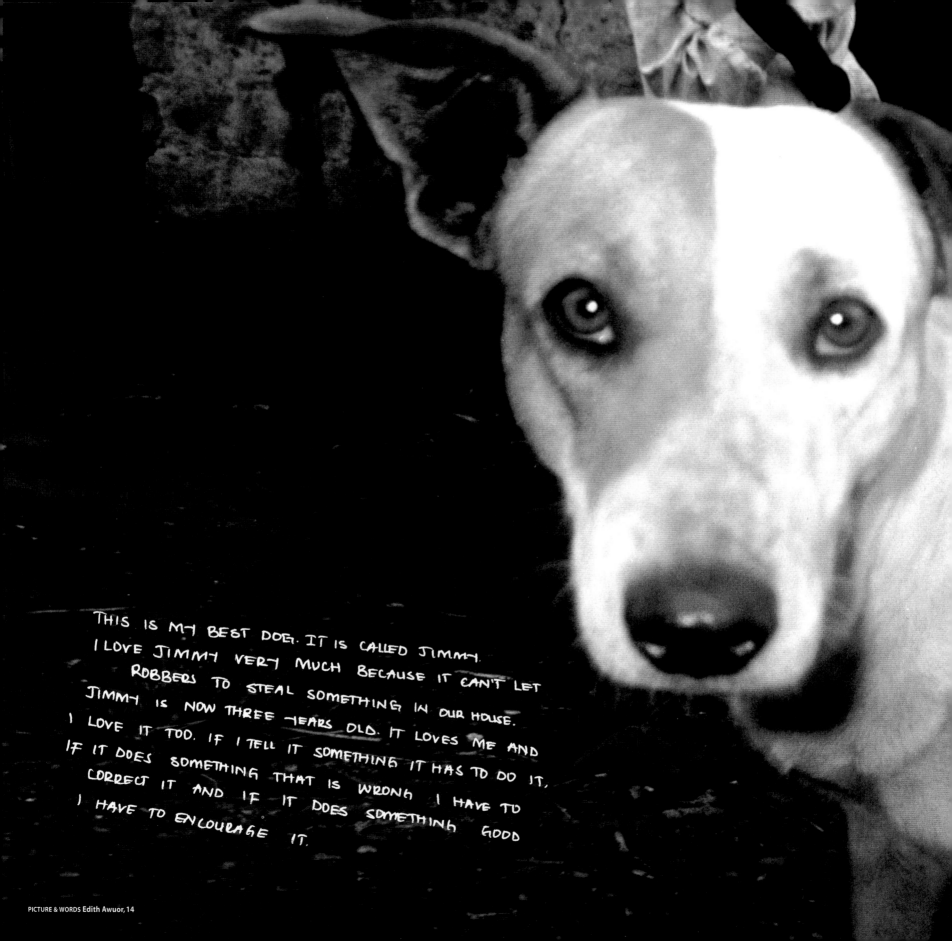

THIS IS MY BEST DOG. IT IS CALLED JIMMY. I LOVE JIMMY VERY MUCH BECAUSE IT CAN'T LET ROBBERS TO STEAL SOMETHING IN OUR HOUSE. JIMMY IS NOW THREE YEARS OLD. IT LOVES ME AND I LOVE IT TOO. IF I TELL IT SOMETHING IT HAS TO DO IT, IF IT DOES SOMETHING THAT IS WRONG I HAVE TO CORRECT IT AND IF IT DOES SOMETHINH GOOD I HAVE TO ENCOURAGE IT.

MY HAIR IS BLACK IN COLOUR.
MY FACE IS CHOCOLATE AND MY
SIZE IS NORMAL. MY WEIGHT
IS NORMAL, I'M FASHIONABLE TOO.
MY FAVOURITE DISHES ARE CHIPS,
MATOKE AND KEBABS.

Vinick Muhanji, 13

I'M MENTALLY A BILLIONAIRE.
I OWN A POSH VILLA IN NAIROBI
SUBURBS AND A FLEET OF VEHICLES
RANGING FROM A ROLLS ROYCE
LIMOUSINE TO A VW BEETLE. DUE
TO MY MASS WEALTH I HAVE BEEN
A VICTIM OF ARMED GANGSTERS
BUT I NORMALLY TIP THEM OFF WITH
A TOKEN OF 2000 DOLLARS.

Collins Omondi, 17

MY SPECIAL INTEREST IS SLEEPING
AND IT MAKES ME NOT TO BE BORED.

Anne Wambui, 12

I LIKE LAUGHING SINCE PEOPLE
FROM OUR AREA ARE VERY FUNNY.
I'M TALKERTIVE, FLEXIBLE AND
IN SCHOOL.

Salome Atieno, 14

NDOLO MEANS MUDDY
DAY, THAT MEANS I WAS
BORN ON A MUDDY DAY.

Peter Ndolo, 13

MY LAST NAME IN MY
LANGUAGE (LUO) MEANS
THAT WHEN MY MOTHER
WAS PREGNANT SHE
LIKED TO EAT A LOT.

Edith Awuor, 14

MULEI MEANS SOMEONE
WHO LIKES TO DISAGREE
WITH PEOPLE. I HAVE
MANY FRIENDS AND
ONLY A FEW ENEMIES
AND THAT MAKES MY
LIFE SATISFYING.

Joseph Mulei, 16

I DON'T KNOW WHERE I COME FROM, WHERE I WAS BORNED I DON'T KNOW. IF YOU KNOW CALL THE FOLLOWING NUMBERS, 0000MYSA OR BOX NUMBER 000 MATHARE SLUMS, FOR MORE DETAILS.

Fredrick Otieno, 14

AS YOU KNOW IN THIS WORLD THERE'S NO GREATER LOVE THAN A MOTHER'S LOVE. MANY FATHERS ARE HARSH BUT A MOTHER'S LAP IS ALWAYS READY TO REST HER TIRED CHILD'S HEAD. SO MY FELLOW FRIENDS, RESPECT YOUR PARENTS SO THAT YOU CAN LIVE LONGER AND BEAT METHUSELAH'S RECORD.

Maureen Atieno, 15

MY FATHER USES HIS WEEKENDS FOR SLEEPING AND SMOKING. I SYMPATHISE WITH HIS SITUATION. HE DOESN'T GO TO WORK. HE IS ALWAYS IN BED AS HE DOESN'T KNOW WHAT TO DO AFTER HE WAKES UP.

Susan Muthoni, 12

IN THE YEAR 1996 MY MOTHER DIED AND MY REAL MOTHER CAME BACK. FIRST I THOUGHT THAT SHE WAS MY ELDER SISTER, BECAUSE SHE LEFT ME WHEN I WAS ONLY 2 AND NOW SHE CAME BACK WHEN I WAS 12.

Pauline Awuor, 14

PICTURES Salome Atieno, 14 & Serah Odeke, 14

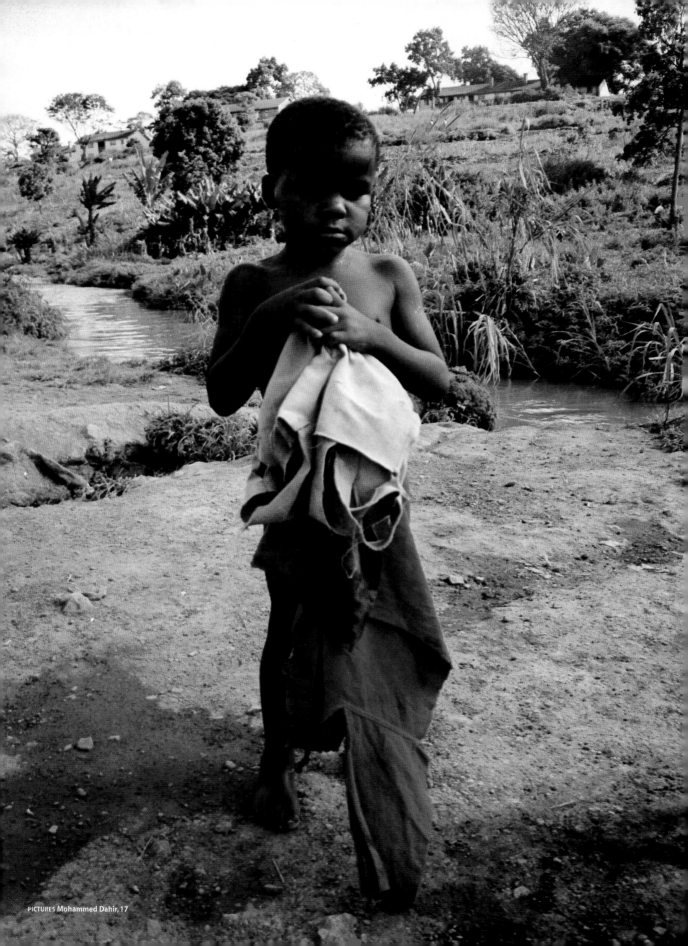

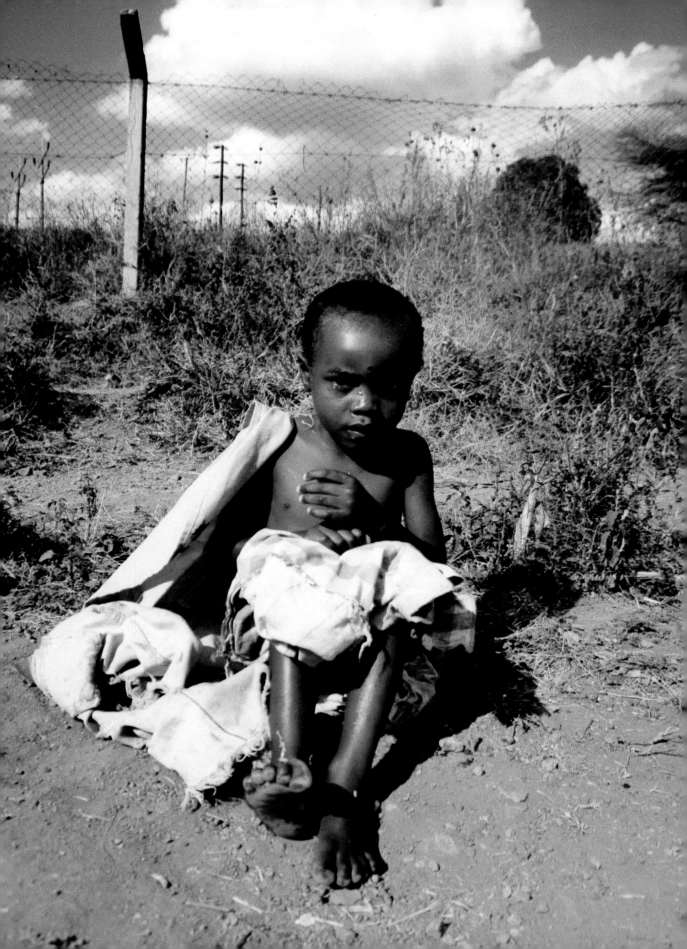

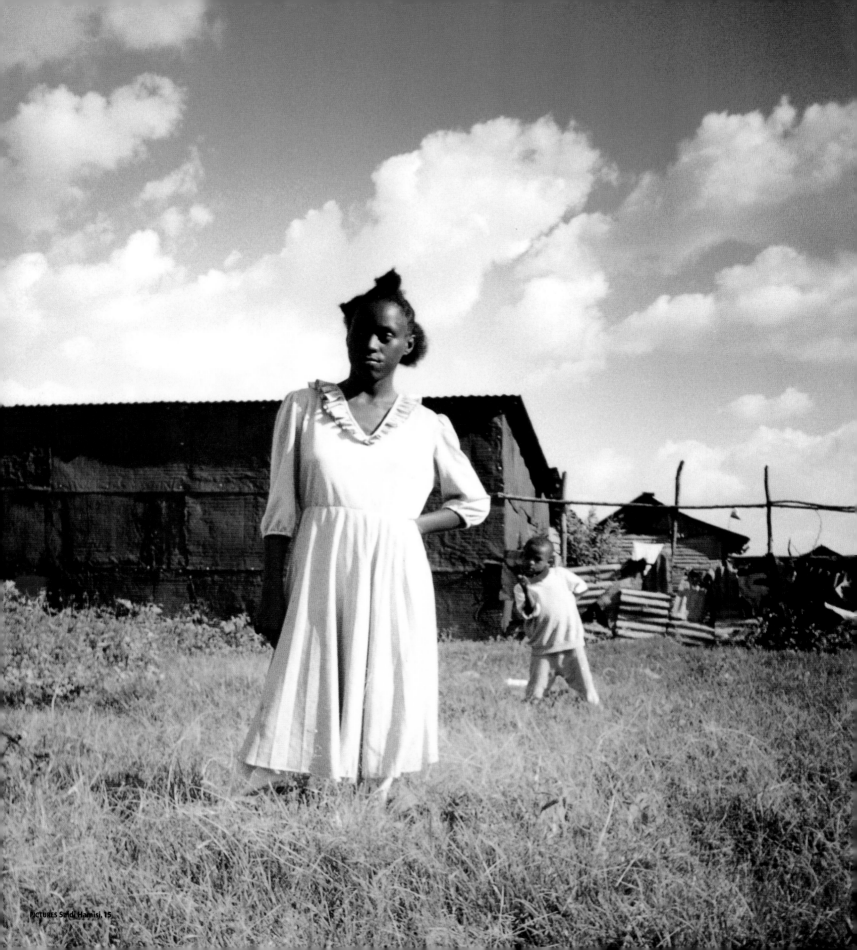

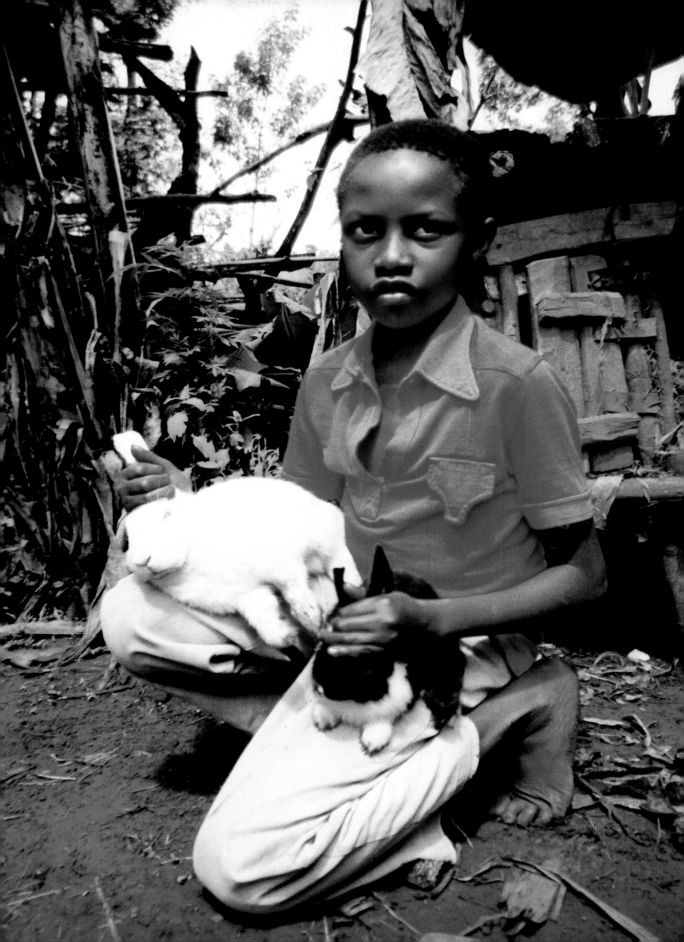

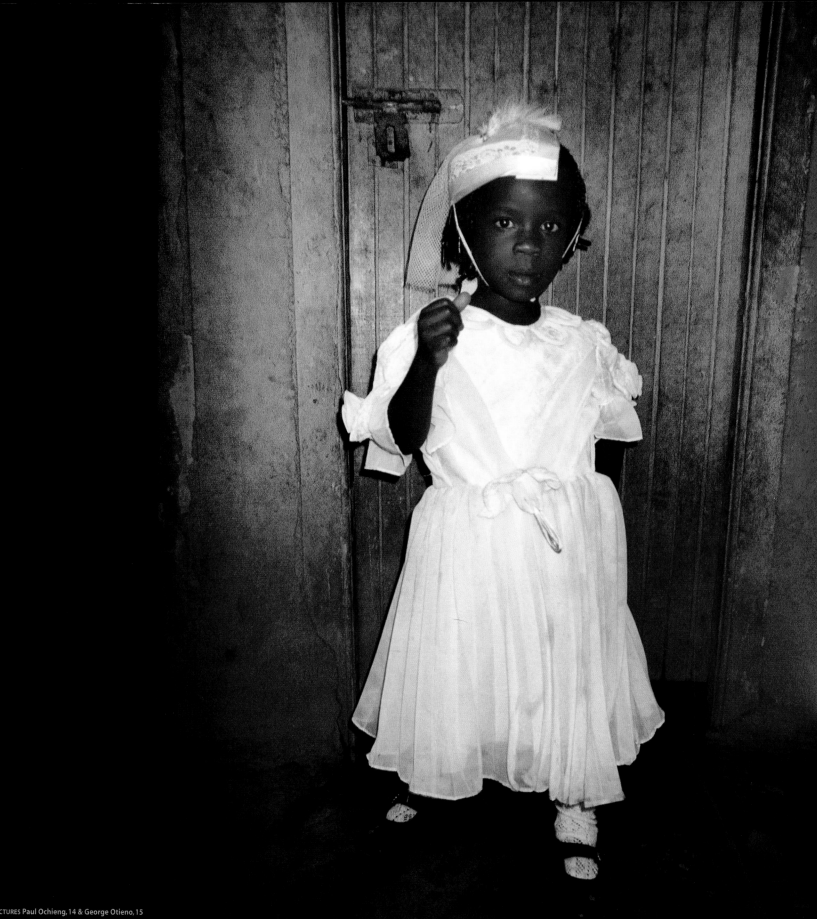

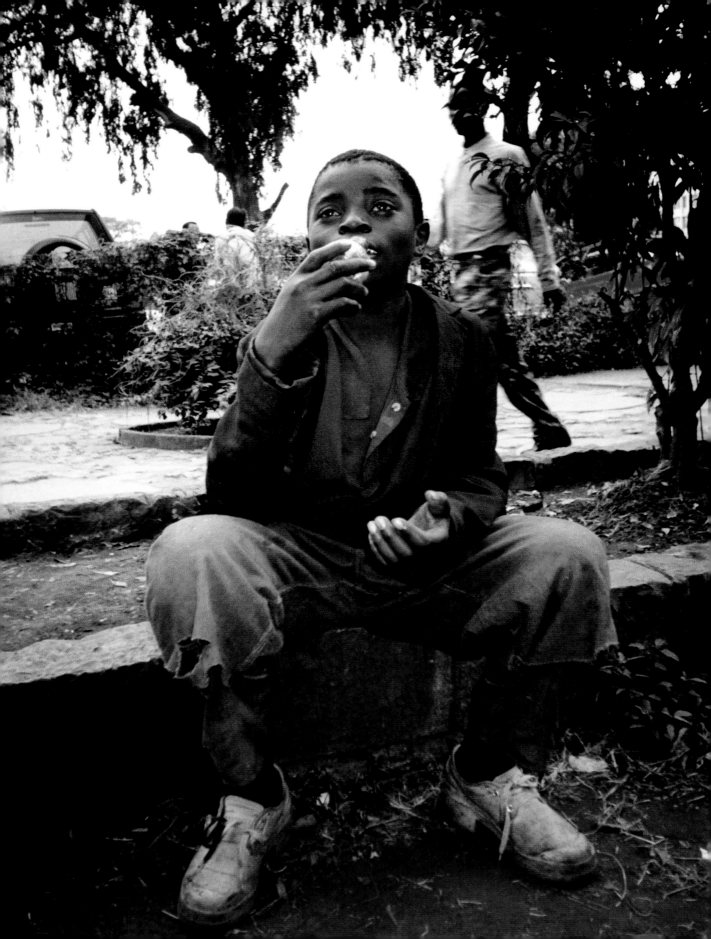

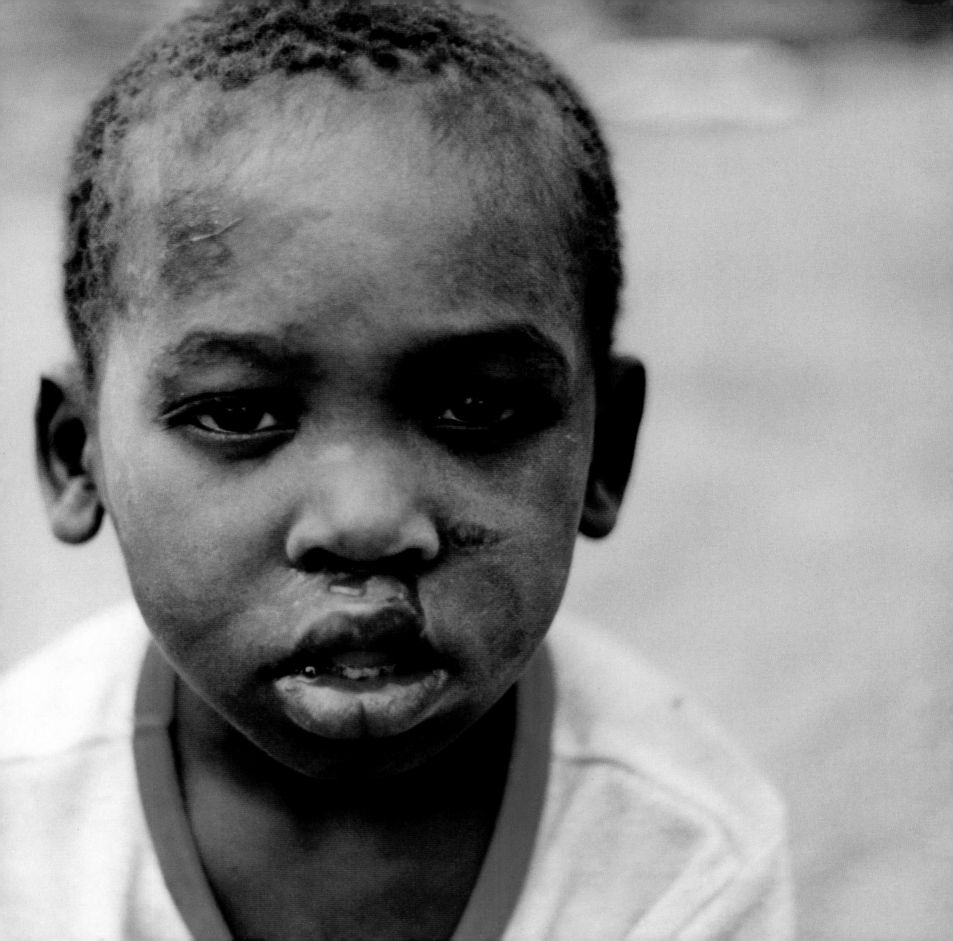

DO NOT STEAL

PICTURES & WORDS Fredrick Otieno, 14

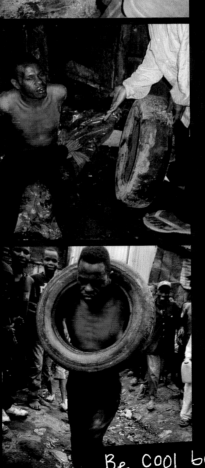

This good man he was very beautiful When he was not enjoying this habit of Stealing. He even has children and a beautiful wife. But When the man left his home, problems Started.

The elders Cried that time of a thief is forty days without discount. He was Caught and beaten. The mob decided to give him a bow tie around his neck and burn him So that he would say the truth.

A good Samaritan took the Opportunity to tell the mob to Leave him alone. The mob heard the Word and took the thief to the Police. Till now the thief is Sleeping on a floor without a bed because of breaking the law of God and Country. He will be there for a long time without Seeing his family eye to eye.

Be Cool be fit and be active in the World

True Story by Ali Barisa

# The road to death

THE MATHS LESSON WAS GOING ON WHEN OUR TEACHER ALERTED US THAT A THIEF WAS BEING CHASED ACROSS OUR SCHOOL COMPOUND.

WHEN I LOOKED THROUGH THE WINDOW I SAW SOME PEOPLE RUNNING WITH SHARP PANGAS AND BIG RUNGUS AND STONES TOWARDS THE WEST SIDE OF OUR SCHOOL. ALL THE PUPILS OF MY CLASS STOOD UP. LUCKILY OUR CLASS TEACHER TOLD US TO GO AND SEE.

I RAN AS FAST AS MY LEGS COULD CARRY ME. I WISHED THAT I WOULD FLY AND REACH THERE BEFORE THE NOTORIOUS THIEF WOULD SEE THE ROAD TO HELL.

WHEN I WENT NEAR FIRST OF
ALL I WAS VERY SURPRISED TO SEE
HORDES OF PEOPLE BEATING THE
THIEF. I RAN HOME AND TOLD MY
PARENTS AND I TOOK OUT MY
CAMERA AND WENT TO TAKE A SNAP.
FOR THE THIEF, HE WAS BEATEN VERY
BADLY THAT TEARS STARTED COMING
OUT OF MY EYES WITH MY FACE FULL
OF SORROW. SUDDENLY OUR HEAD
TEACHER TOLD US TO GO BACK TO
SCHOOL. I FOUND IT VERY DIFFICULT
BUT I WAS FORCED TO GO...

...from that day I knew that mob justice is a bad thing.

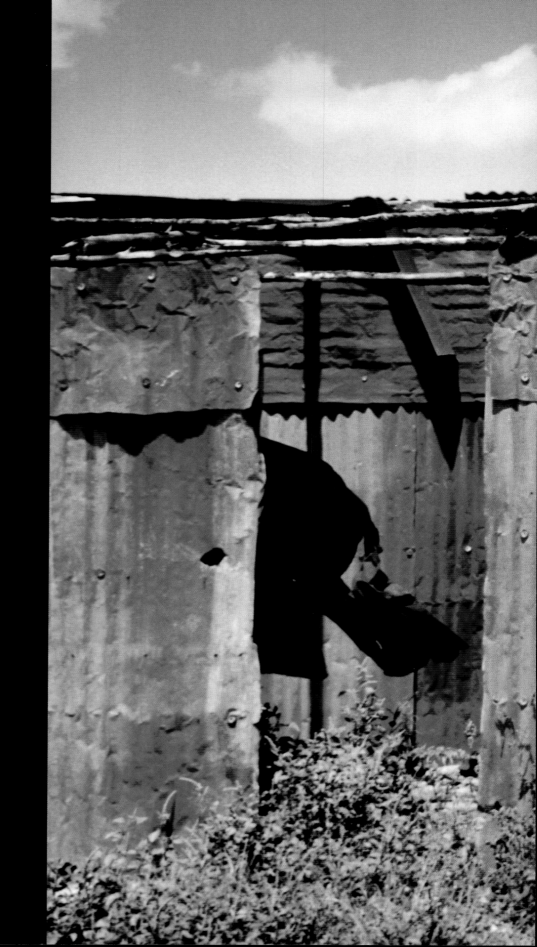

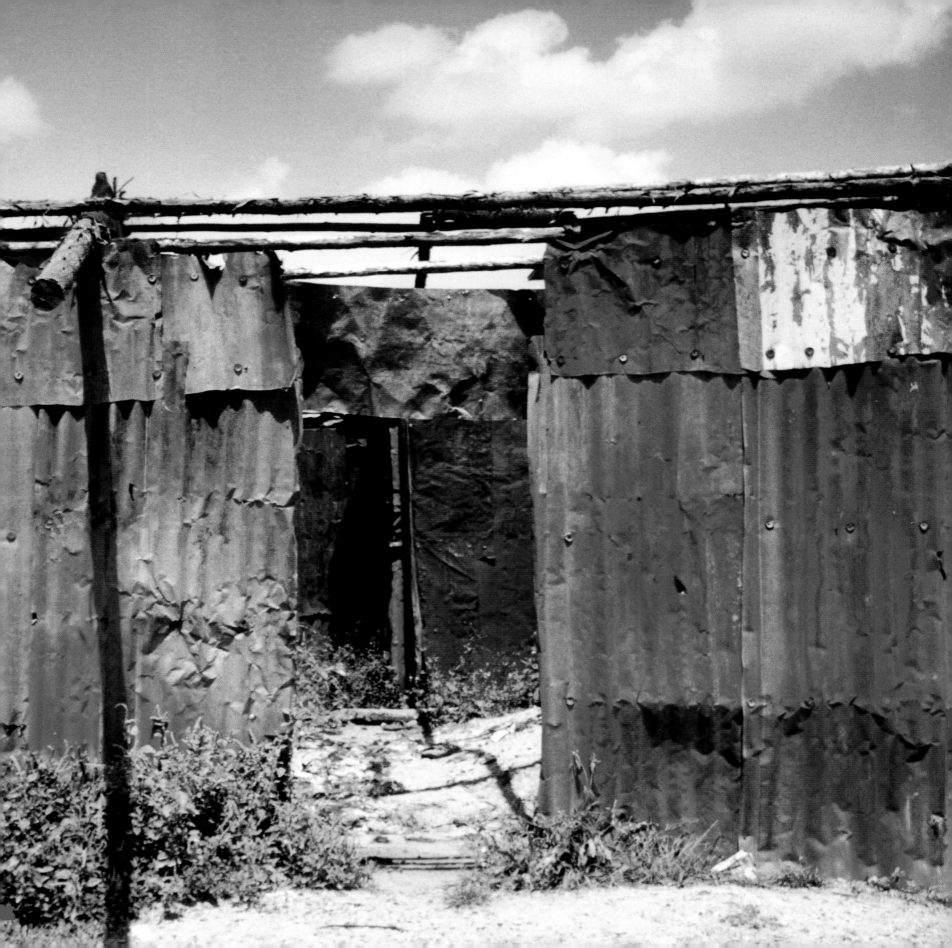

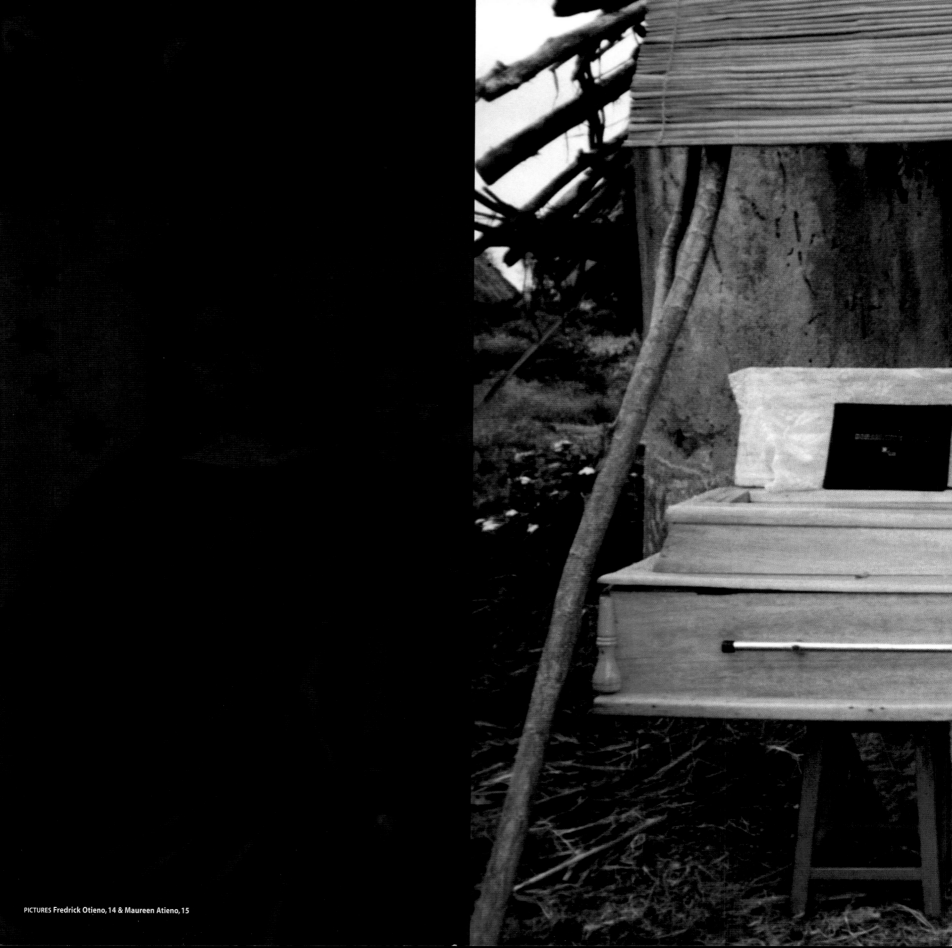

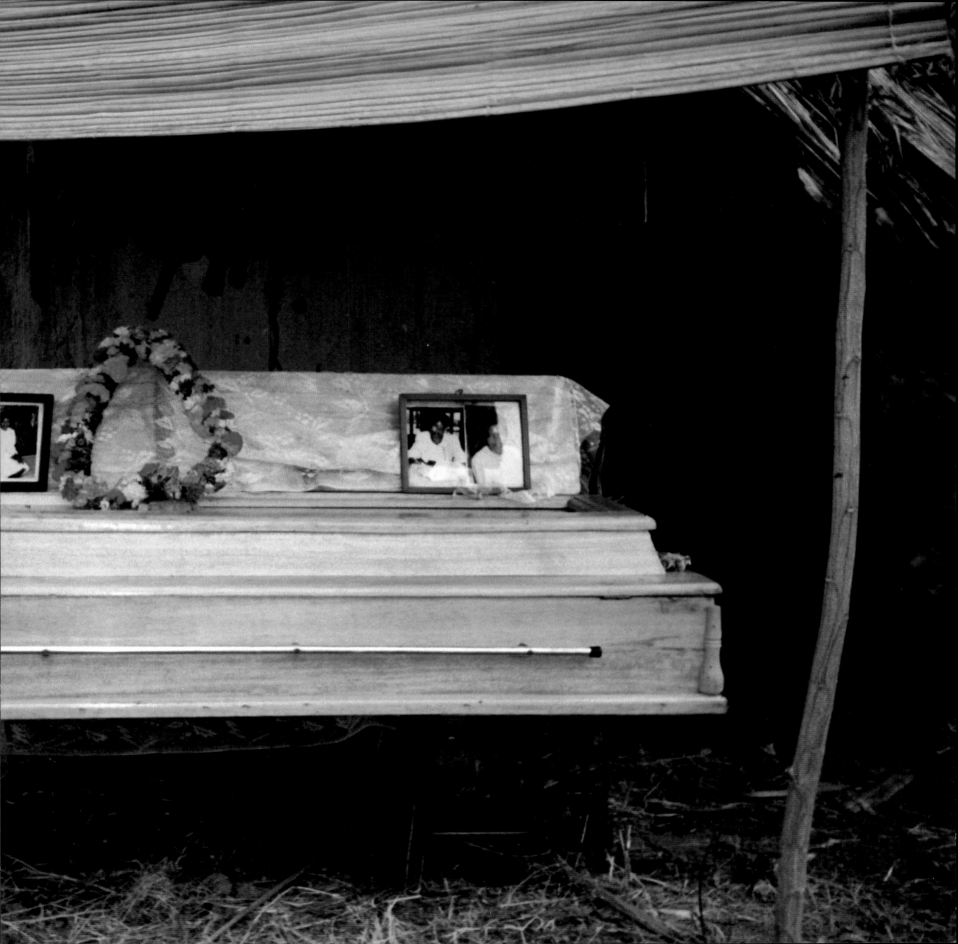

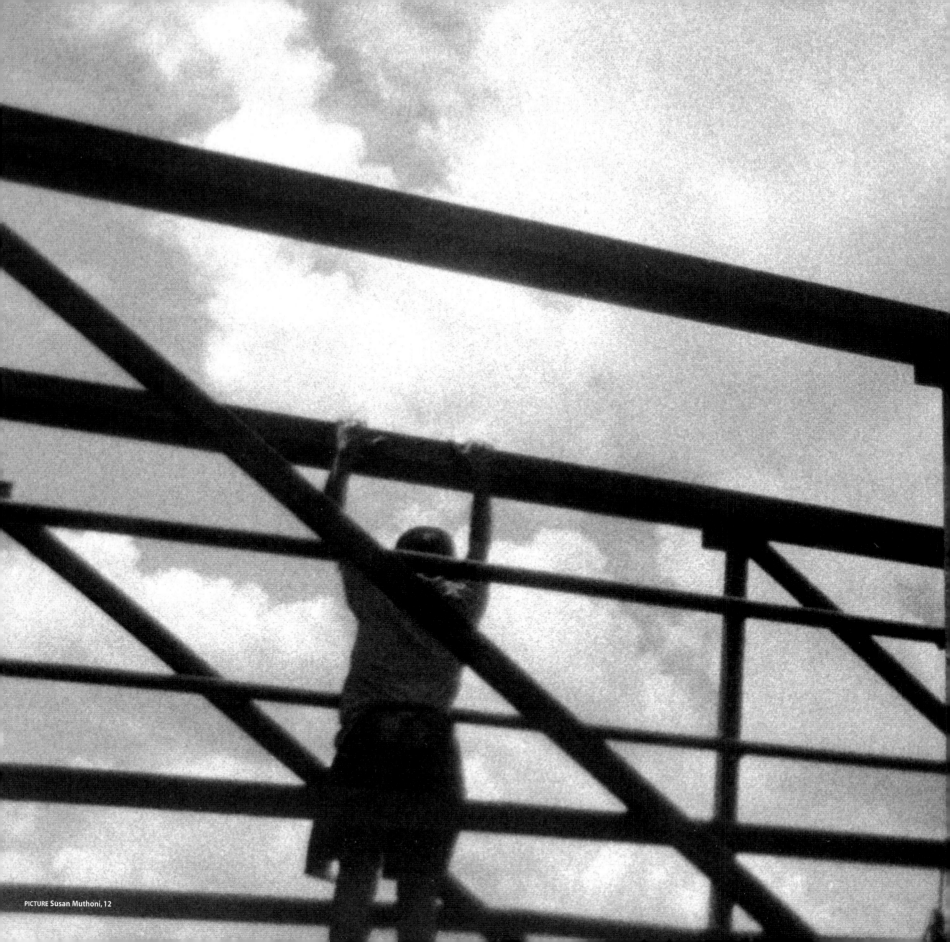

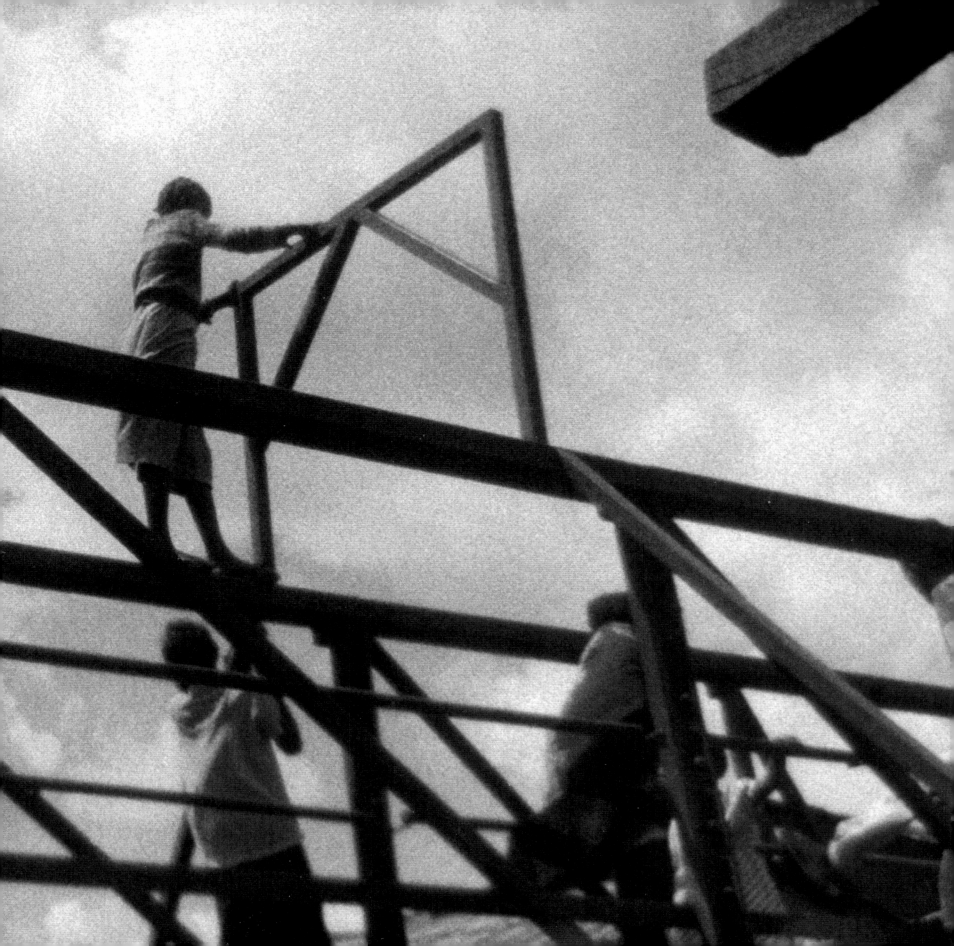

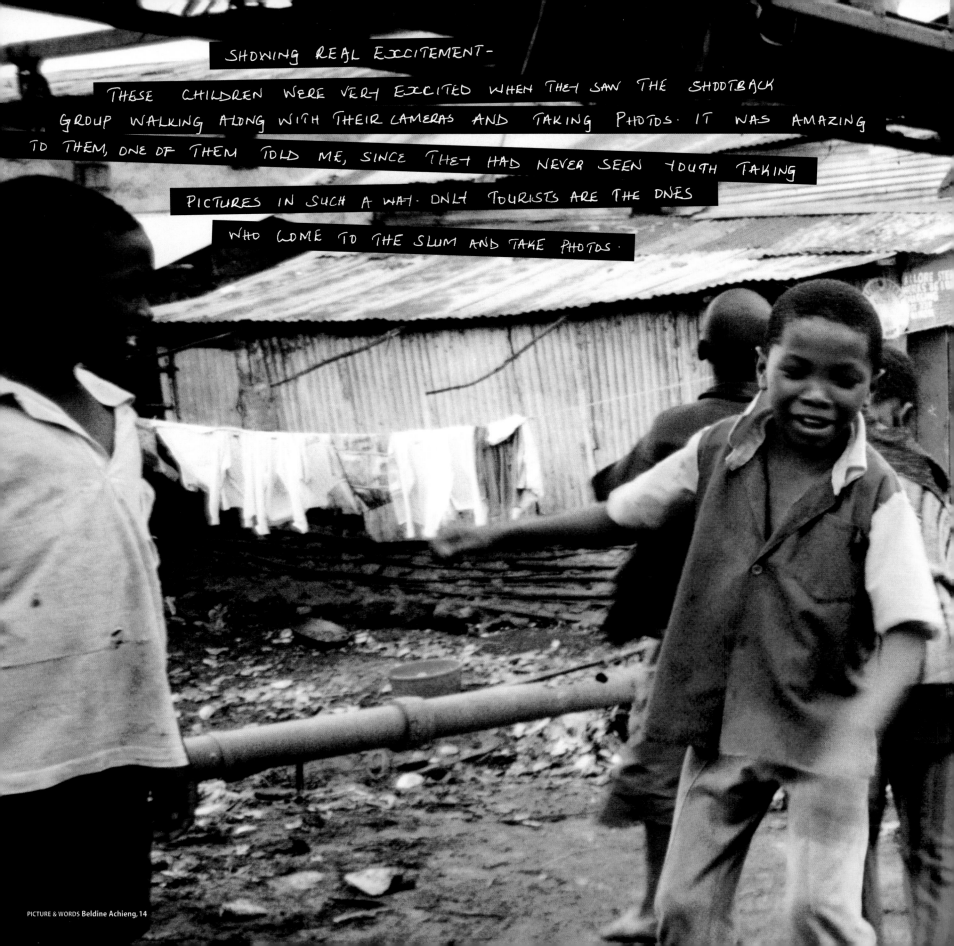

SHOWING REAL EXCITEMENT —

THESE CHILDREN WERE VERY EXCITED WHEN THEY SAW THE SHOOTBACK GROUP WALKING ALONG WITH THEIR CAMERAS AND TAKING PHOTOS. IT WAS AMAZING TO THEM, ONE OF THEM TOLD ME, SINCE THEY HAD NEVER SEEN YOUTH TAKING PICTURES IN SUCH A WAY. ONLY TOURISTS ARE THE ONES WHO COME TO THE SLUM AND TAKE PHOTOS.

PICTURE & WORDS Beldine Achieng, 14

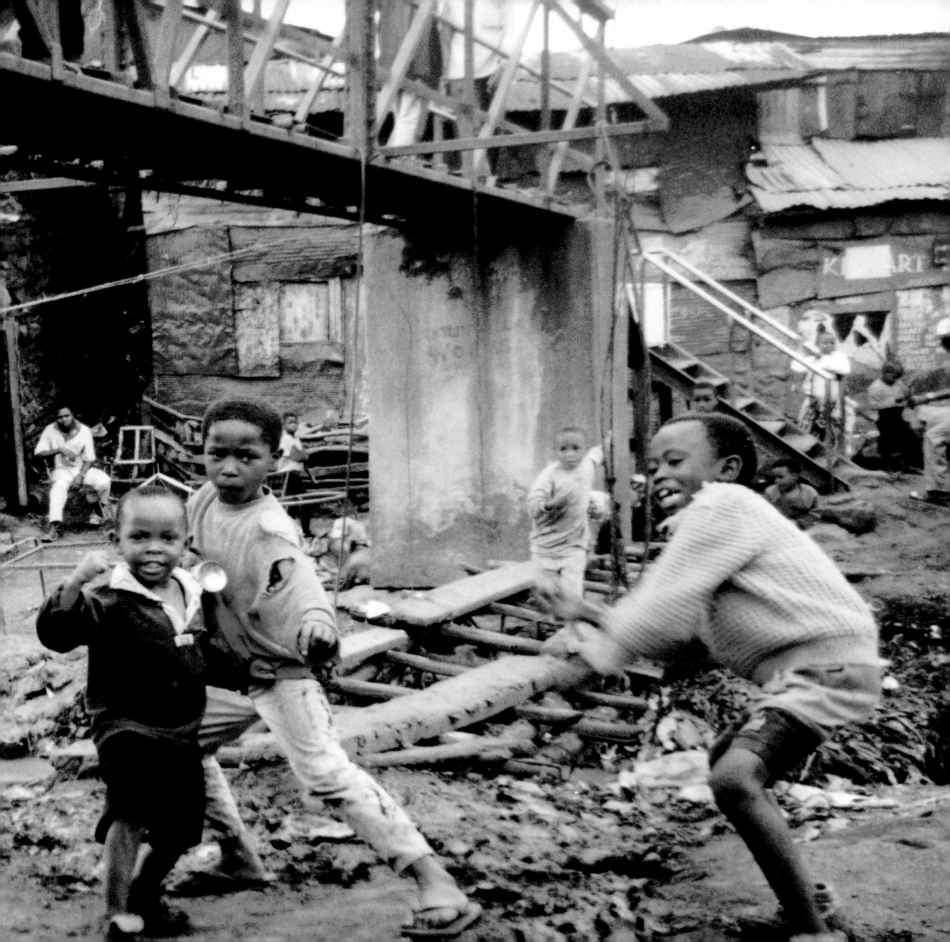

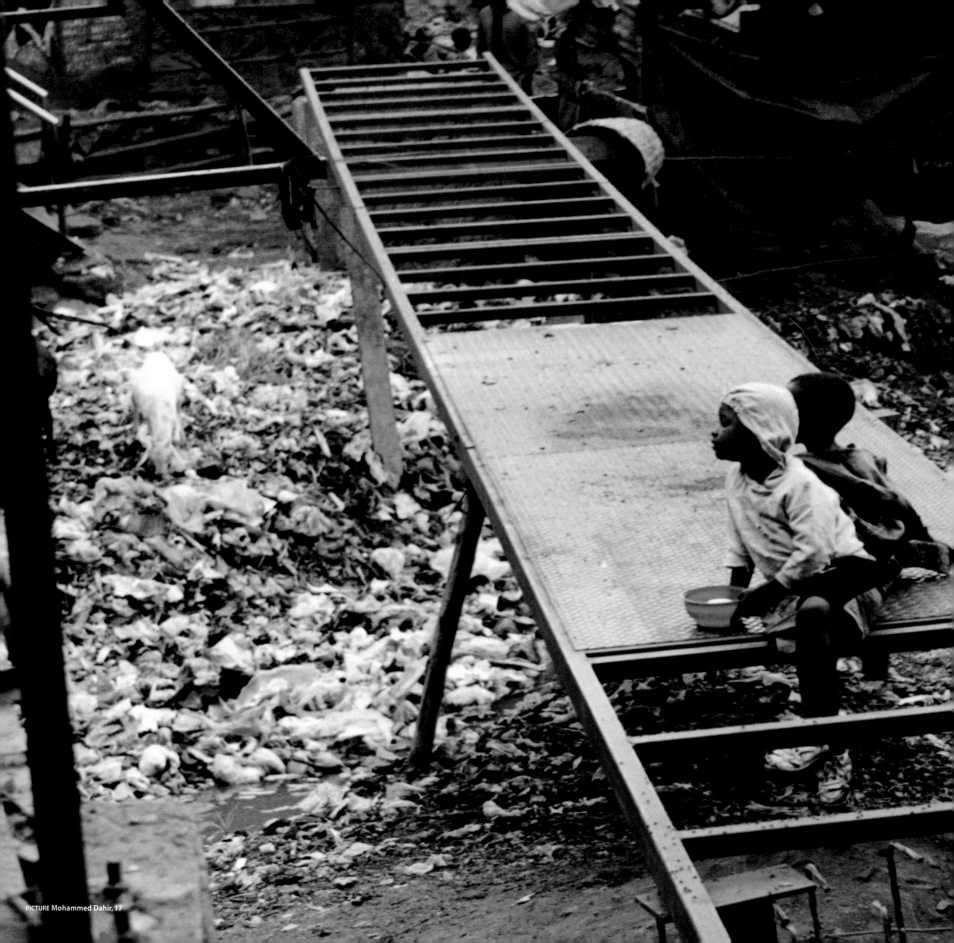

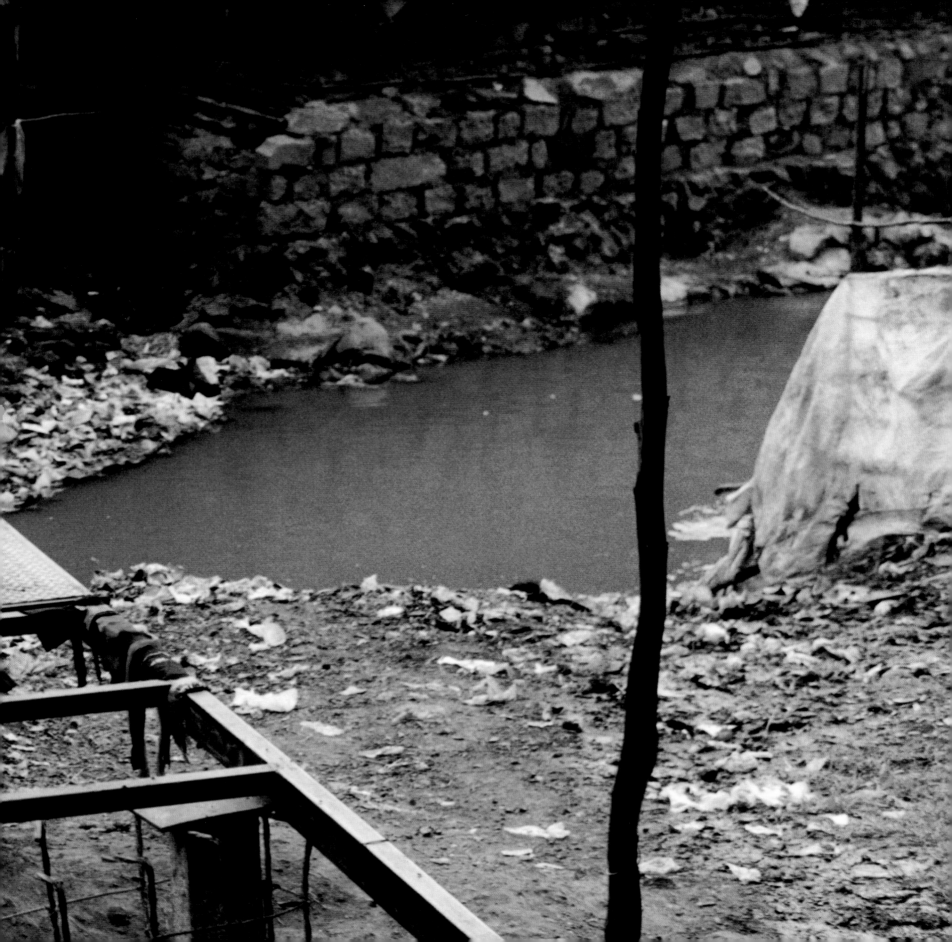

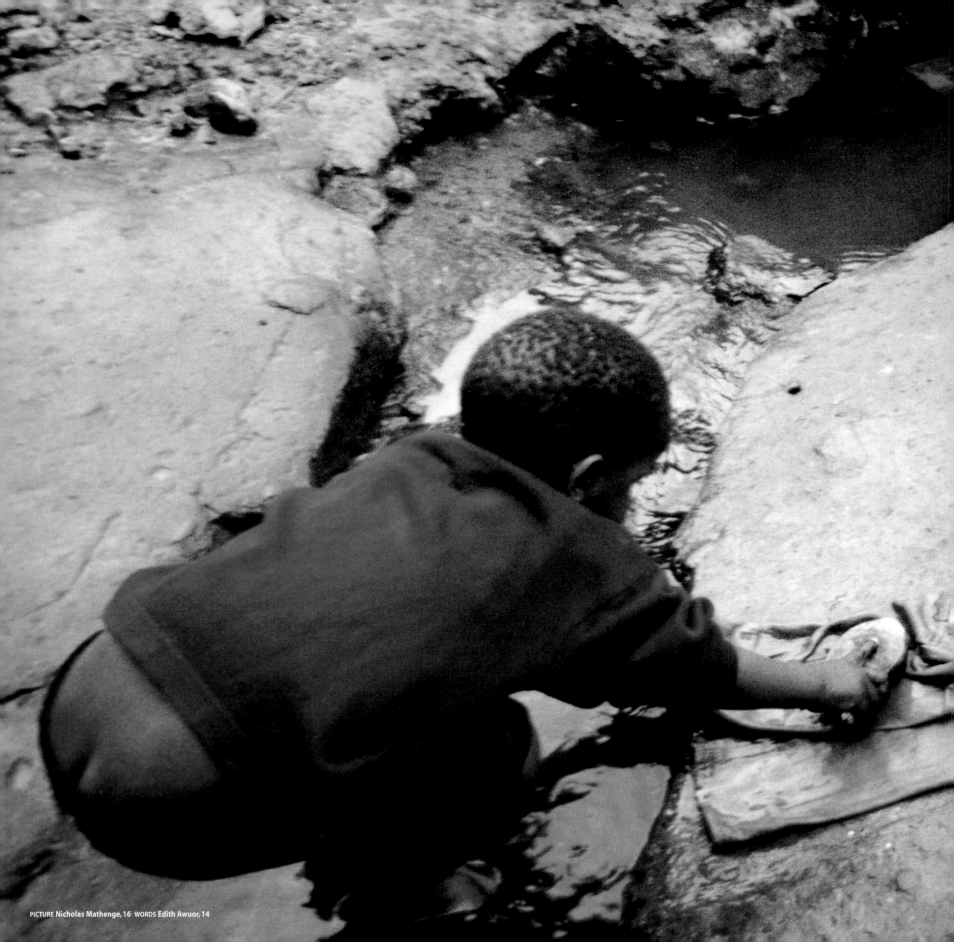

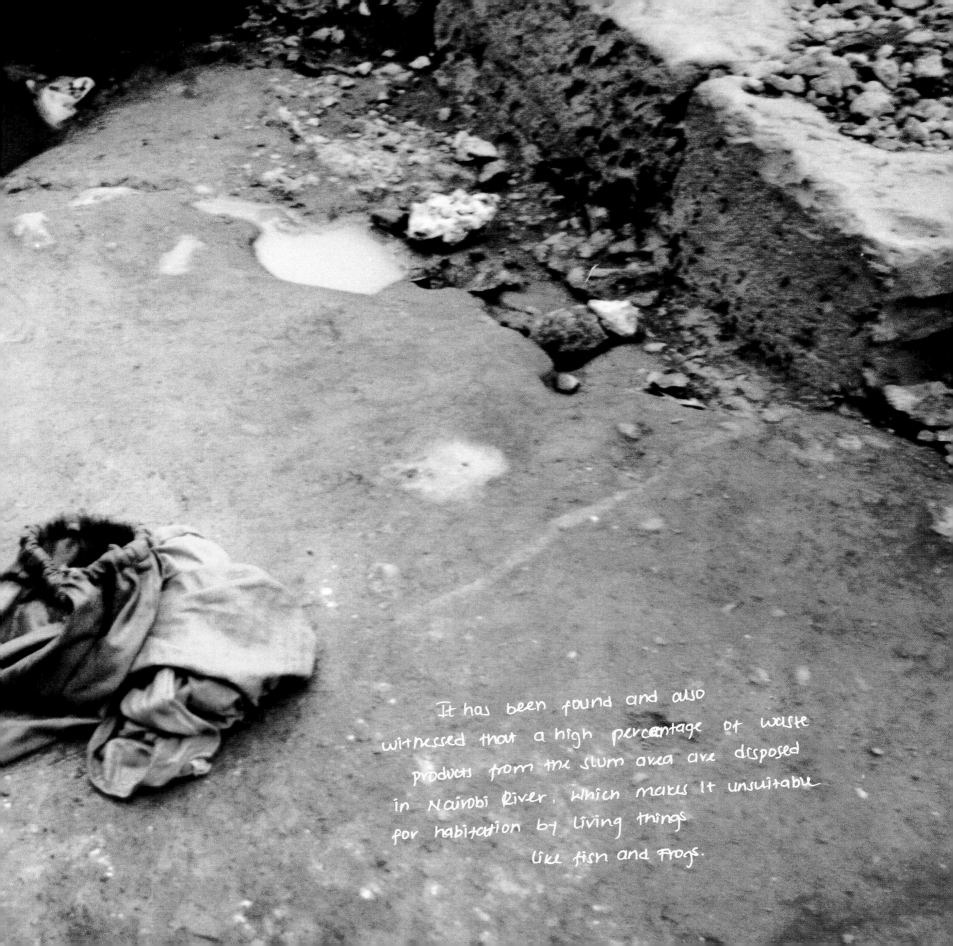

It has been found and also
witnessed that a high percentage of waste
products from the slum area are disposed
in Nairobi River, which makes it unsuitable
for habitation by living things
like fish and frogs.

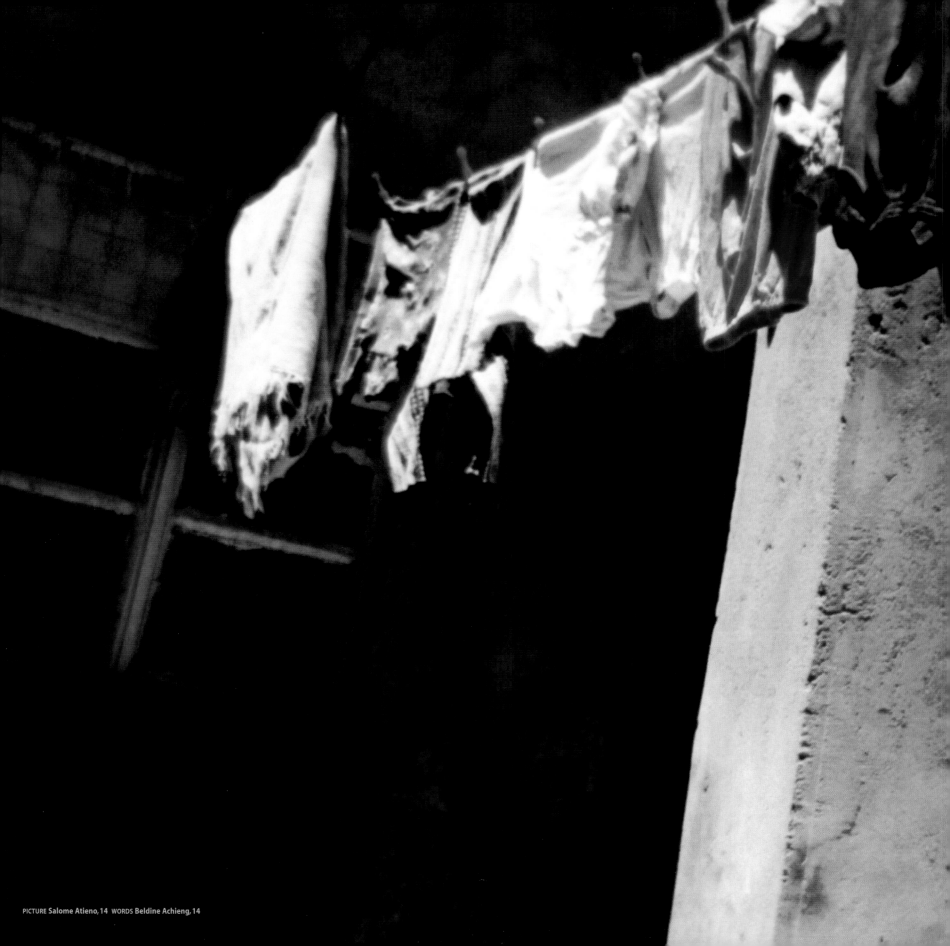

Wake up at 8 am, observe grooming.
Prepare tea for the family, dust the
house, wash utencils and clothes.
At about quarter to noon start preparing
lunch for myself and my younger brother
who schools near our home.

During the afternoon rest for an
hour, then iron clean clothes. At 5.30 pm,
prepare supper for the whole family.
After eating supper wash the utencils
then up-date my journal book and sleep.

* Not all afternoons do I iron
clothes. Sometimes I walk
around with my camera.

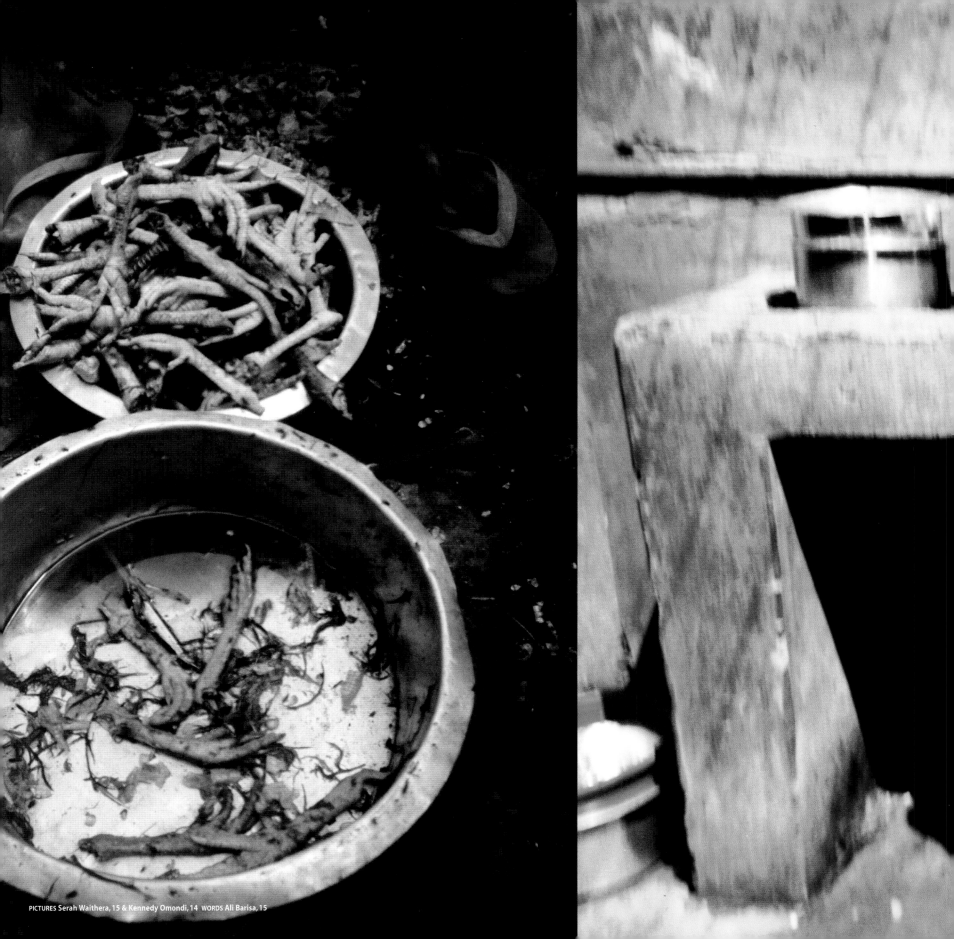

PICTURES Serah Waithera, 15 & Kennedy Omondi, 14  WORDS Ali Barisa, 15

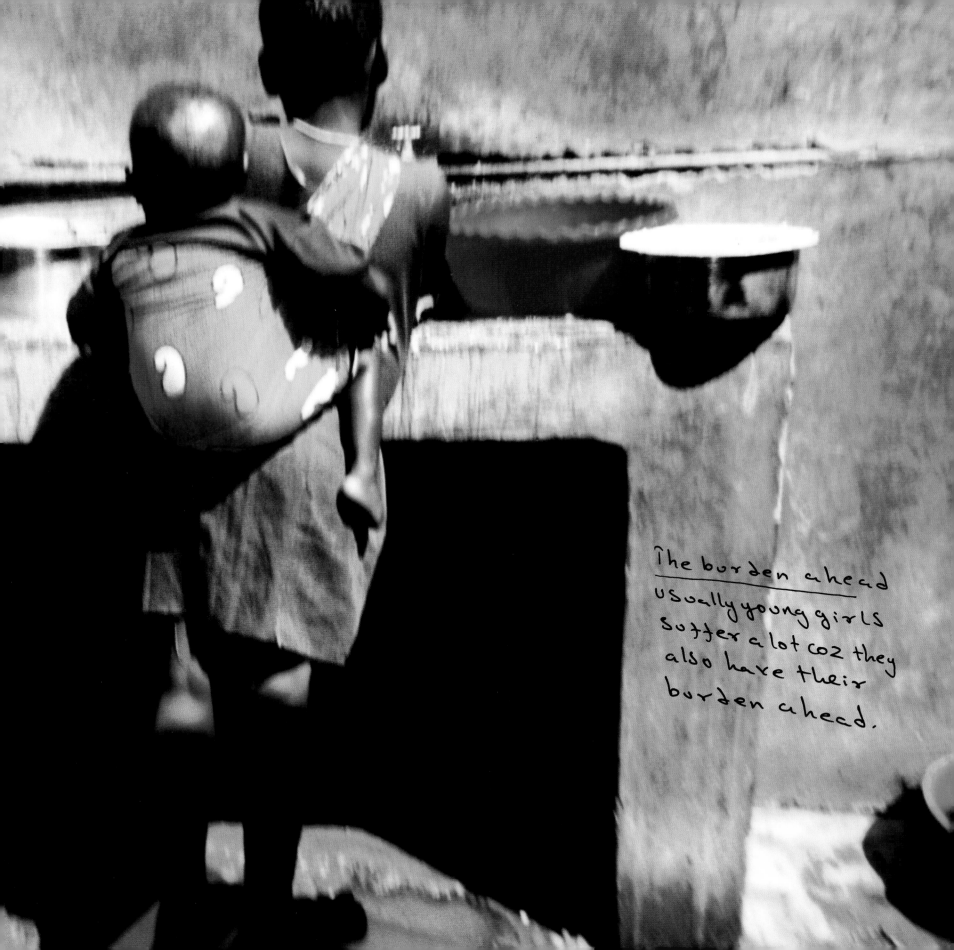

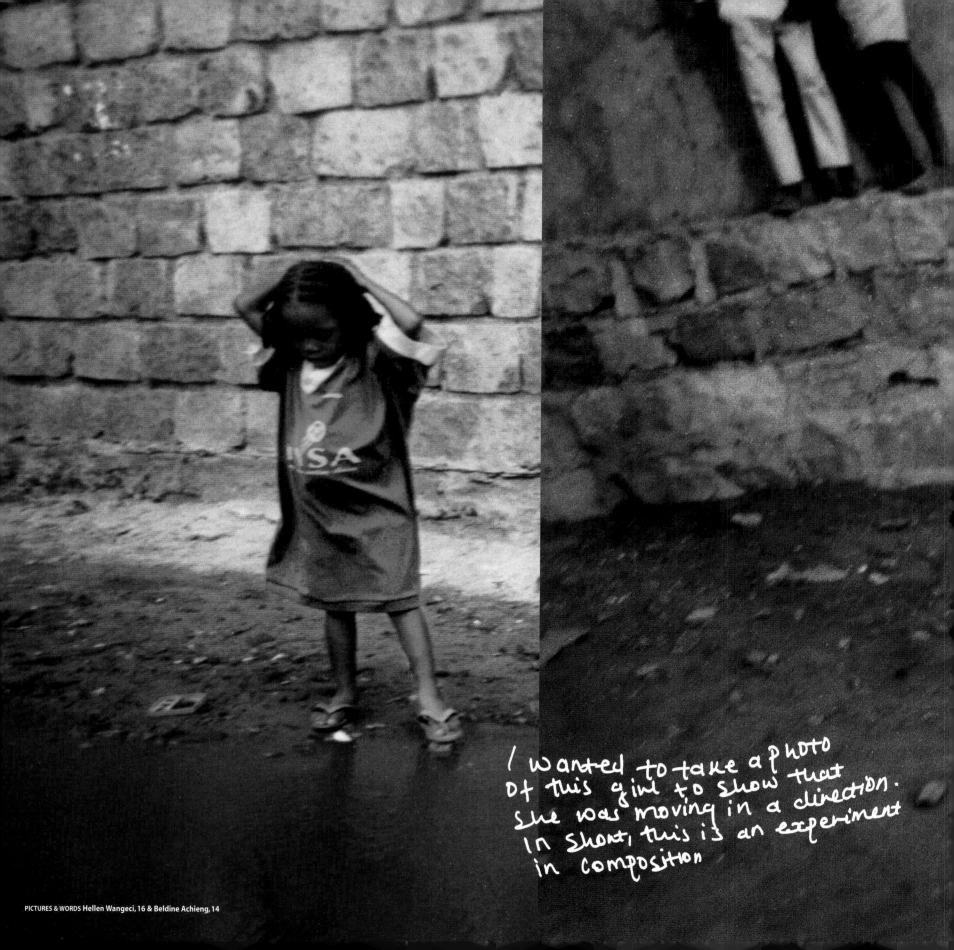

I wanted to take a photo of this girl to show that she was moving in a direction. In short, this is an experiment in composition

PICTURES & WORDS Hellen Wangeci, 16 & Beldine Achieng, 14

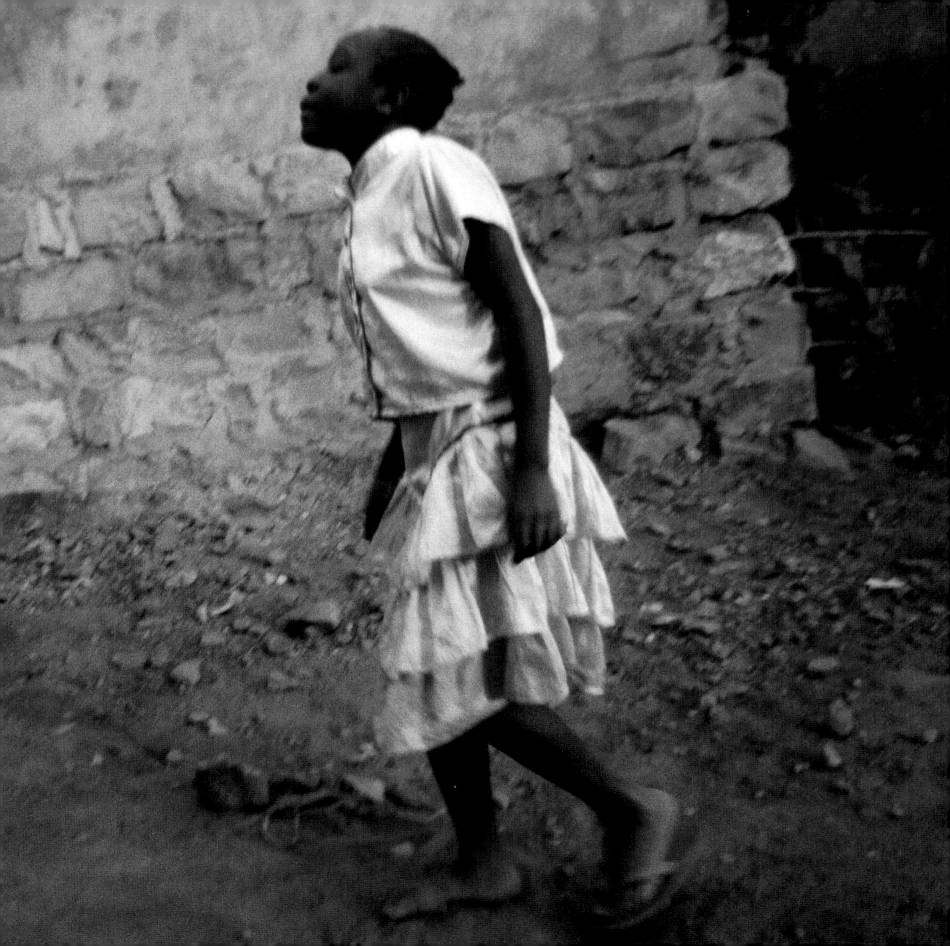

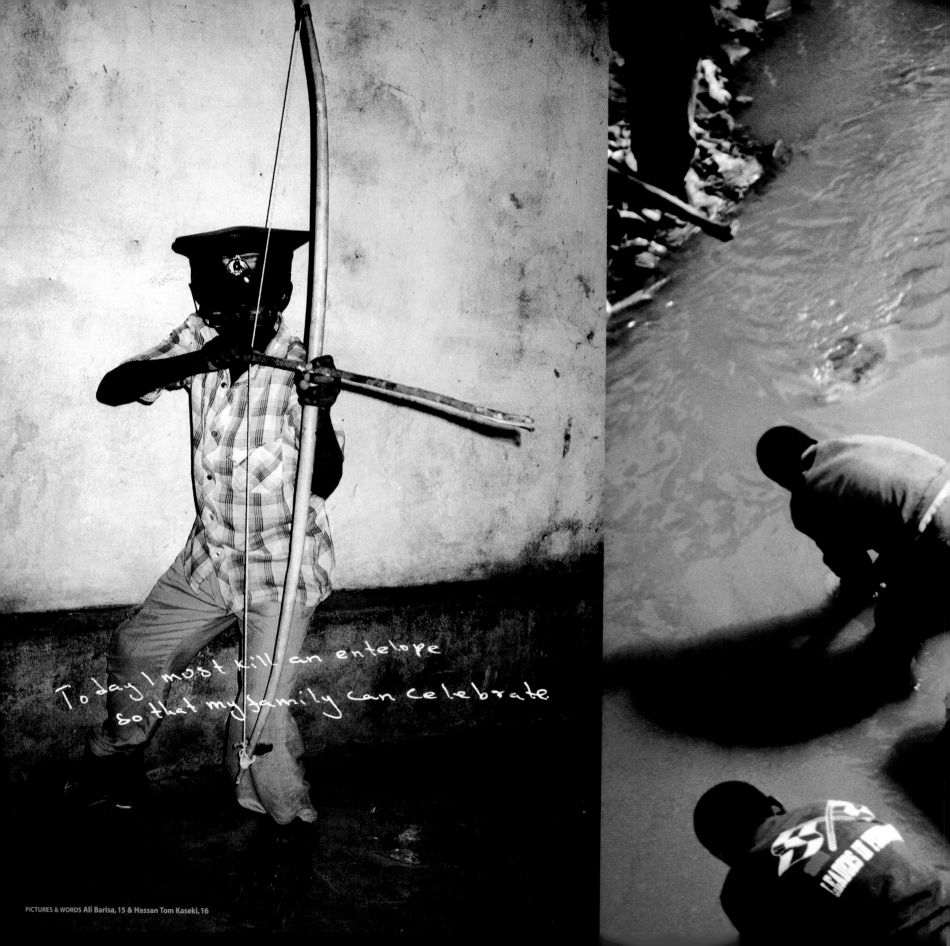

Today I must kill an entelope so that my family can celebrate.

PICTURES & WORDS Ali Barisa, 15 & Hassan Tom Kaseki, 16

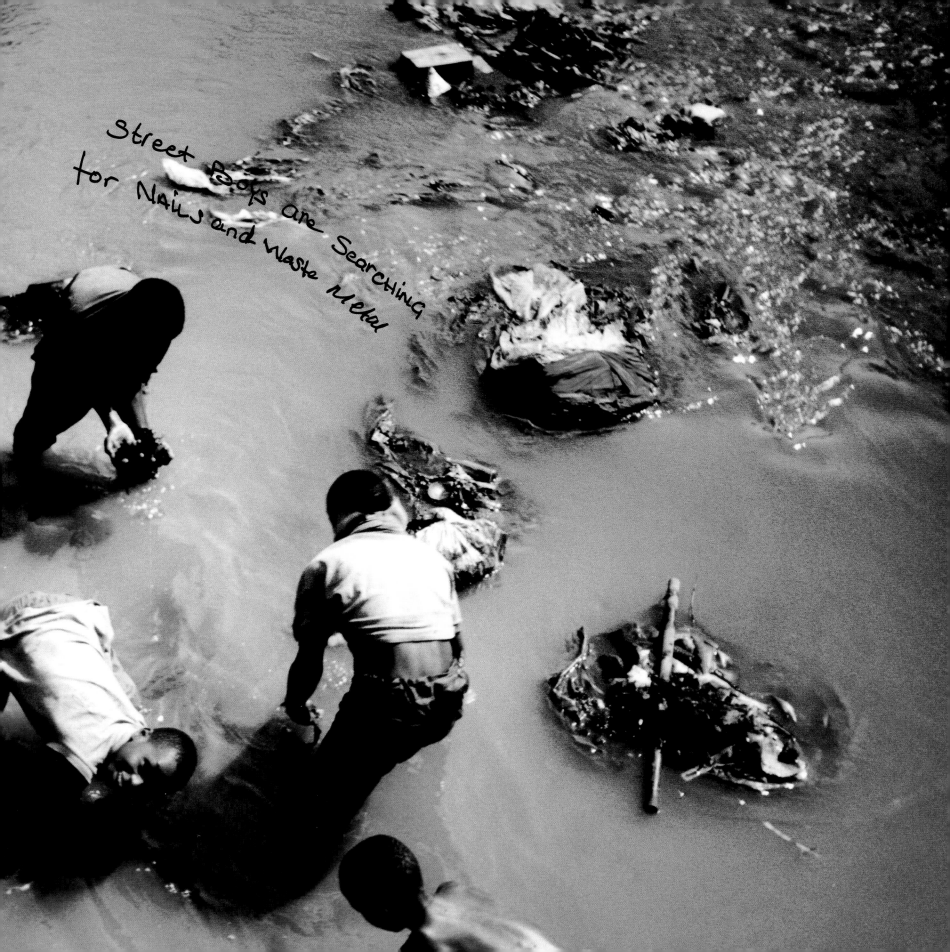
Street Boys are Searching for Nails and Waste Metal

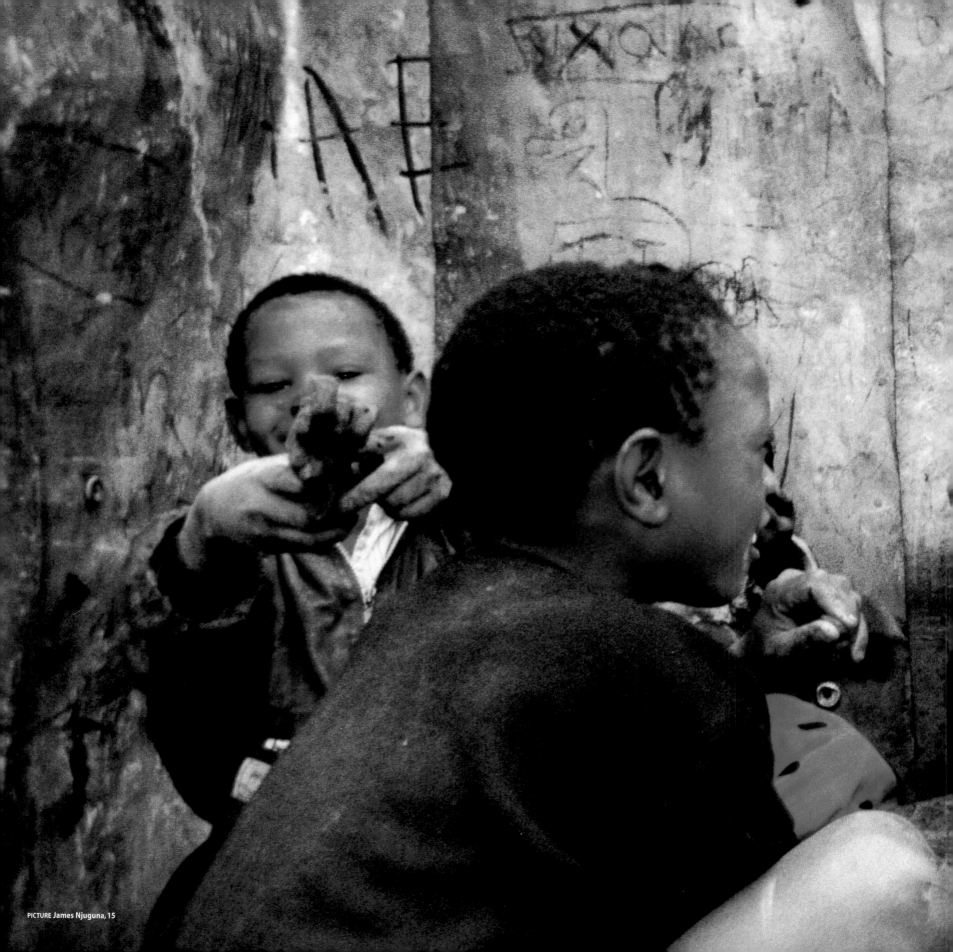

PICTURE James Njuguna, 15

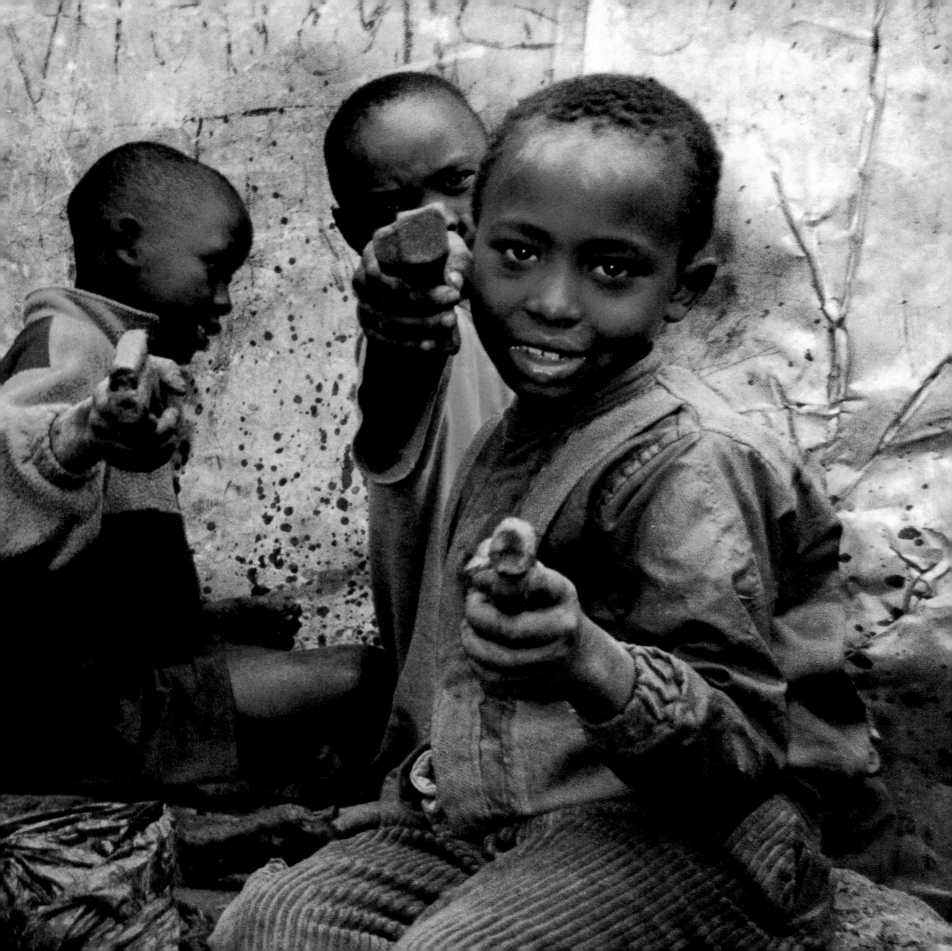

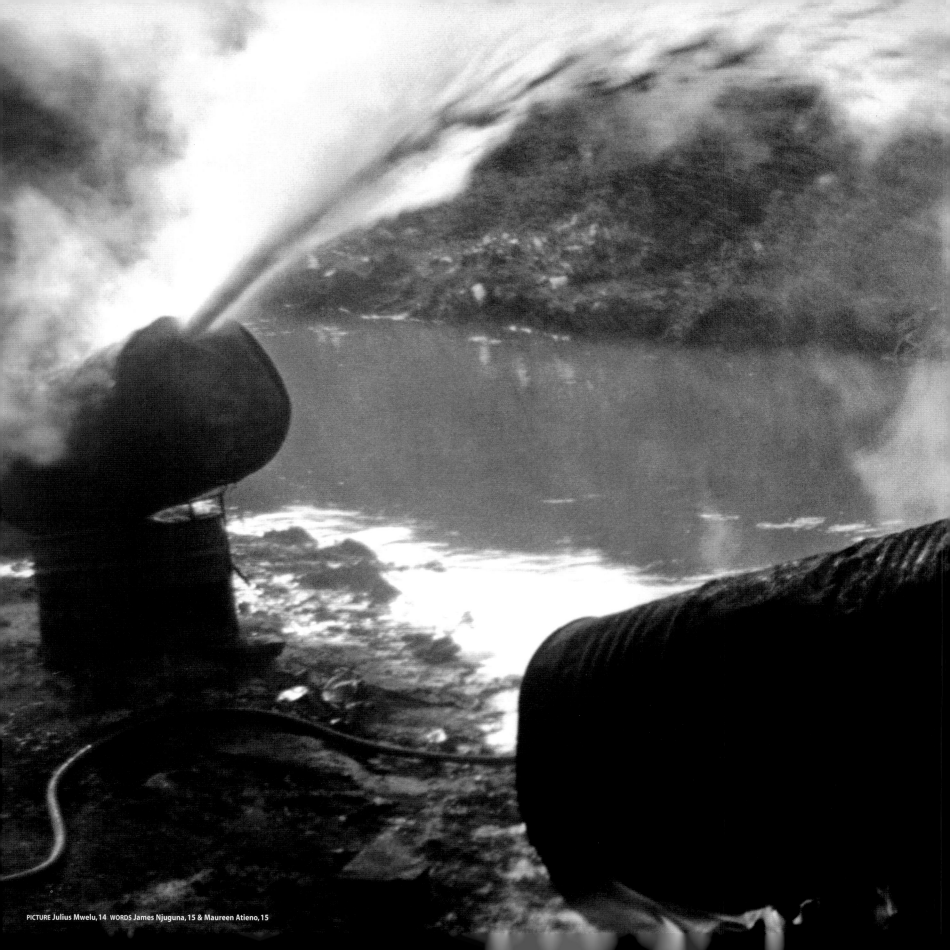

PICTURE Julius Mwelu, 14  WORDS James Njuguna, 15 & Maureen Atieno, 15

# PREPARING ILLEGAL BREW: CHANG'AA

This picture shows how illegal brew (chang'aa) is prepared in Mathare. It is very dangerous to drink because it is made up from contaminated water, mortuary preservatives, washing detergents to name but a few. They don't care about the hygiene because it's easy to sell and easy to get money.

Slum people enjoy drinking chang'aa because it's cheap and sweet. They know it is harmful to their body and can lead to the breaking of marriages, but they ignore this and drink it anyway. And that's why others sleep anywhere because they can't move anymore.

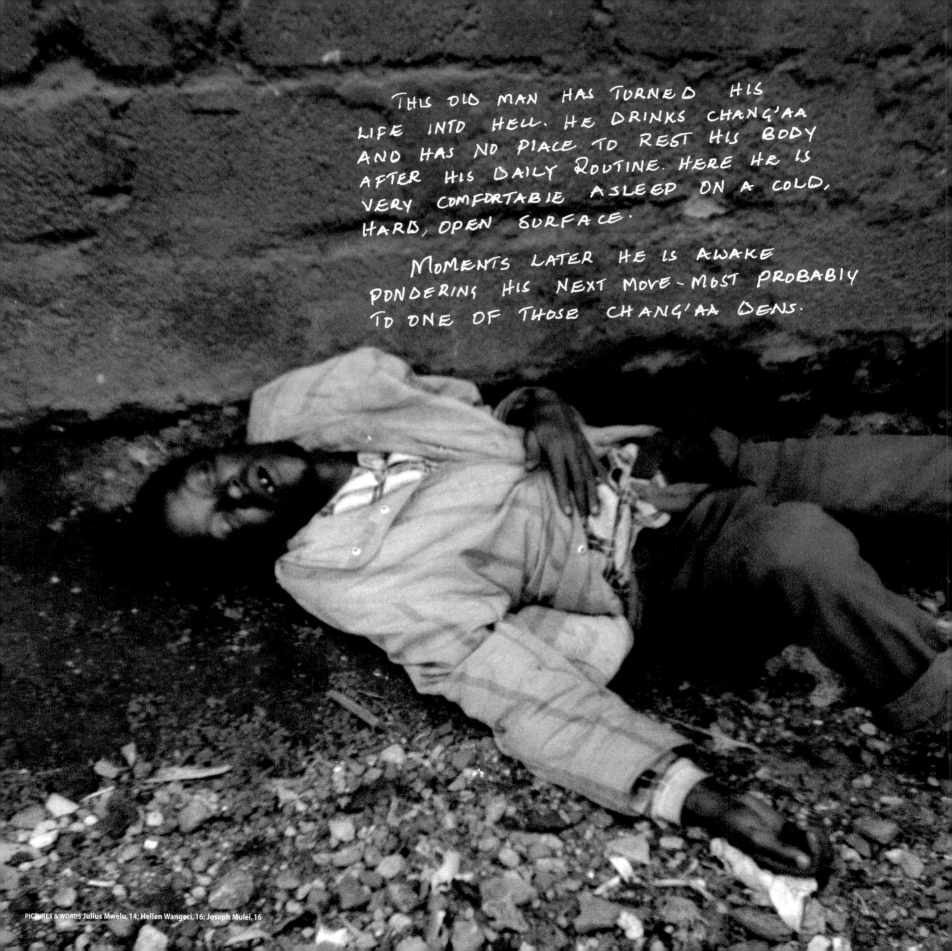

THIS OLD MAN HAS TURNED HIS LIFE INTO HELL. HE DRINKS CHANG'AA AND HAS NO PLACE TO REST HIS BODY AFTER HIS DAILY ROUTINE. HERE HE IS VERY COMFORTABLE ASLEEP ON A COLD, HARD, OPEN SURFACE.

MOMENTS LATER HE IS AWAKE PONDERING HIS NEXT MOVE - MOST PROBABLY TO ONE OF THOSE CHANG'AA DENS.

PICTURES & WORDS Julius Mwelu, 14; Hellen Wangeci, 16; Joseph Mulei, 16

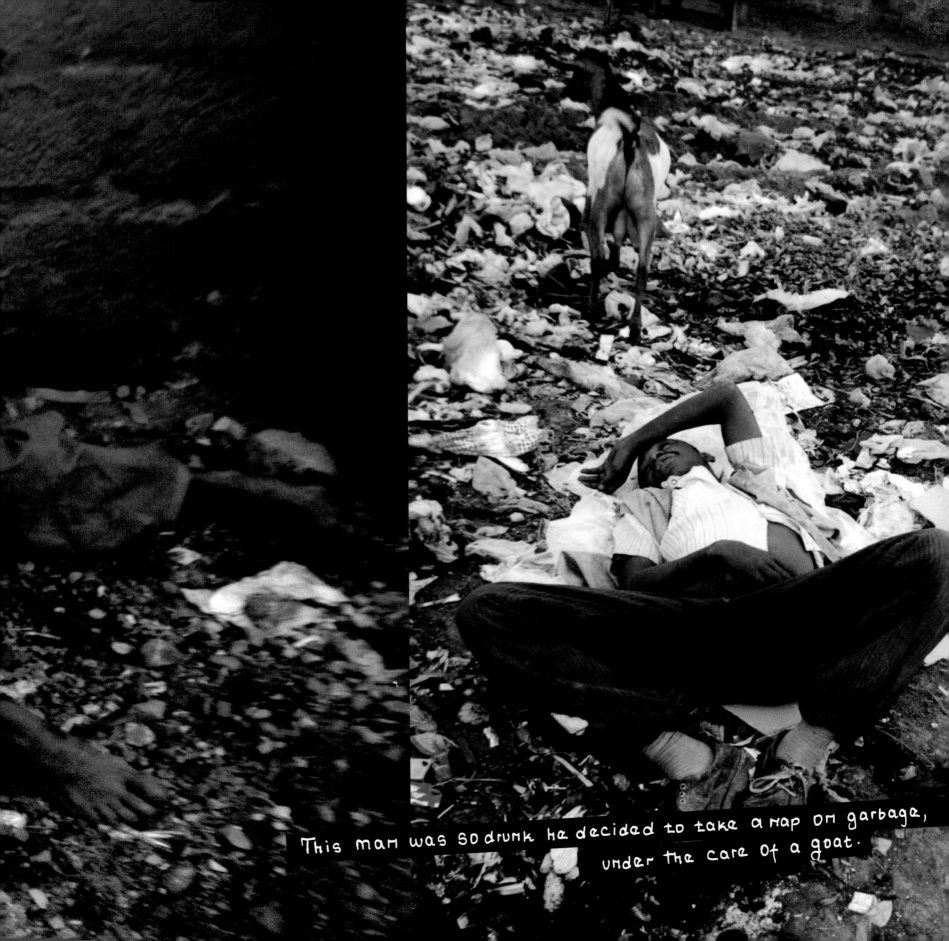

This man was so drunk he decided to take a nap on garbage, under the care of a goat.

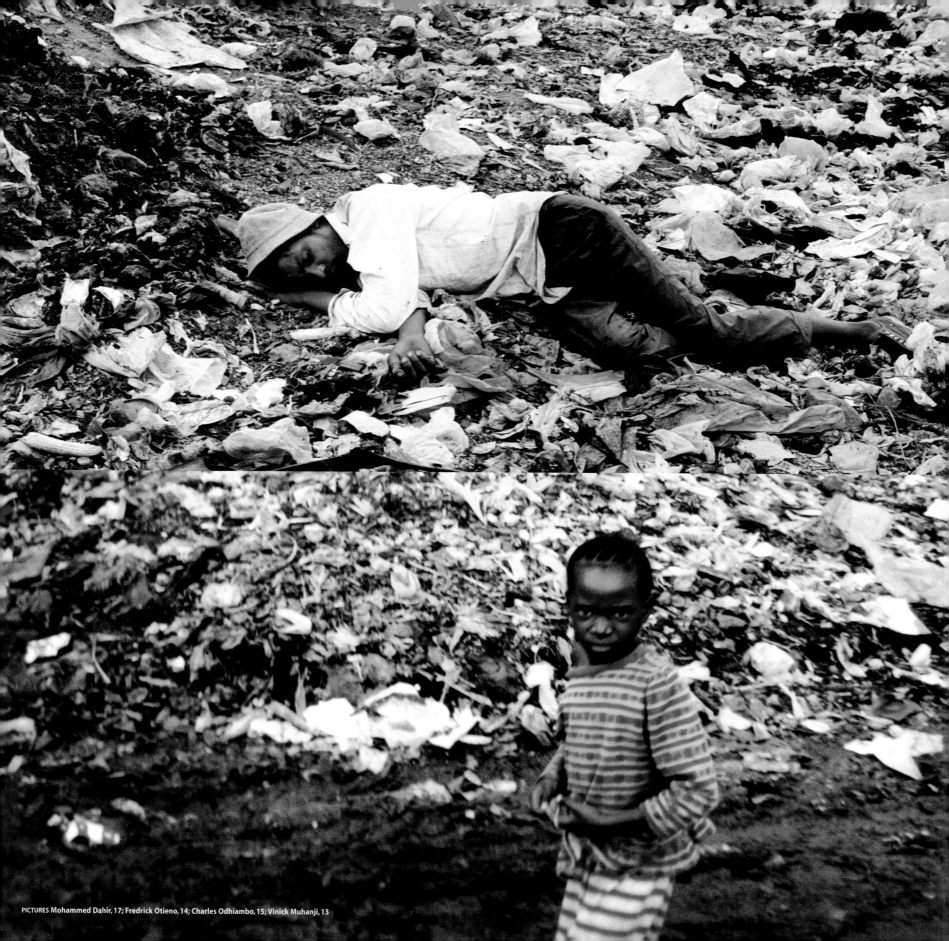

PICTURES Mohammed Dahir, 17; Fredrick Otieno, 14; Charles Odhiambo, 15; Vinick Muhanji, 13

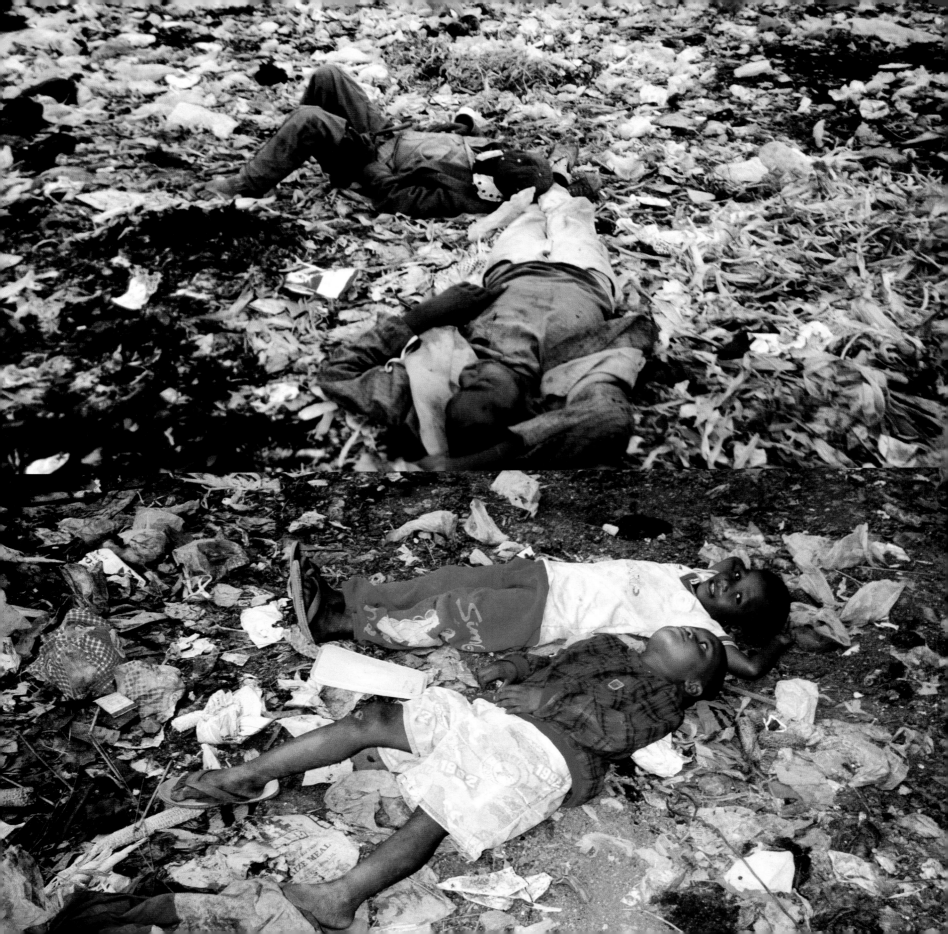

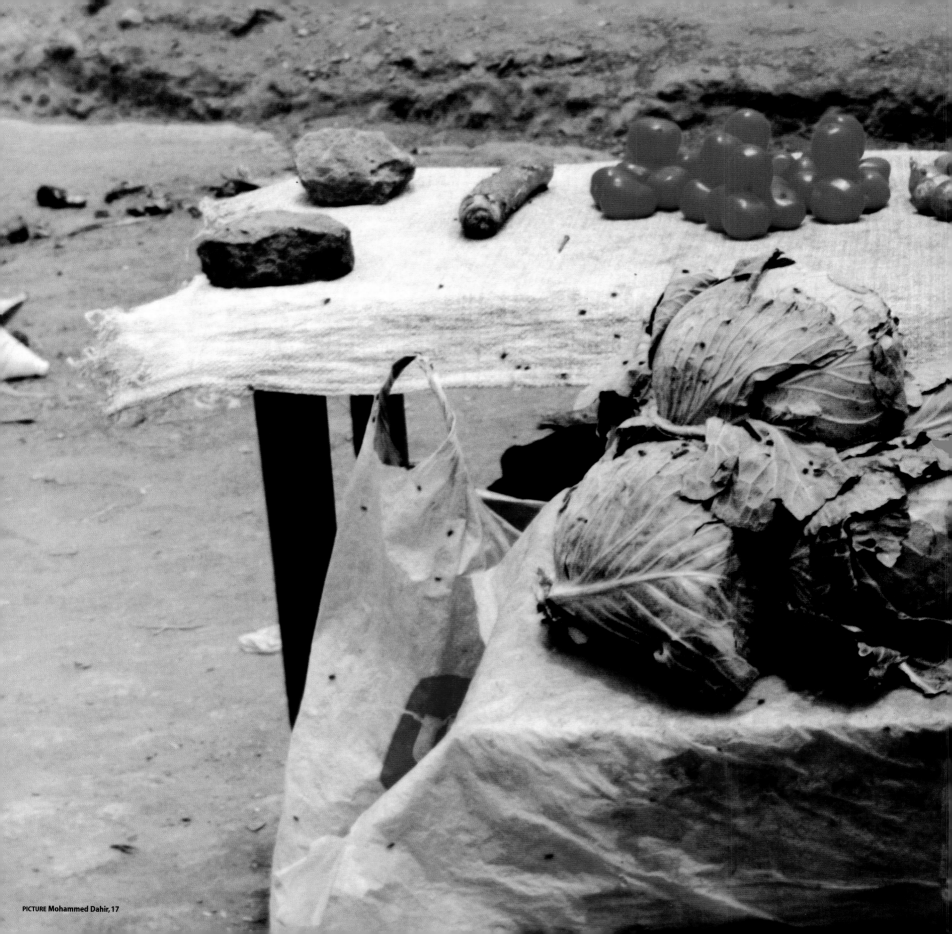

**Yes!** CHILDREN ARE A VERY SPECIAL GIFT FROM THE ALMIGHTY FATHER YET SOME THROW THEM AWAY LIKE RUBBISH OR LEAVE THE WORLD TO TAKE CARE OF THEM.

DAY AFTER DAY, STREET CHILDREN ROAM AROUND OUR STREETS. PEOPLE DON'T WANT THEM NEAR OR CLOSE. SOME OF THESE KIDS ARE MISTREATED SO THEY SEE THE ONLY PLACE TO RUN IS THE STREETS WHERE NO HATRED WILL BE SHOWN TO THEM BY PEOPLE THEY LOVE. OTHERS RUN INTO THE STREETS ON THEIR OWN FREE WILL TO PRACTICE ACTIVITIES SUCH AS THEFT, BUT THEIR PAY IS THAT THEY END UP IN WORSE PLACES LIKE JAIL OR DEATH.

Nicholas Mathenge, 16

PICTURE Ali Barisa, 15

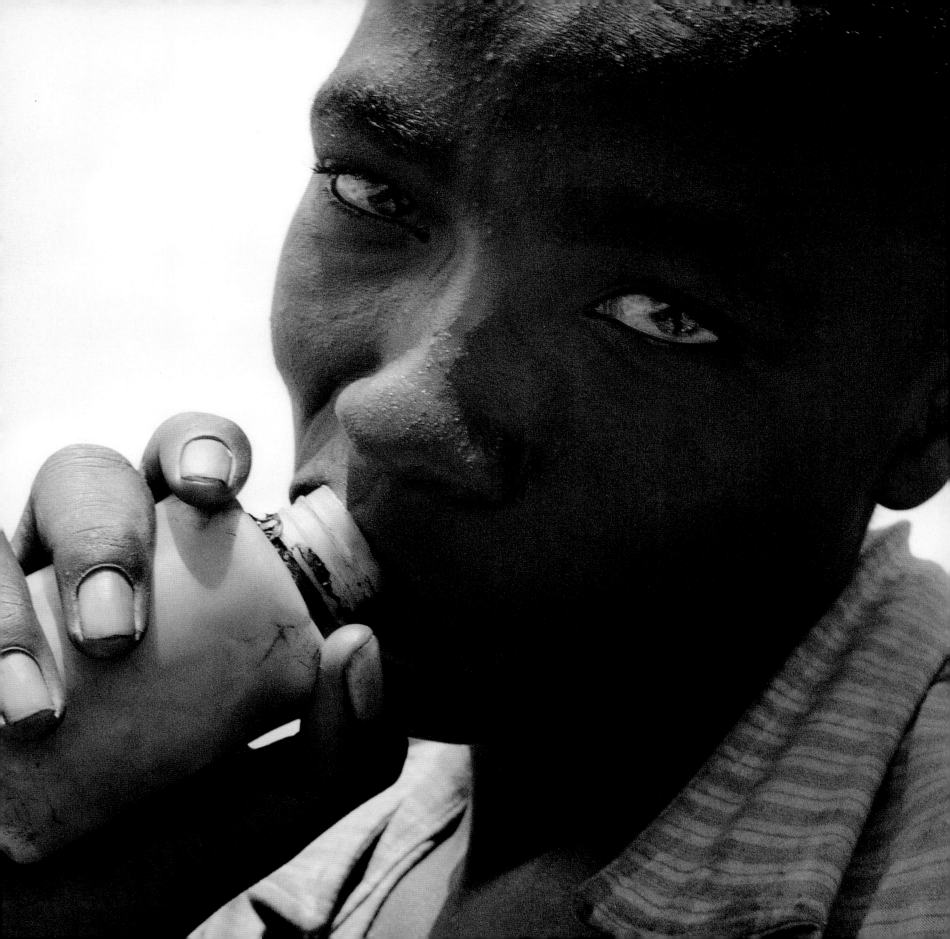

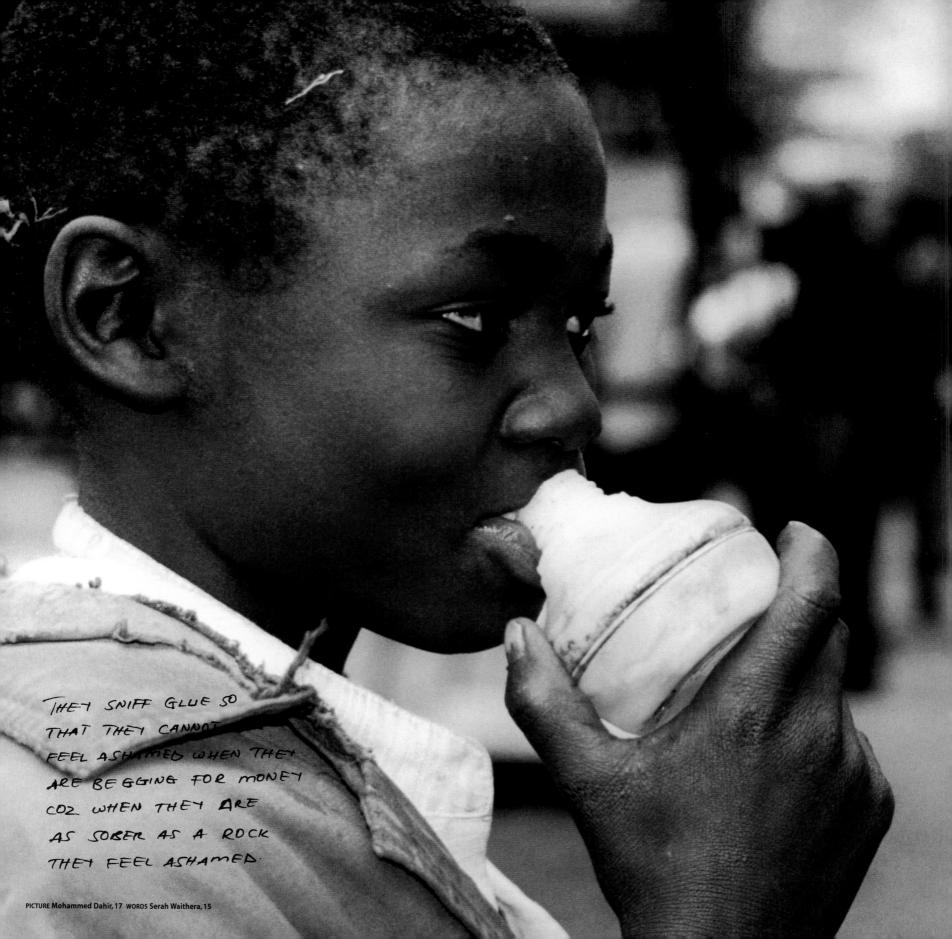

THEY SNIFF GLUE SO
THAT THEY CANNOT
FEEL ASHAMED WHEN THEY
ARE BEGGING FOR MONEY
COZ WHEN THEY ARE
AS SOBER AS A ROCK
THEY FEEL ASHAMED.

PICTURE Mohammed Dahir, 17  WORDS Serah Waithera, 15

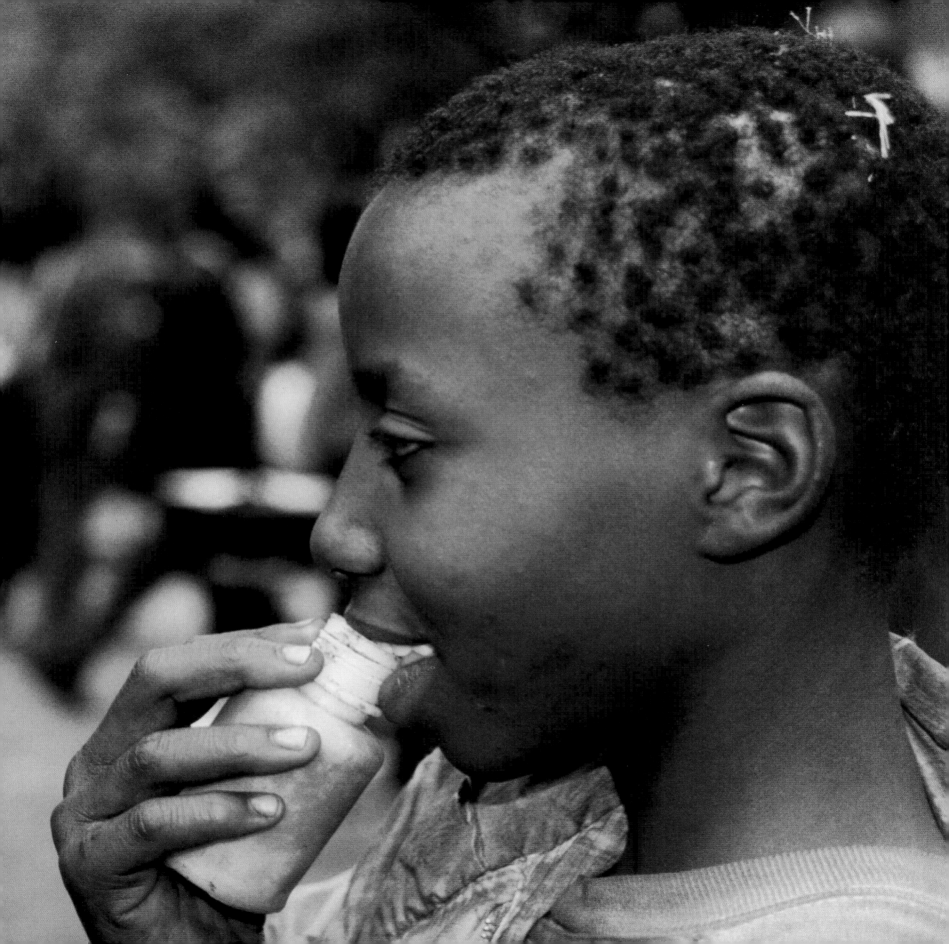

It might sound strange and funny but it is true. These young kids are busy eating wastes from the garbage.

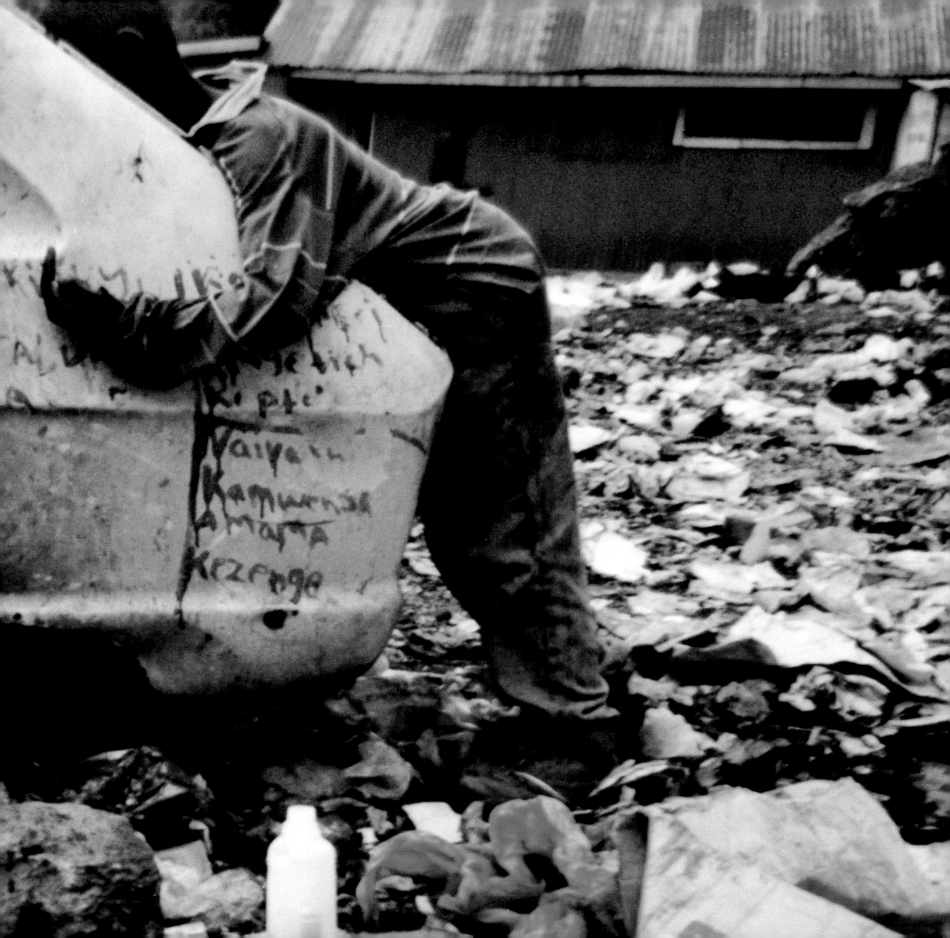

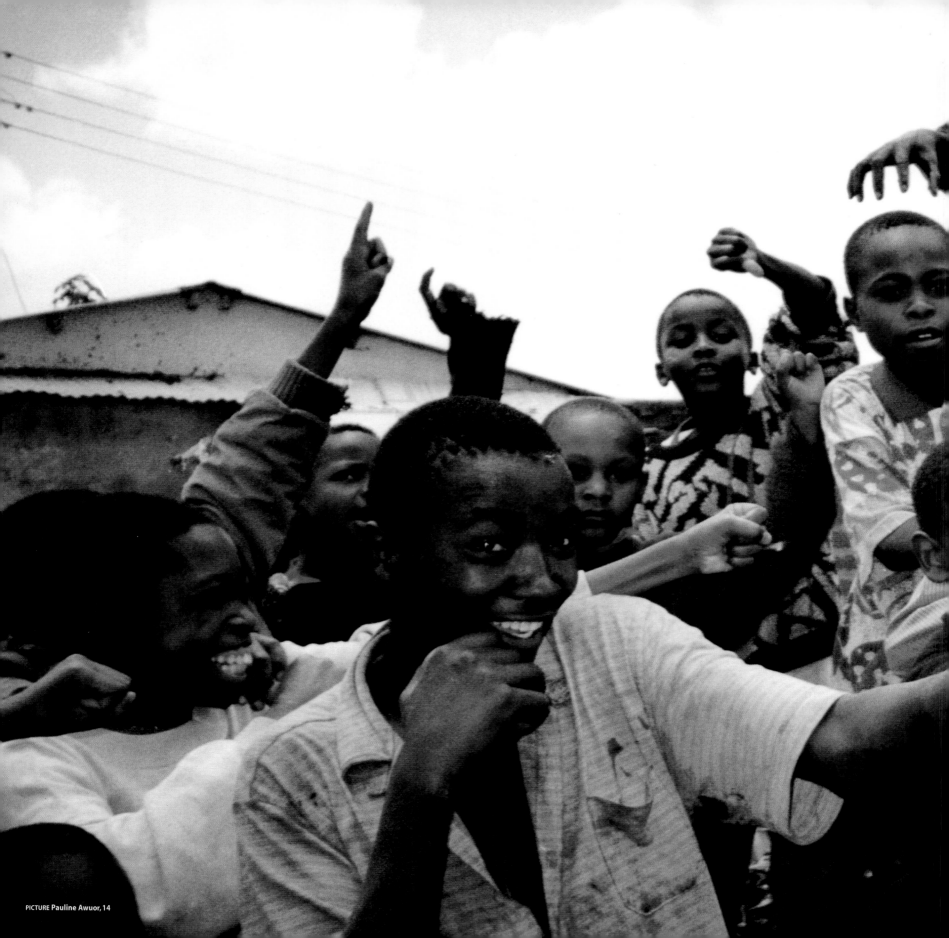

PICTURE Pauline Awuor, 14

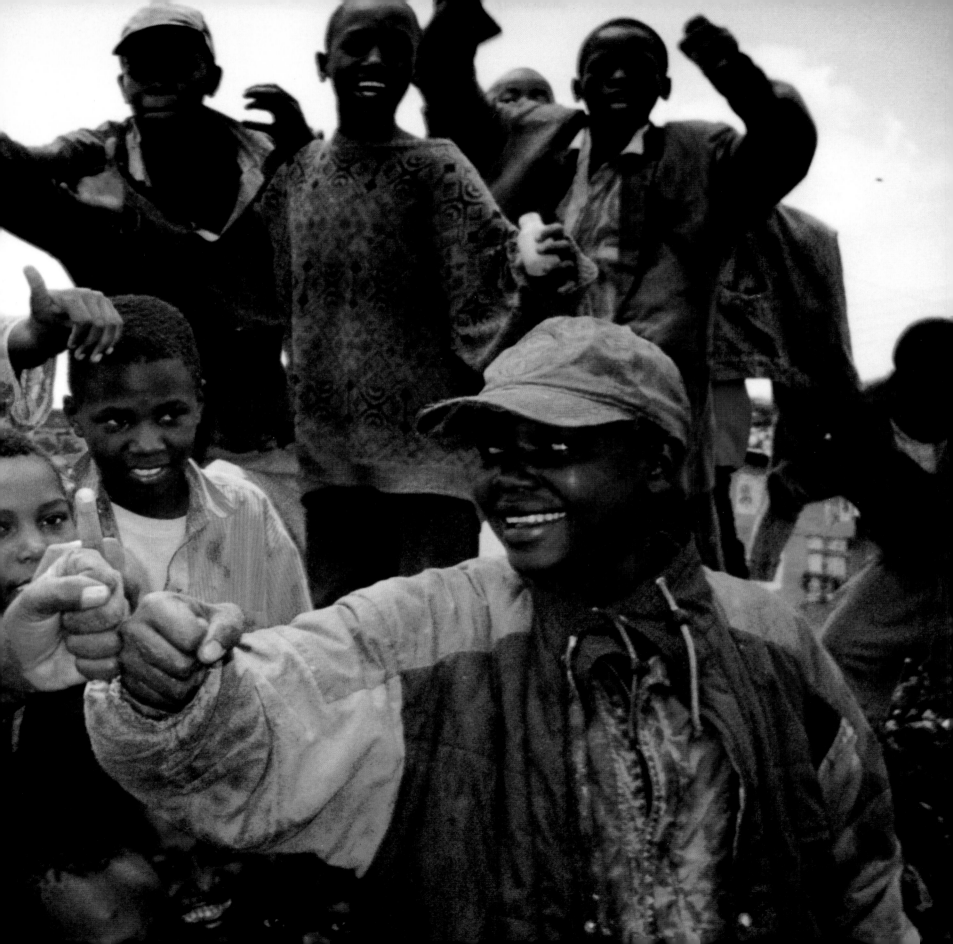

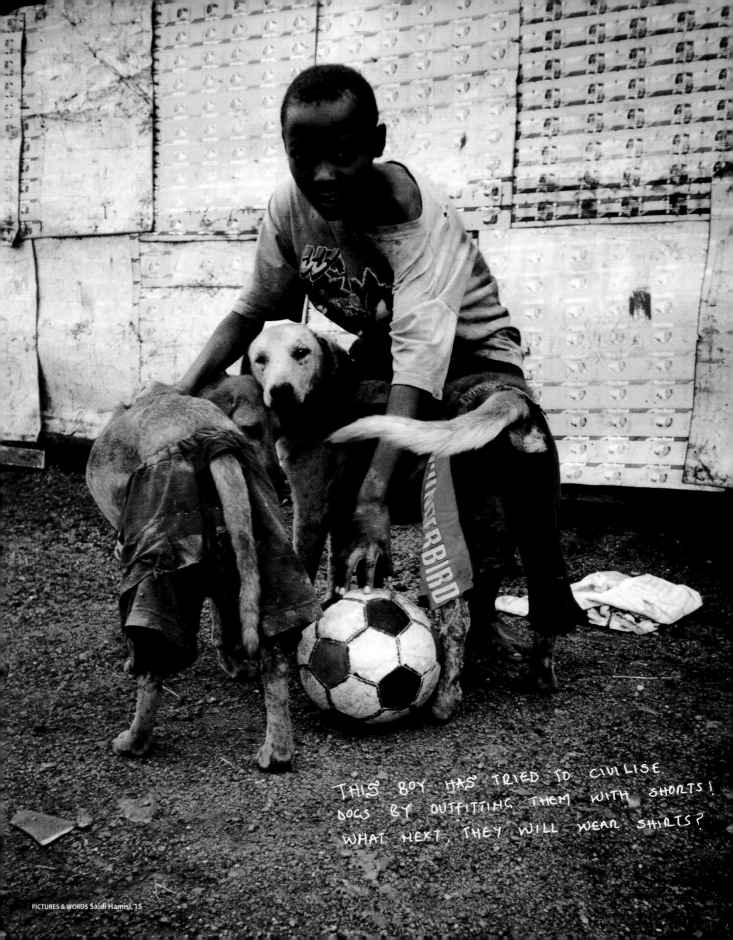

THIS BOY HAS TRIED TO CIVILISE DOGS BY OUTFITTING THEM WITH SHORTS! WHAT NEXT, THEY WILL WEAR SHIRTS?

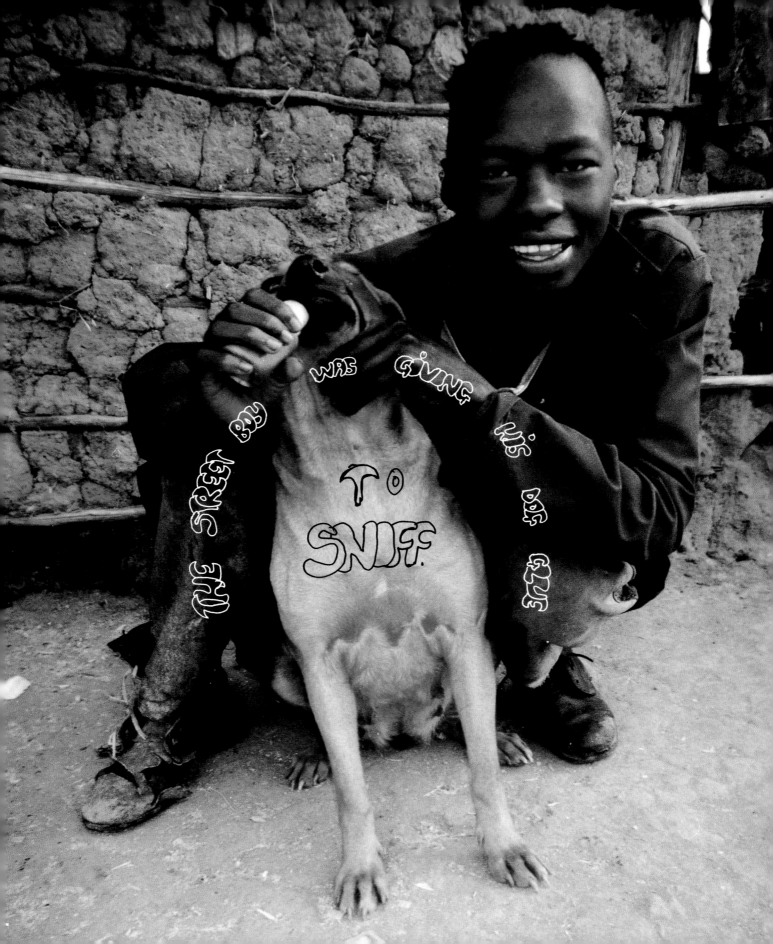

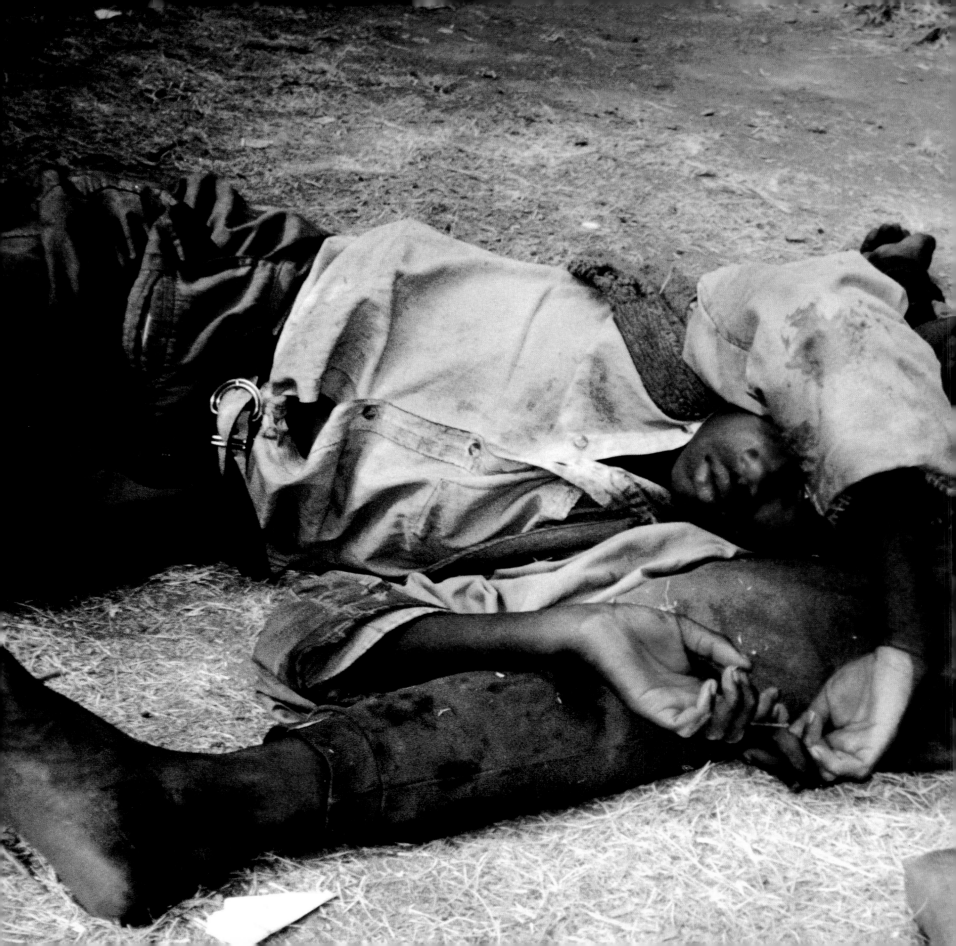

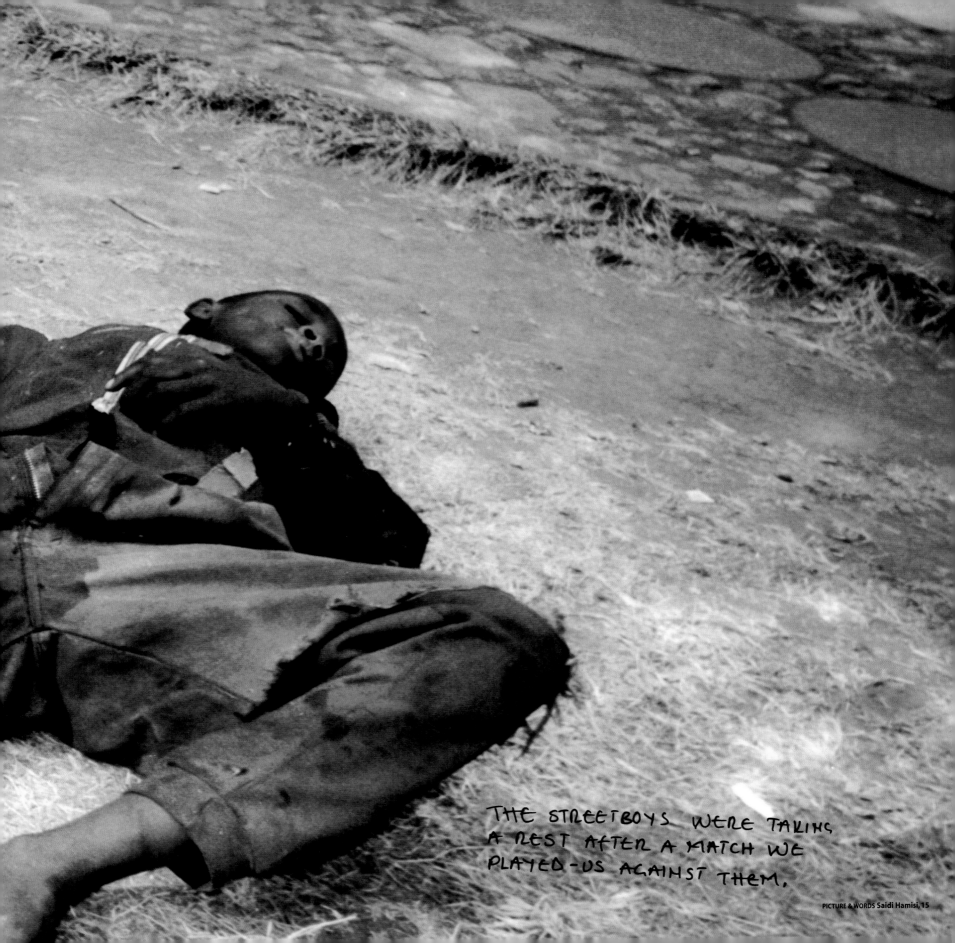

THE STREETBOYS WERE TAKING
A REST AFTER A MATCH WE
PLAYED-US AGAINST THEM.

Everyone in the slum apart
from a few plays football and
prays to be world stars.

These two girls hope to become
footballers in the near future.
The balls they are holding are made
of plastic bags and string.

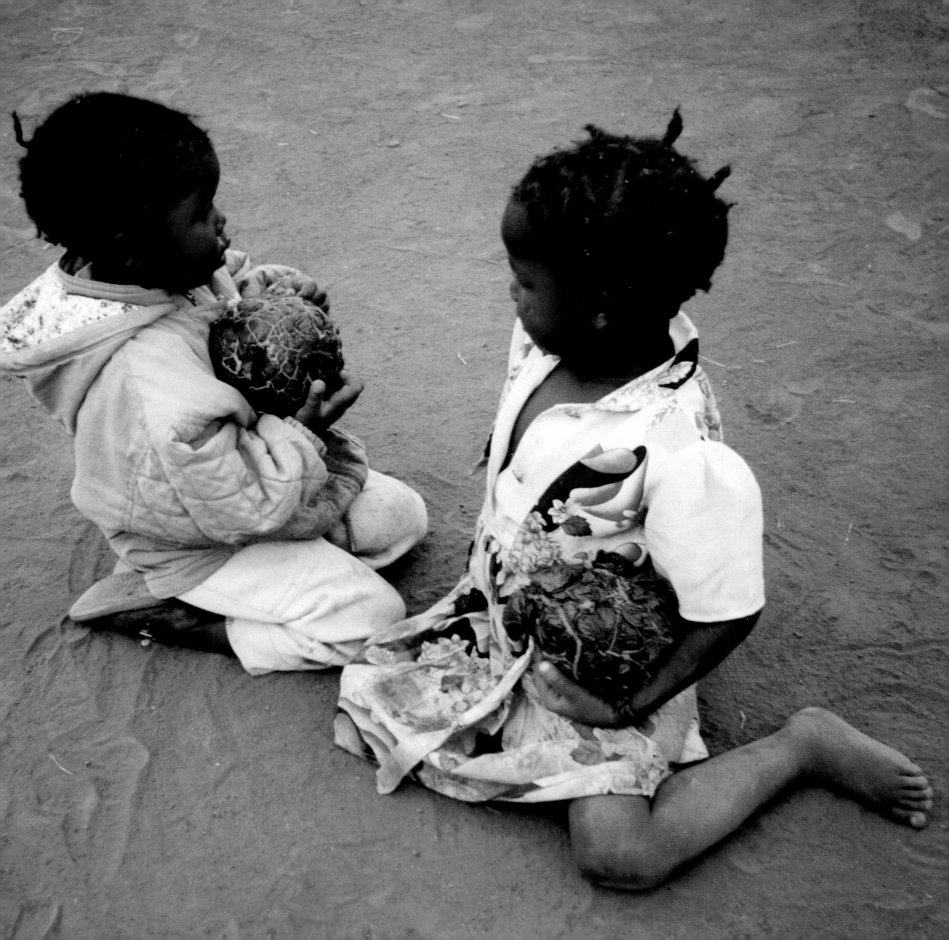

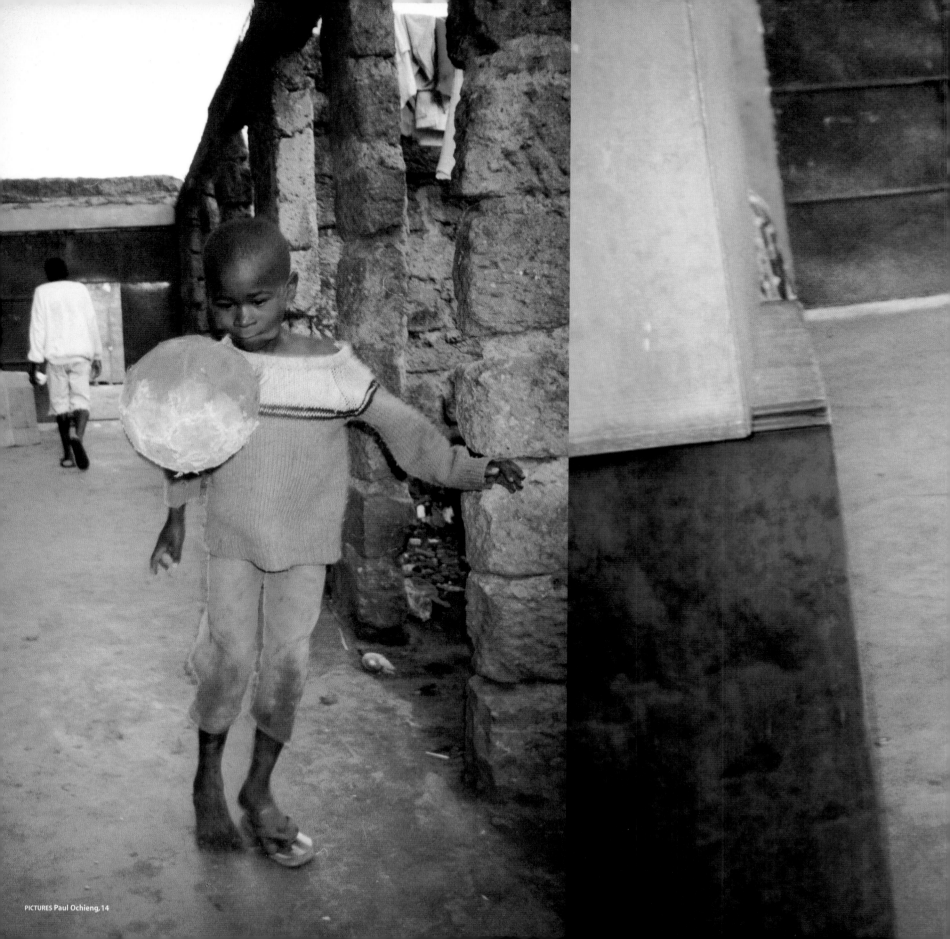

PICTURES Paul Ochieng, 14

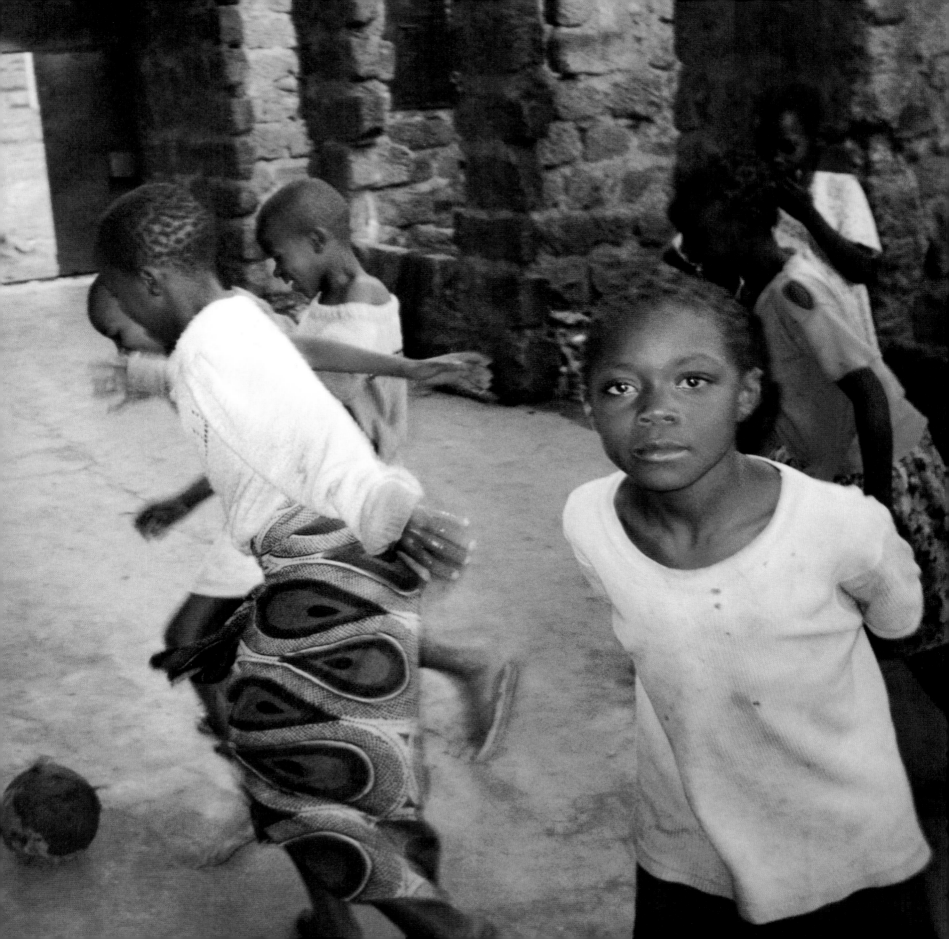

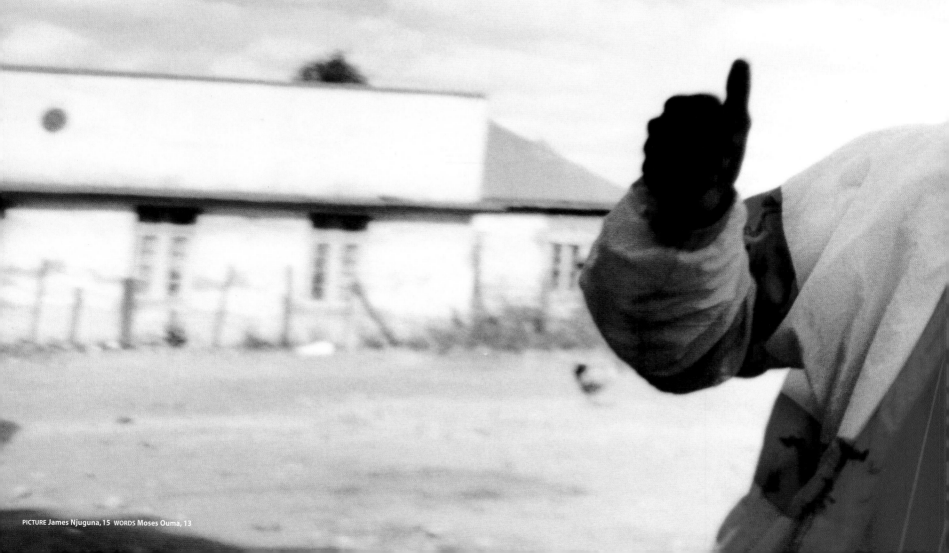

NOW IT IS ONE, ONE. THE REFEREE SOUNDS THE
WHISTLE AND IT WAS HALFTIME. WE WENT OFF THE GROUND AND OUR COACH
GAVE US SOME ADVICE. THE WHISTLE SOUNDS AND WE GO BACK TO
THE FIELD. THE FIRST TWENTY-FIVE MINUTES WE DIDN'T SCORE AND THEY DIDN'T SCORE.
BY GOOD LUCK OUR STRIKER GETS THE BALL AND HE DRIBBLES UNTIL
HE'S NEAR THE OPPONENT'S POST AND I KICK THE BALL AND IT IS IN THE NET.
THE OPPONENT BEGINS THE BALL BUT THE TIME WAS OVER AND THE REFEREE SOUNDS
THE WHISTLE AND THE MATCH ENDS AND WE WON IT.

PICTURE James Njuguna, 15  WORDS Moses Ouma, 13

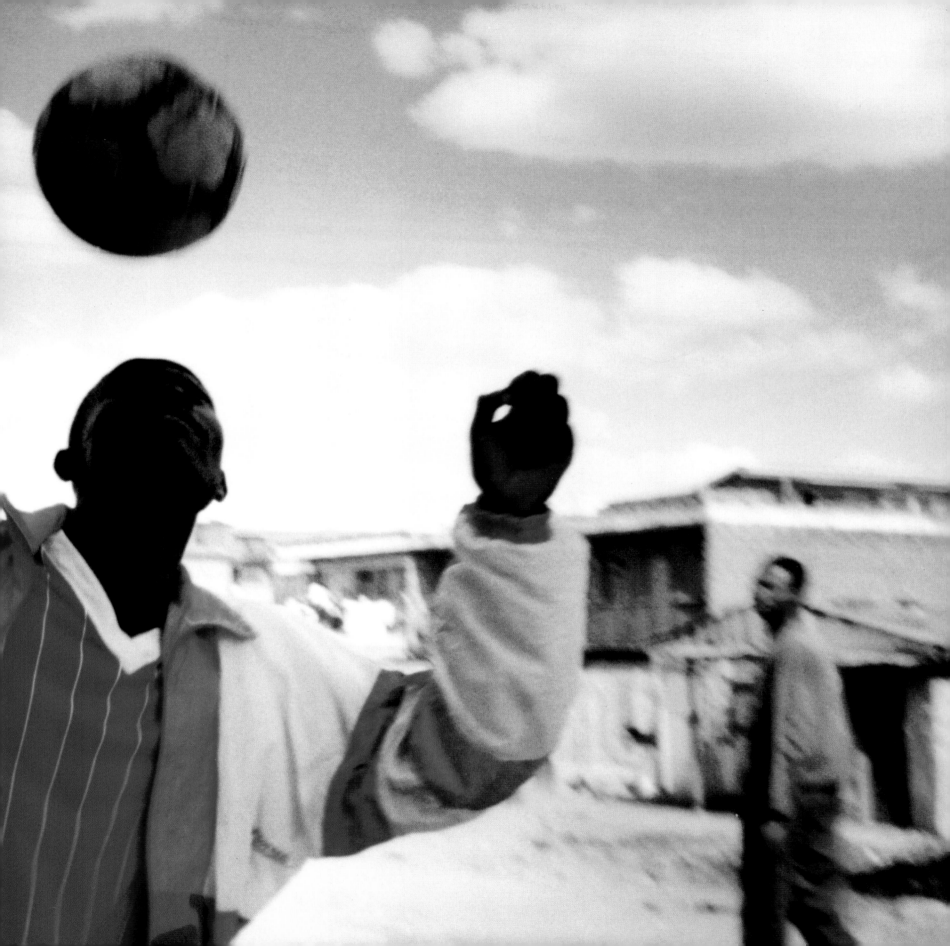

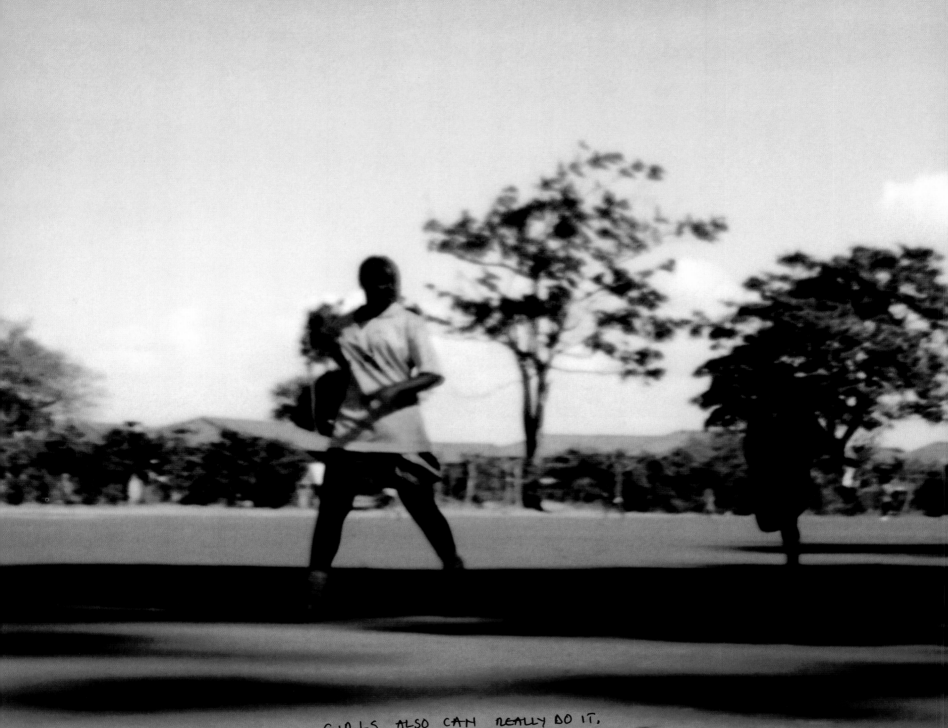

GIRLS ALSO CAN REALLY DO IT.
THESE YOUNG LADIES ARE DETERMINED TO HIT THE BALL. AT FIRST FOOTBALL
USED TO BE CONSIDERED FOR BOYS BUT NOWADAYS
ANYONE CAN DO IT.

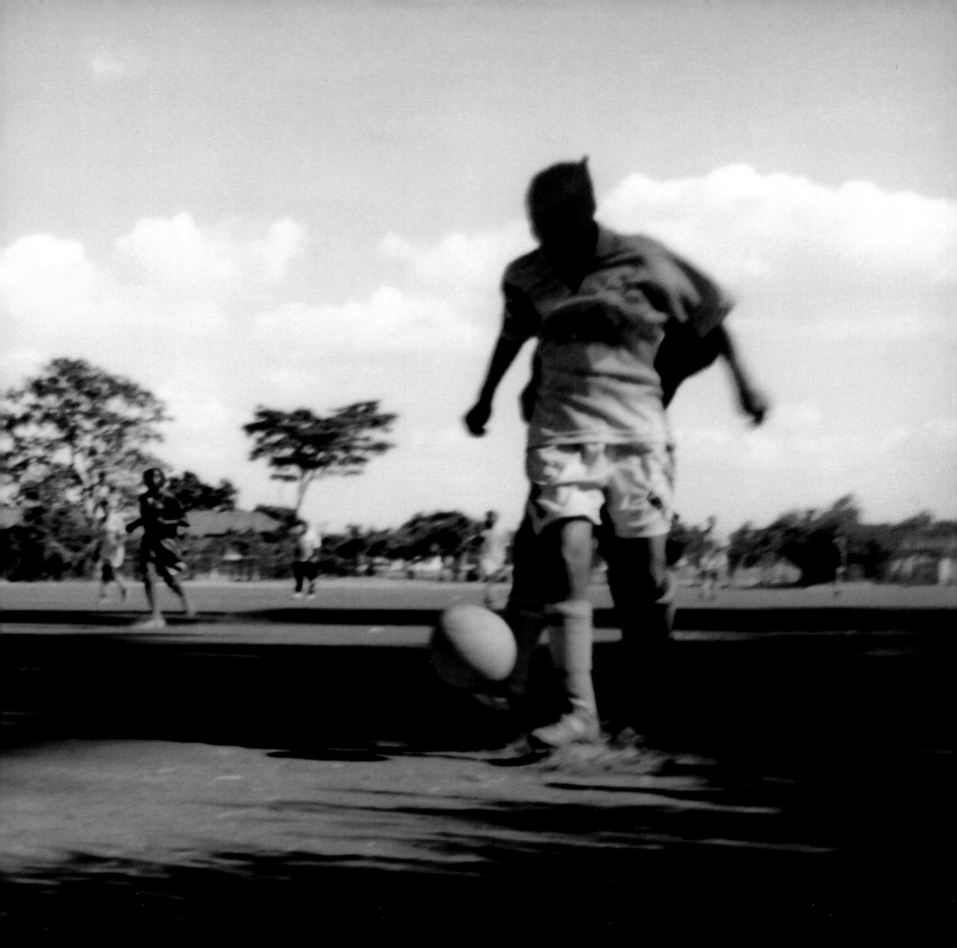

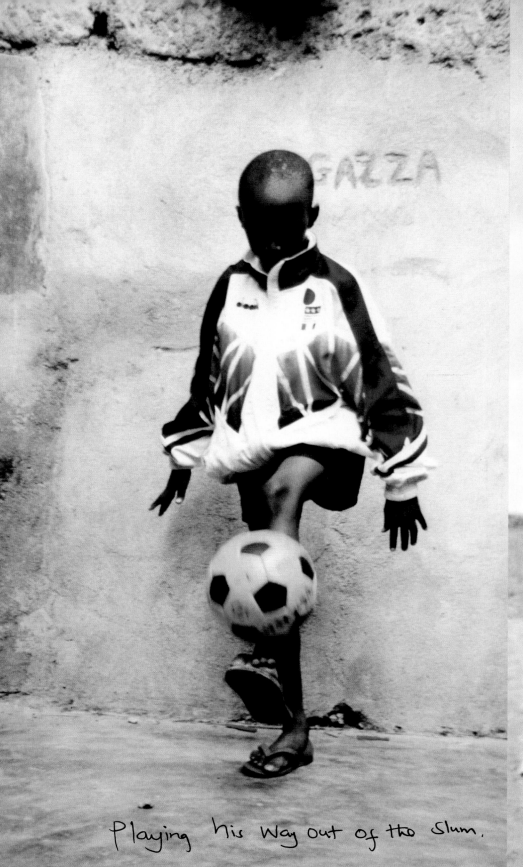

Playing his way out of the slum.

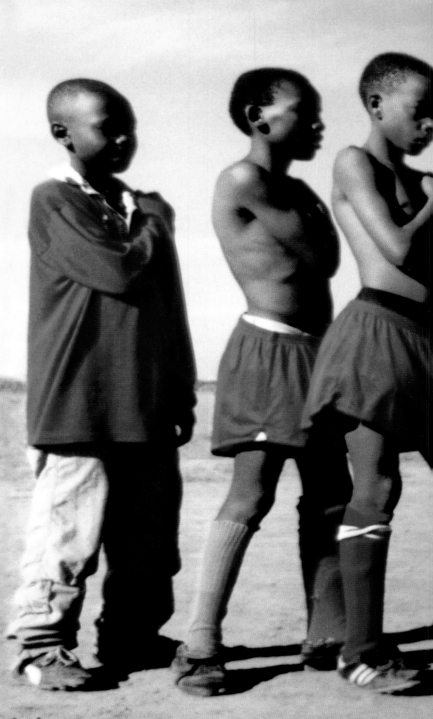

PICTURES & WORDS David Mbuthia, 15 & Saidi Hamisi, 15

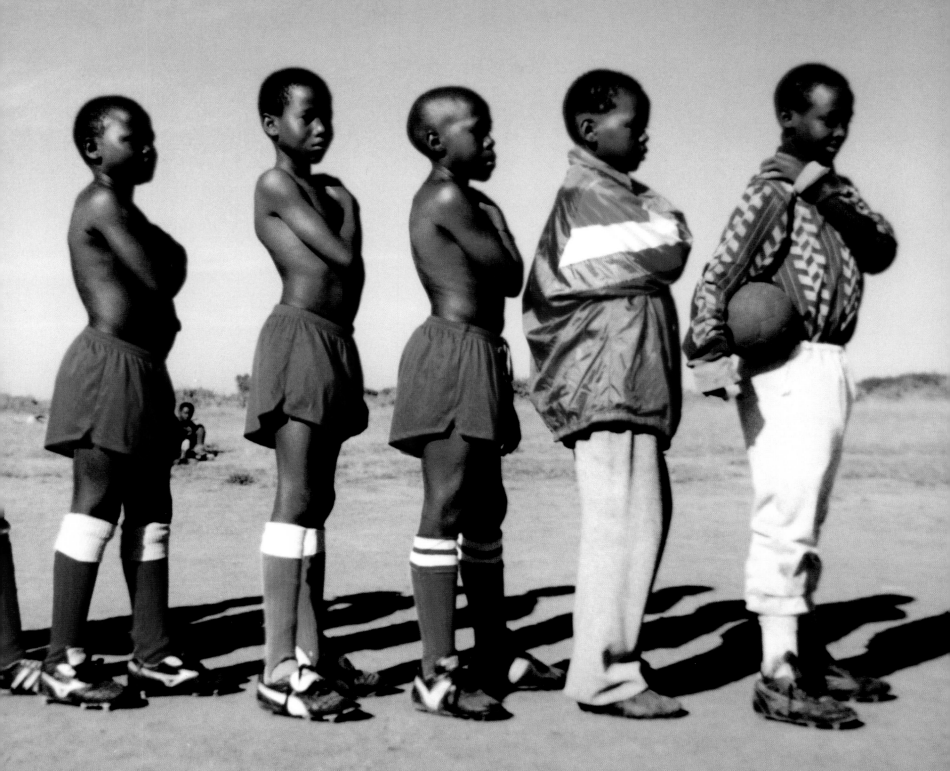

My father told me if you steal, steal big.

One day I stole an Elephant.

And when I was asked why I stole an Elephant, I told them that
my father told me if you steal, steal big

# GHOST STORY

ONCE UPON A TIME THERE WAS A DROUGHT IN THE COUNTRYSIDE AND THERE WAS A MAN WHO WAS VERY POOR. ONE DAY THE MAN DECIDED TO GO TO THE FOREST TO FIND SO SOME FRUITS. HE SAW A BEAUTIFUL HOUSE WHICH HE HAD NEVER SEEN BEFORE AND FAT SHEEPS, GOATS AND COWS. INSIDE HE FOUND ALL TYPES OF FOOD SO HE STARTED EATING. WHEN HIS STOMACH WAS FULL HE HEARD SOUNDS OF FOOT OF PEOPLE SO HE HID IN A CUPBOARD.

THE PEOPLE WERE GHOSTS. ONE SAID, "I CAN SMELL A MAN." BY MISTAKE THEY FOUND THE MAN AND TOLD HIM. "WE WANT TO EAT YOU. IF YOU CAN DEFEND YOURSELF, START." THE MAN STARTS SHAKING THE ALL BODY. THE GHOSTS ASKED, "HOW MANY CHILDREN DO YOU HAVE?" THE MAN SAID, "SIX." THE GHOSTS SAID, "WE WILL ALLOW YOU TO TAKE ANY AMOUNT OF FOOD, BUT FROM TOMORROW TELL YOUR WIFE WE WILL BE EATING ONE CHILD EACH DAY TOGETHER WITH YOU AND YOUR WIFE."

THE MAN TOOK MUCH FOOD TO HIS HOUSE AND TOLD HIS WIFE WHAT THE GHOSTS HAD SAID. HIS WIFE THINKS AND THINKS UNTIL SHE GOT AN IDEA. THEY WERE VERY LUCKY BECAUSE THEY HAD EIGHT DOGS. SHE TOOK A DOG, COOKED IT, THEN SHE TOOK ONE CHILD AND HID HIM WHERE NO ONE CAN KNOW. THE GHOSTS COME AND EAT THE DOG AND THEY WERE HAPPY. EVERYDAY THE WIFE COOKED A DOG AND HID A CHILD. THEN SHE WENT AND HID HERSELF.

WHEN THE DAY CAME FOR THE MAN TO BE EATEN, HE COOKED A DOG AND LEFT IT. THE GHOSTS CAME AND ATE THE DOG. THEY STARTED SINGING, "WE'VE EATEN A MAN WITH HIS FAMILY!" THE MAN ANSWERED LOUDLY, "WE ARE HERE!" THE GHOSTS STOPPED SINGING AND DECIDED TO GO EAT THEM RAW. THE MAN AND HIS FAMILY STARTED THROWING STONES TO THEM UNTIL THE GHOSTS DIED. SO THE WEALTHS OF THE GHOSTS REMAINED TO THE MAN AND HIS FAMILY AND THEY LIVE HAPPILY.

PICTURES Paul Ochieng, 14 & Vinick Muhanji, 13  WORDS Moses Ouma, 13

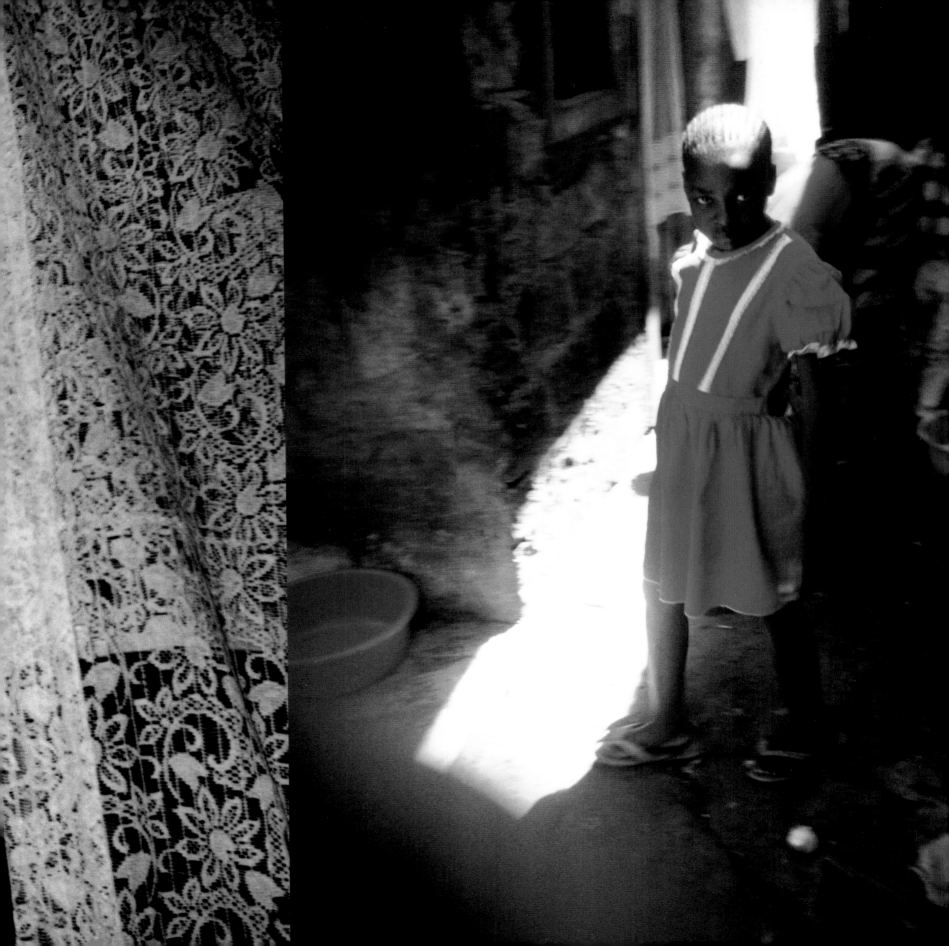

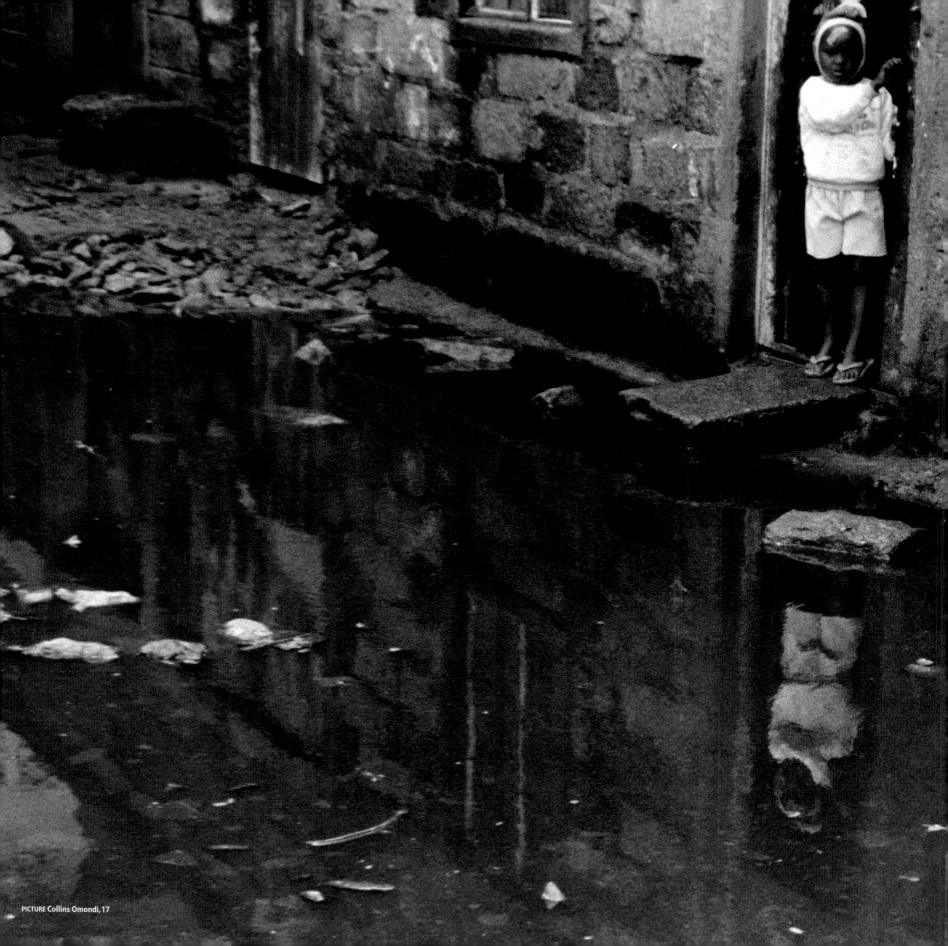

PICTURE Collins Omondi, 17

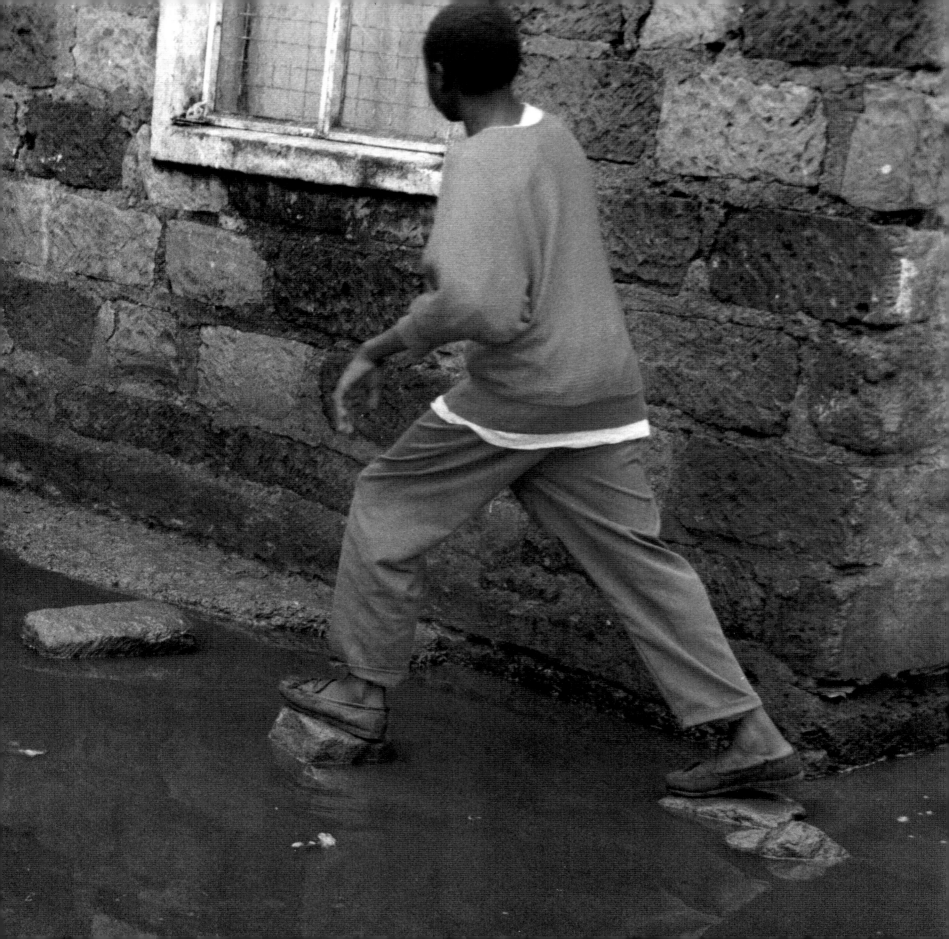

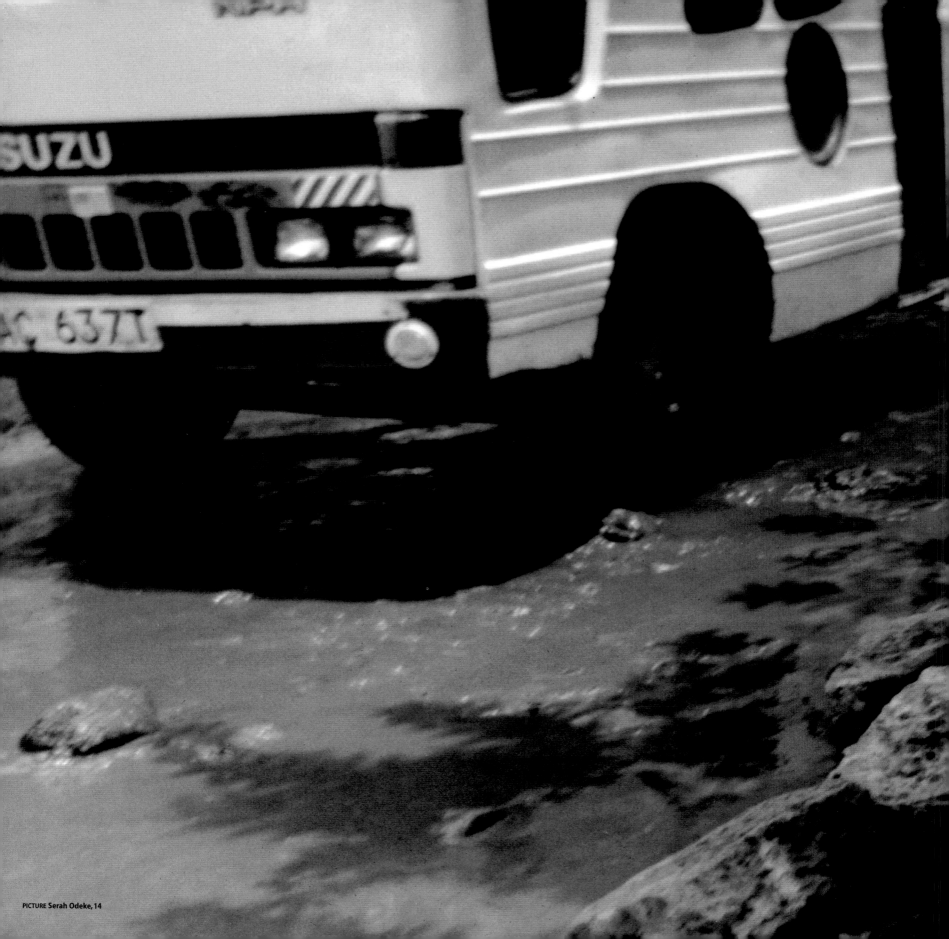

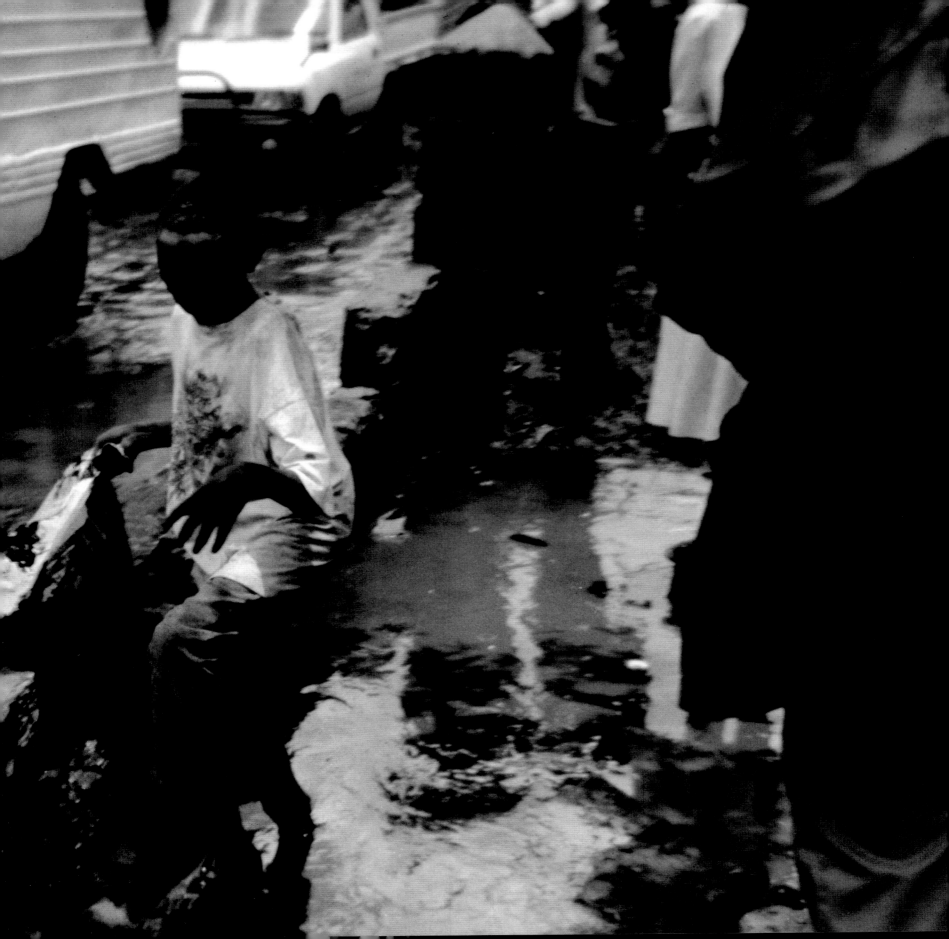

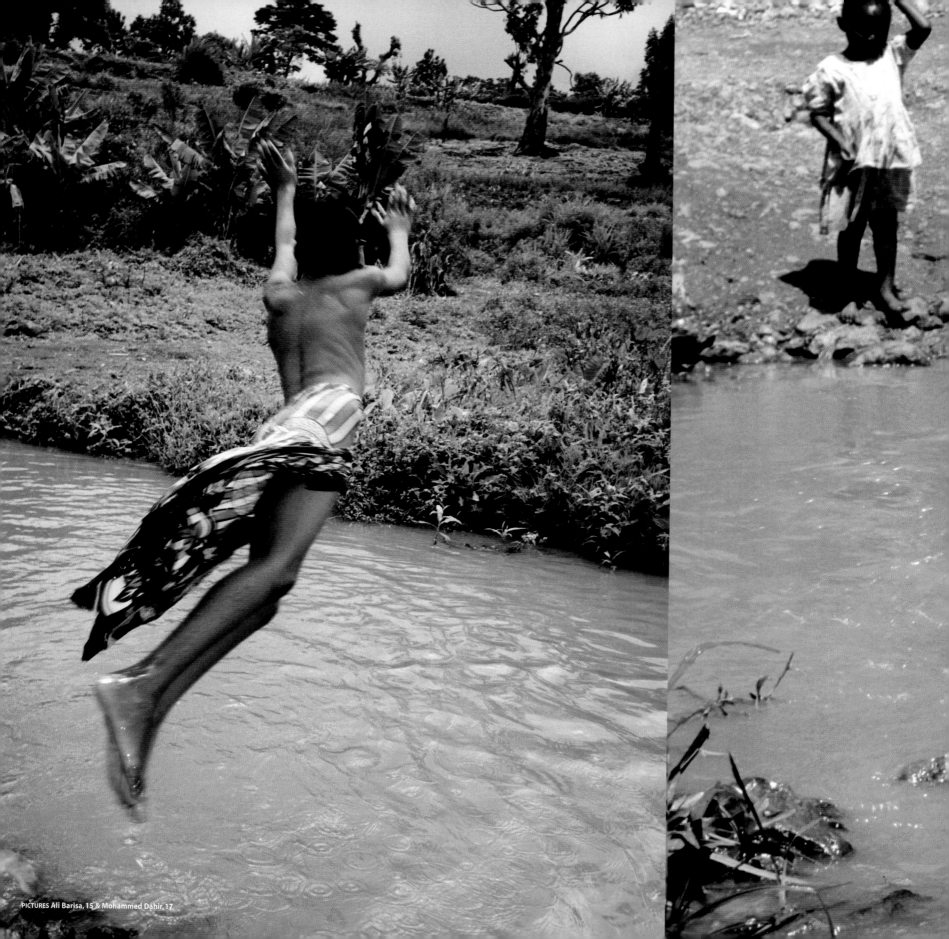

PICTURES Ali Barisa, 15 & Mohammed Dahir, 17

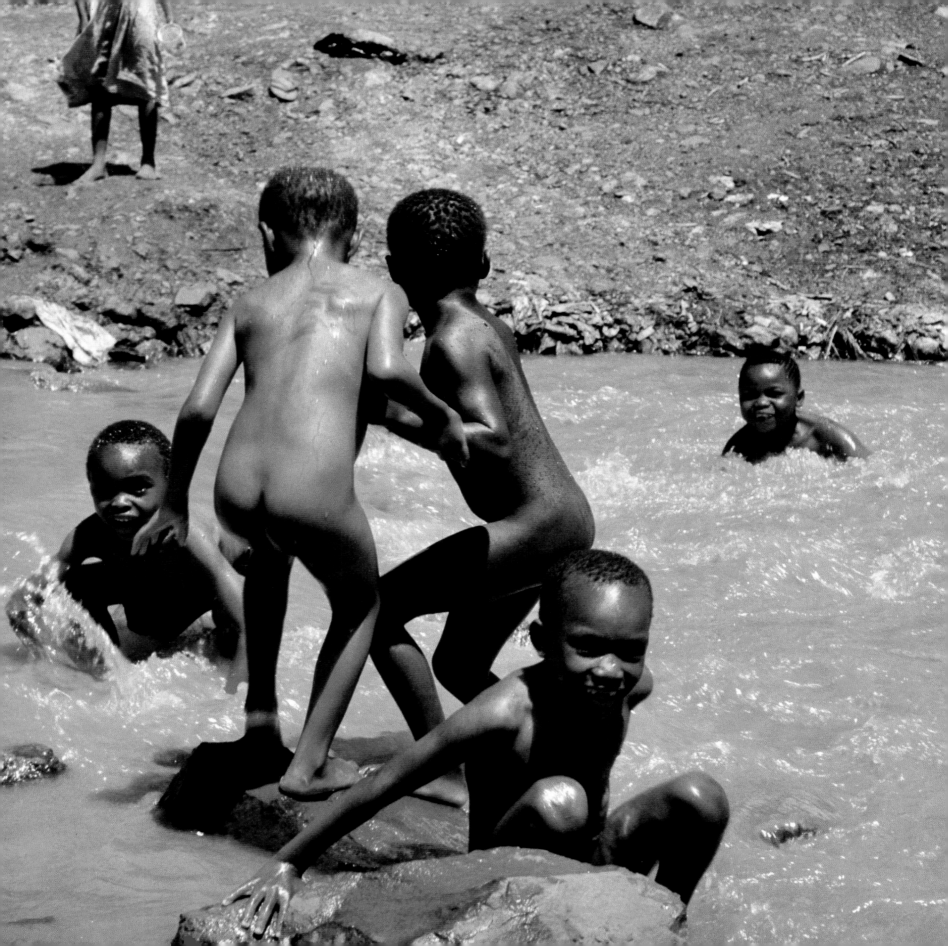

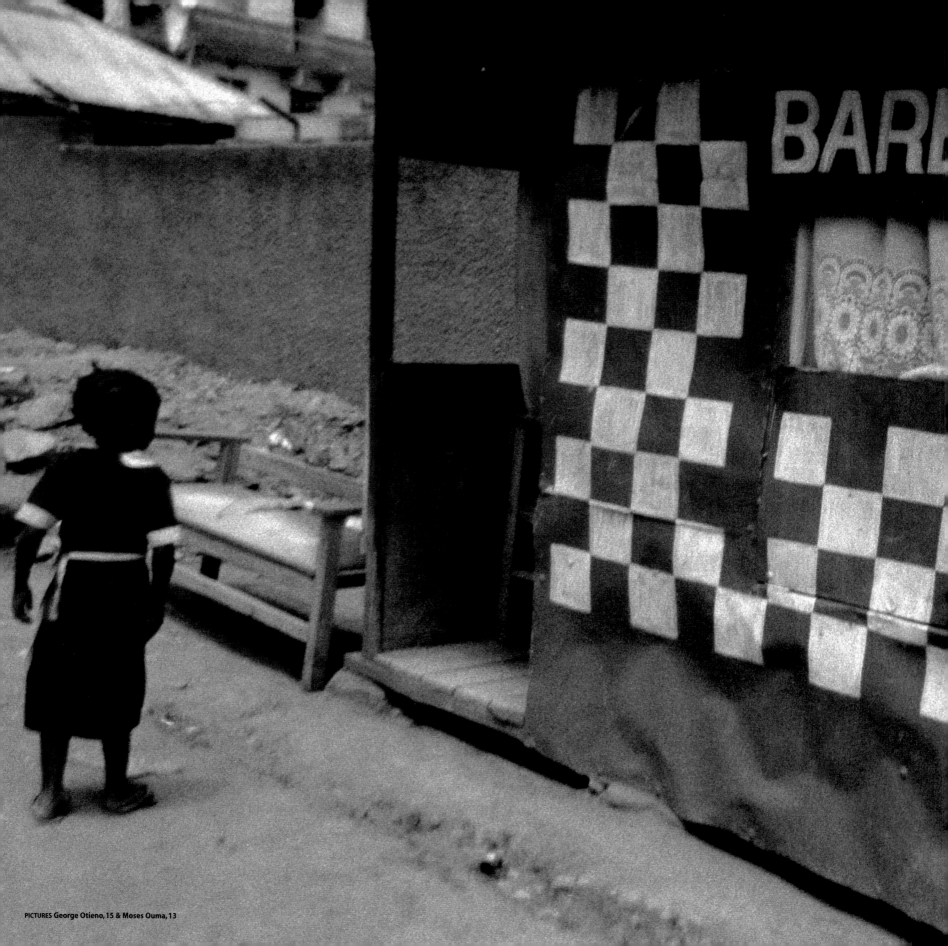

PICTURES & WORDS Salome Atieno, 14 & David Mbuthia, 15

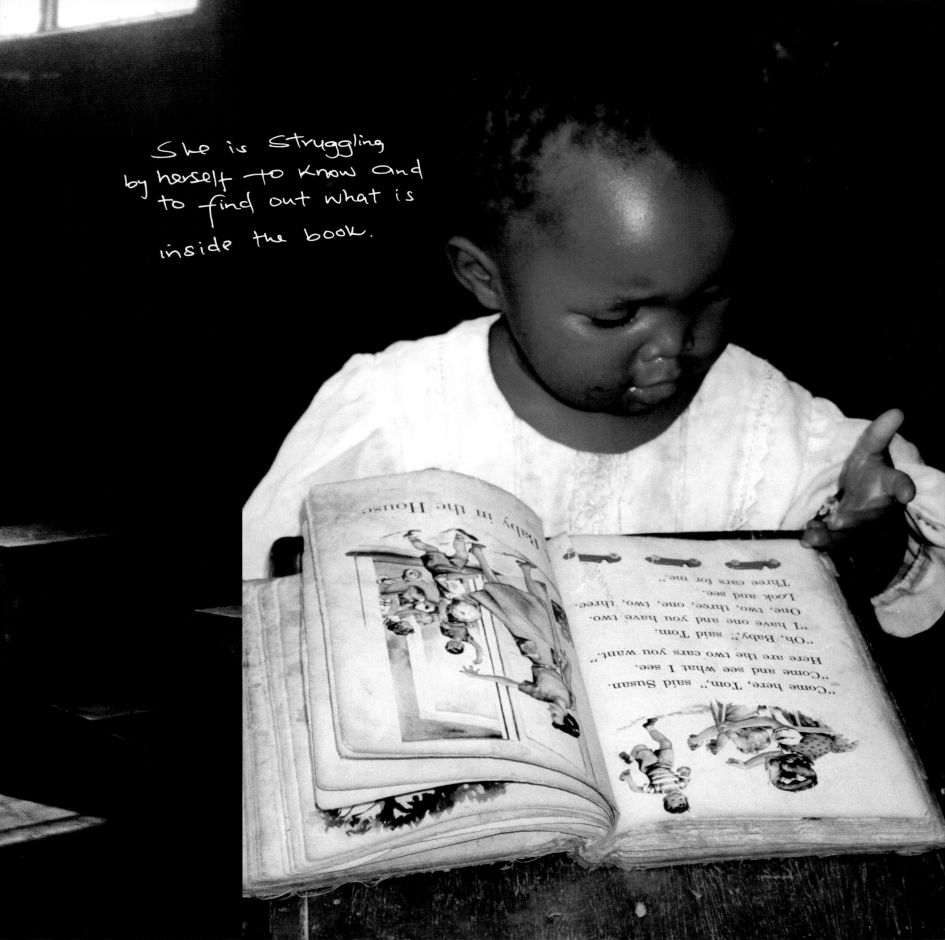

She is struggling
by herself to know and
to find out what is
inside the book.

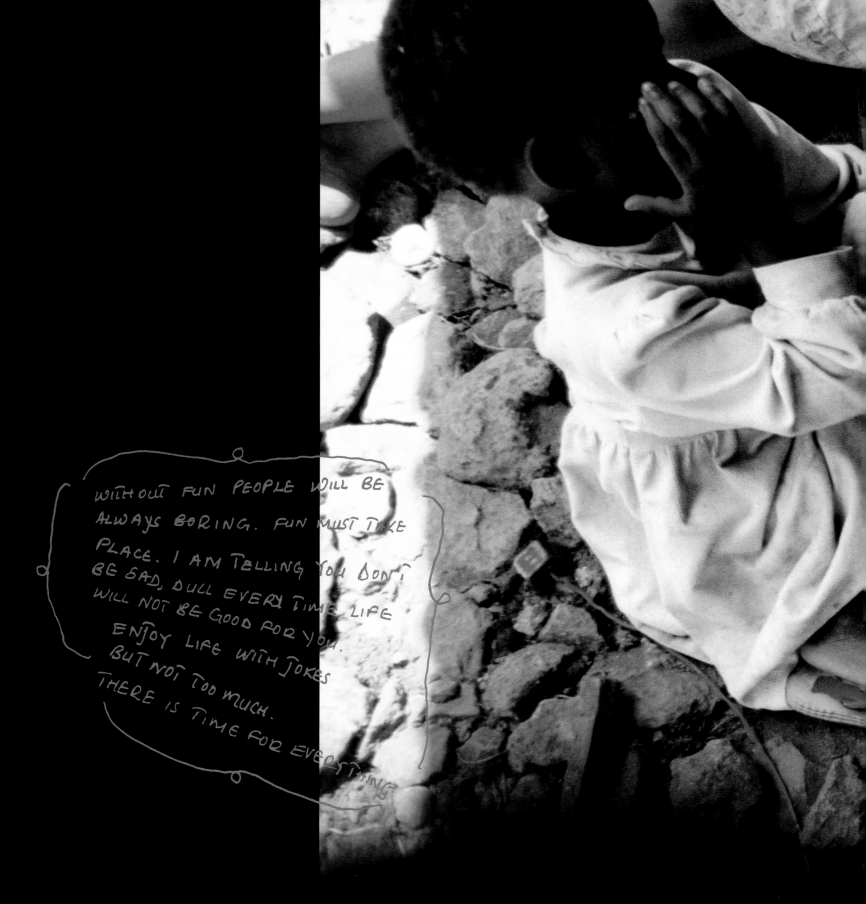

WITHOUT FUN PEOPLE WILL BE
ALWAYS BORING. FUN MUST TAKE
PLACE. I AM TELLING YOU DON'T
BE SAD, DULL EVERY TIME LIFE
WILL NOT BE GOOD FOR YOU.
ENJOY LIFE WITH JOKES
BUT NOT TOO MUCH.
THERE IS TIME FOR EVERYTHING

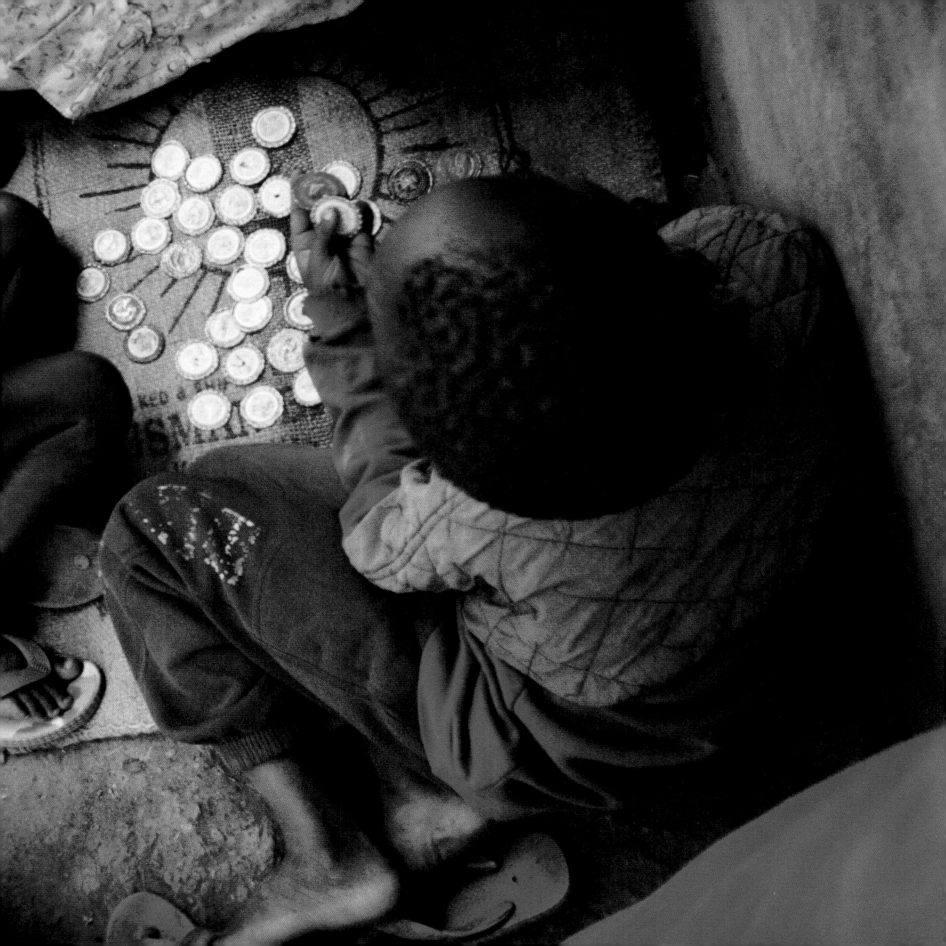

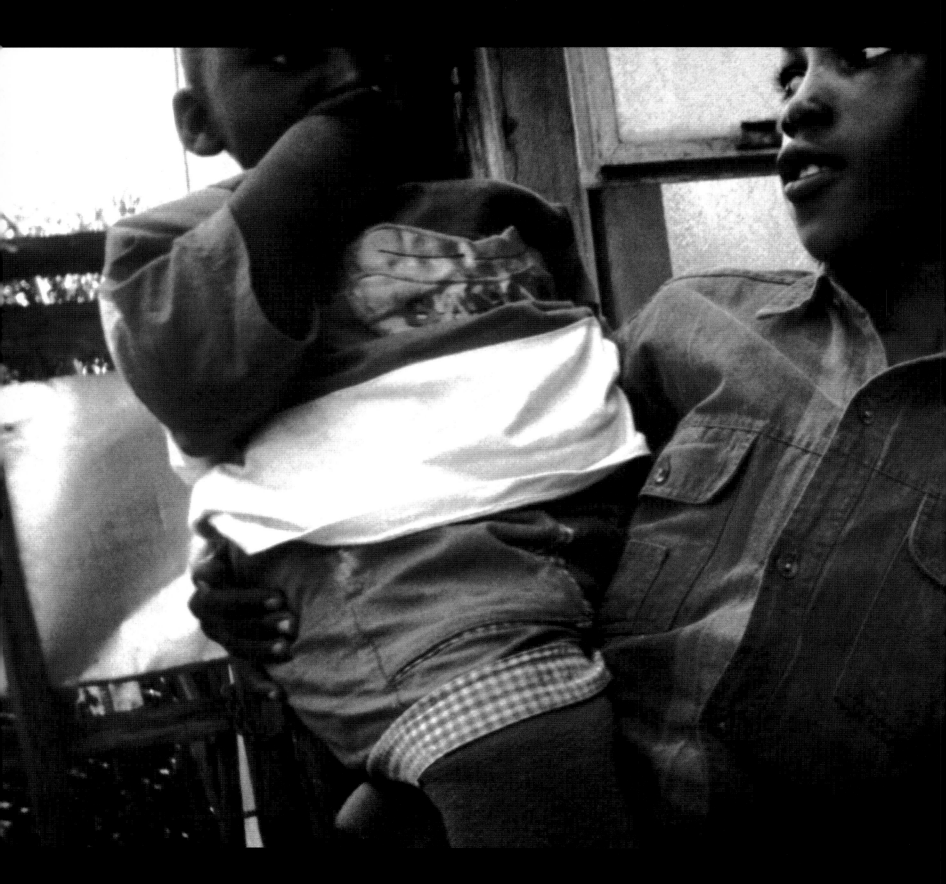

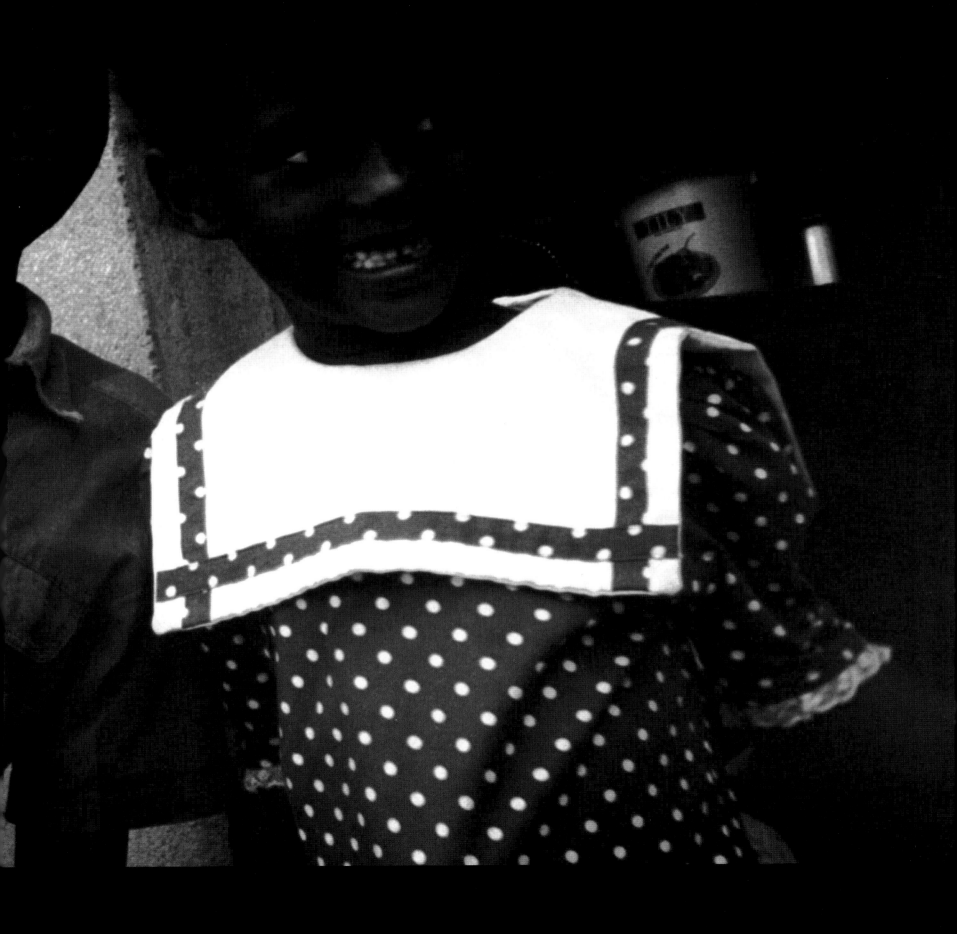

# EPILOGUE

**Every time it rains in Nairobi,** especially during the rainy season when the sky unleashes enough water for a small sea, I think of my friends in the slums around the edge of town. Trying to avoid the litter, sewage and shards of glass scattered across slum paths is hard enough in the day. 'Try it in the dark, in the rain, and without shoes,' my friend Kim once said to me with a grin as we leapt across a blocked drainage pit.

Most of my friends in Mathare, Nairobi's largest and poorest slum, survive without many of the things I take for granted. They do not have toilets, running water, electricity or a good pair of shoes. Working people in the slum are lucky if they earn sixty Kenyan shillings (roughly one US dollar) a day. Crammed into one-room shacks with sheets hanging from the ceiling as room dividers, families are large, with five to ten children. Single mothers run the majority of households. Many fathers have left or died, perhaps from AIDS or one of the other illnesses that plague the slum.

This is the Nairobi most tourists do not see. Many local Kenyans, expatriates and *wazungus* (white people) do not see these areas either, because the slums are no-go zones. The only stories they hear about 'notorious Mathare' involve violence, drugs and prostitution. Most are told or written by outsiders. But as the kids' photographs in this book show, this is not the whole story.

As a photographer, I have always struggled with issues of access, ownership and subjectivity within the documentary tradition. My reason for first visiting Mathare was a freelance job: an assignment to photograph a youth group which is also Africa's largest youth football league — the Mathare Youth Sports Association (MYSA). Just off of Juja Road, the main artery that links the vast Mathare slums to downtown Nairobi, I met a group of kids playing soccer with balls made of plastic bags, waste papers and string. They were obsessed with football and aspired to be the Ronaldos of the future. Football could be their way out.

I started hanging out with these kids, watching young boys and girls play football barefoot on dusty pitches covered with rubbish and stones. I photographed their weekly community clean-ups and listened to their peer counsellors tell friends about the dangers of drugs and AIDS. I was struck by the quiet strength and hope of these kids who, despite dire living conditions, dreamed of becoming football stars, lawyers and doctors.

The promise of these kids inspired me to follow the lead of photographers like Jim Hubbard (founder of the Shooting Back Center in California), Wendy Ewald and Nancy McGuirre, all of whom have demonstrated photography's power with disadvantaged young people around the world. Their work has shown that kids have vivid and important stories to tell, and cameras are dynamic tools for this expression. I hoped to teach the MYSA footballers a new skill: shooting with cameras. Thirty-one kids who had never touched cameras before were given basic 35mm point-and-shoots and a roll of film per week. Some had never even heard of the word photography.

In September 1997, Francis Kimanzi — aka 'Kim', a MYSA youth leader and top striker on Mathare United, the professional slum football team — began working with me to teach photography and writing skills to a group of boys and girls, aged twelve to seventeen, selected from the MYSA youth teams. During our weekly sessions at the MYSA office, we watched shy kids bewildered by these strange plastic machines transform into confident young photographers, emboldened by their new talent and the attention their pictures have generated in Kenya and abroad.

Throughout this process, the Shootback Team has repeatedly humbled me with their vision and perspectives. Although I have spent three years working in Mathare, the intimacy and insight these youths have on their own lives is something I cannot replicate. Collins Omondi, a wry seventeen year-old, expressed it well when he wrote in his Shootback project journal, 'There is no difference between us and other photographers. The only difference is that they shoot and we shoot back.'

After seeing the kids' pictures in the Shootback exhibitions shown throughout Africa and Europe, many people have asked me, 'What is the slum really like? Is it scary?'

There is a certain tension that marks one's first visit to Mathare. 'China, Chinese, ching-chong, kung fu, ayeeeeyah!' This was the chant, followed by a series of impressive Bruce Lee imitation high kicks, that greeted me. As most people in the slum have only seen Chinese people in kung fu movies, many assumed that I was a black-belt master. This could protect me, my MYSA friends told me.

I will never forget the walk down Juja Road. One of my most lingering memories is the smell: the dense mingling of exhaust fumes, burning rubbish, sweat, sewage and roasting corn. On a hot day, you can almost taste it, as red dust stirred up by hundreds of walking feet coats the skin and brings tears to the eyes.

The street sounds hit you next. A symphony of urban sprawl layered with the competing rhythms of honking horns, babies crying, gangsta rap and roadside hawkers selling their wares.

Amidst the cacophony, you can also hear laughter — mischievous giggles of children playing between street stalls; warm, loving peals of mamas hugging friends; howls of old men sharing a joke.

Juja Road's animal life belies the fact that you are on the edge of one of Africa's major urban centres. Skinny goats and cows pick through trash heaps while chickens zigzag across the road, dodging speeding buses, overloaded trucks and candy-coloured *matatu* minivans emblazoned with names like 'Black Casanova' or 'Ghetto Love'. Ancient Peugeot taxis putter along, brave souls pedal old Chinese bicycles and barefoot men navigate dilapidated handcarts around crater-sized potholes, adding to the intoxicating mayhem.

The mountains of foul-smelling rubbish next to neatly stacked tomatoes and bananas for sale along the sidewalks are a world apart from the manicured lawns and grand mansions of Muthaiga, the wealthy residential neighbourhood just five minutes drive away. The contrasts are jarring. Muthaiga Road is lined with high security fences and uniformed guards. Peering through the dense bushes, you catch glimpses of immaculate tropical gardens and imposing residences. Here, Nairobi's élite lives cocooned in their compounds with a staff of watchmen, house servants, gardeners and nannies. These are coveted jobs for those living in the slum.

Down the road in Mathare, most people are forced to try their luck with small-scale businesses due to lack of opportunities elsewhere. Ragged stalls selling second-hand clothes, tin cooking pots, brightly patterned *leso* fabrics and bric-a-brac compete for space and customers. The wide variety of makeshift enterprises illustrates the entrepreneurial spirit in the slum: butcheries displaying slabs of bloodied meat, cafés serving steaming cups of sweet tea, shoe repairers, 'video shows', or slum movie houses, and salons adorned with comical signs showcasing the latest hairstyles.

People are everywhere, many of them kids. Some are street children, living on food they find in dumps. Others are simply poor, with parents who cannot afford to pay the school fees required by all Kenyan schools. The kids who aren't in school are usually working. They look after younger siblings, wash the family's clothes and dishes, or walk long distances to fetch or buy water and firewood.

As you make your way deeper into Mathare Valley and descend closer to the river, houses become more densely packed and building materials more shabby. Rags, plastic bags, sticks, stones and mud are the poor man's bricks. Metal sheets and concrete are luxuries. Countless houses are destroyed every year during the rainy seasons when the filthy river rises and the riverbanks collapse, but people continue to rebuild their vulnerable mud huts here because they have nowhere else to go.

During the wrath of El Niño in late 1997, the destruction in the slums by the unrelenting rains was immense. Many people lost their homes, belongings and lives. The flood water became a fast carrier of disease, and sparked a cholera outbreak in Mathare. Several MYSA boys drowned as they tried to help people cross the overflowing river.

Amidst these grim realities, the Shootback Team continued to photograph their lives and the aftermath of El Niño, with a matter-of-factness that was both surprising and moving. Collins took a beautiful black-and-white image of a young boy striding across a flooded path, stepping on stones to avoid the dirty water as a little girl peers out from a doorway. His caption reads: *This picture was taken during the El Niño rainy season when people had a rough time because of the havoc created by the floods. People had to use stones as bridges so that they wouldn't step in the water. The rain was so hard even the umbrellas went on strike.*

After spending so much time in the slum over these last few years, I am a *rafiki* (friend), I can speak basic Kiswahili and *sheng* (street slang) and I am proud to have earned the title of 'Mama Shootback'. In this book however, the kids speak for themselves. It is a document of their lives in Mathare and their power to create. The team's quick and quirky humour has constantly made me laugh, and reaffirmed that in spite of their difficult circumstances, these kids possess a vibrant spirit and energy that when nurtured, becomes powerfully creative.

This book is the end result of several hundred rolls of film, but it is by no means an end to the project. All royalties from the book's sales will go directly towards school fees for the Shootback Team and a scholarship fund for further photographic training at a new community media centre that MYSA is helping to initiate. Shootback, far from looking back, is moving forward.

This book comes from and is dedicated to the Shootback Team and their families, the MYSA community and our friends and neighbours in Mathare:

*Asante sana kwa kufanya kazi pamoja.*
*Haba na haba hujaza kibaba.*
Thank you so much for working together.
Step by step we will reach the goal.

21 April 1999, Nairobi
Lana Wong

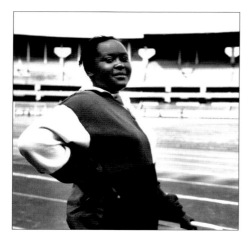

**BELDINE ACHIENG**

'Achieng' is my tribe name which comes from *chieng* which means 'sun'. I was born at midday when the sun was brightly shining. My hobbies are playing football, cracking jokes, reading, watching movies, listening to music and taking environmental photos. I also like trips, making new friends and much more. I hate roaming, staying idle and the worst is rumour mongering. I'm fourteen and belong to a large family of four brothers and one sister. The best couple is my dad and mum — the greatest human beings in the whole world. I joined MYSA in 1996 as a footballer and later joined other projects such as AIDS awareness, Shootback and Gender Partnership. Shootback is so interesting. I've gained a lot of experience in taking photos, writing journals and camera techniques. My ambition is to be a photojournalist or a lawyer. I hope I'll cope.

**MAUREEN MAK'OPIYO ATIENO**

My family consists of six members — two sisters and a brother together with my mum and dad. I'm fifteen and the second-born. I live in Nairobi in an estate called Kariobangi South. It's rather an old estate, but it's a good place to live. Our city is polluted and some of the roads have very big potholes which look like craters. Anyway that's the bad part — the good part is that there are many parks with animals that you can visit. My special interests include reading novels, creating awareness about gender and AIDS and listening to hip-hop music. My ambition in life is to become a politician and who knows, maybe I will become the first woman president in Kenya! One good thing I like about myself is that I don't care what other people think or say 'cause deep down inside I'm sure of who I really am.

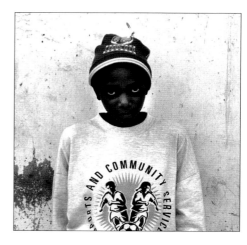

**SALOME 'SALLY' ATIENO**

'Atieno' in my Luo tribe language means 'one who is superior or unique'. We are seven in our family and my mother is the breadwinner due to my father's death in 1992. She has a small business selling second-hand clothes. The money she earns is just enough for feeding us and paying rent. We live in a single room all together. I'm fourteen, the fourth-born, tall in size, blackish in colour and have short brownish hair. I like laughing since people from our area are very funny. I'm talkertive, flexible and in school. Through MYSA, I have been playing football and participating in clean-ups. I'm really thankful for this golden opportunity, Shootback. I'm glad to get such a chance and I'll not misuse it. My hobbies are taking pictures, sharing ideas and studying. My favourite colours are red, green and orange. My favourite food is chicken and rice.

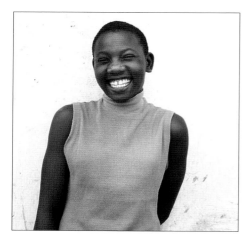

**EDITH AWUOR**

My last name in my language (Luo) means that when my mother was pregnant she liked to eat a lot. I am fourteen and the third-born in my family of two brothers and three sisters, together with my mother and father. We live in Dandora estate which is very noisy. With Shootback, MYSA introduced a new thought for us — photography. I was interested in taking photos and I have achieved a lot. Apart from knowing how to handle expensive cameras, I also know how to position myself towards the light which plays a big role in photographing. My hobbies are playing football, swimming, taking photos, sharing new ideas, listening to music and rapping. On our football team I am the captain. My ambition in life is to become a professional journalist. I like taking pictures so when I am sad I can look at them and smile at myself.

**PAULINE AWUOR**

My father passed away in 1990 — but it is normal that death is here. We are only ten people — six sisters and four brothers. I am staying with my mother. But nowadays I know that she is my real mother because my father married another woman and my mother went in 1986. She left me behind. In 1996, my mother died and my real mother came back. First I thought that she was my elder sister, because she left me when I was only two and now she came back when I was twelve. I joined MYSA in June 1997. I didn't know how to play but was interested in football. My effort lead me to Shootback. Photographing is not quite as easy work that people might think, but when you know what you are doing and what you want in life, things cannot be all that difficult.

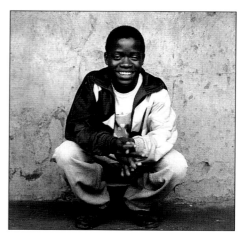

**ALI BARISA**

I am fifteen years old and I live in Kahawa Githurai zone. I have six brothers and one sister, and I am living with both of my parents. I was named Ali after my grandfather. 'Ali' means 'great father of the Nation'. I am doing all I can so as to earn my future living in this tough globe. I am looking forward in my life to be a professional footballer and photographer. Shootback is my dream because I was waiting for such a chance. In our project, we are working with Francis Kimanzi and Lana Wong. They are helping us very much. They have taught us how to use cameras. At this moment we are using Yashica, Canon and Clearshot cameras. My hobbies are taking pictures and playing football. I have taken a lot of pictures covering clean-ups and lifestyles in the slum.

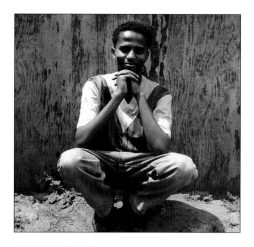

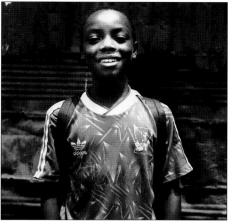

**MOHAMMED DAHIR**

My name means 'the praised one'. I am seventeen years old. We are a family of six. I joined MYSA when I was twelve. My nickname is 'BMX' but people call me 'Sinyorita' becoz I look Mexican. I happen to be a Muslim. Shootback involves taking pictures and learning so many kinds of crazy words of photography. At first, my thoughts were, 'What's good about taking pictures?' As time passed, I started learning more and more and things started sounding interesting. And that's when I started being interested in photography. I like taking pictures becoz it's a way of showing people what's happening in a place rather than describing it. Always I dreamed about my future but I did not know what to do. Photography is now my hobby which I take as my future coming job. I also like swimming and reading politics.

**COLLINS OMONDI GUYA**

I am fourteen years old. My name 'Omondi' means that I was born in the morning. The size of my family is four and I am the last-born. My mother does some work at Kenyatta University (KU) and my father is a soldier at Kenya Airforce. I live in an area called Mathare North and have been a member of MYSA since 1995. My special interest is football. I like playing football very much because one time one day it will help me. Shootback has helped me to take pictures and touch the camera. I would like to say that we should be serious with our project because our leaders are helping us in many ways.

**SAIDI HAMISI**

'Saidi' in our language means 'a person who is kind, strong and aggressive when he does his work'. I'm fifteen years old. I live in Kayole in a slum area called Soweto. It's one of the poorest slums in Kenya. I am the only boy in a family of six. I joined MYSA eight years ago and I have been able to learn a lot from the organization. For example: playing football, facts about AIDS and taking good pictures through Shootback. My ambition in the future is to become a photojournalist.

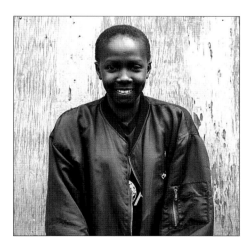

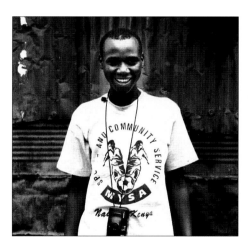

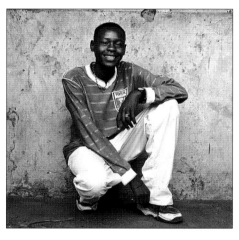

**BERYL ANYANGO JUMA**

My name 'Anyango' means 'the sun that comes at ten o'clock'. I am fourteen years old, black in colour, short and my hair is short and black. I stay in Dandora Area Four with my family. My family consists of my mother, father and my three brothers. I play football and I have football boots. I also have shin guards and socks. My socks are yellow with white stripes at the top. I am also training to be a journalist. I have a camera and the snaps that I have taken since I entered the Shootback project. I was very happy to get that chance. It is very fantastic to take a photo of yourself.

**HASSAN TOM KASEKI**

*Jambo, habari* (Hi, how are you)? My name is Hassan. I am sixteen years old and I like football and swimming. I am the tallest boy in the group and I have short hair. I have three sisters and five brothers. I like them so much but I don't have a father. My father died in December last year. I would like to say that I like the Shootback project so much — it has taught me how to use the camera and the Shootback teachers have taught me how to take the best pictures. I don't have so many things to say, so *kwaheri* (goodbye).

**NICHOLAS MATHENGE**

'Mathenge' comes from *thenge* which means 'he-goat', and is used to refer to a brave and strong person. I am sixteen years old and the fourth-born in a family of five children. I have three sisters and one brother. I have been a member of MYSA since 1992 as a football player. Since 1997, Shootback has done a lot for me and helped me polish a talent I didn't know of. My special interest is of course taking pictures around my home area because I think I can make something out of it for my future. I hope that I can be a good example for the rest of the MYSA youths. I believe the project can do miracles for me because I can manage to get a job when the time comes and also it can take me to countries which I hadn't dreamt of going to and I will be able to help my family.

**DAVID MBUTHIA**
We have 42 tribes in our country, and each speaks its own mother tongue. I belong to the Kikuyu tribe. 'Mbuthia' is a Kikuyu name which comes from my father's and grandfather's name. 'David' is a Christian name meaning the courage and confidence it took to make him (David) kill Goliath. I belong to a family of eight and I have six siblings. I am fifteen and the third-born. We live in a slum called Mathare Valley. There are many people living here, but we have some other slums like Korogocho, Majengo and Kibera. I am proud of Mathare Valley. MYSA, our self-help youth group, has many activities such as AIDS awareness, gender partnership, sports and photography. Through MYSA I have become a peer educator and now I am a member of the Shootback Team. My ambition in life is to be a professional photojournalist and football coach.

**VINICK MUHANJI**
My hair is black in colour, my face is chocolate and my size is normal. My weight is normal, I'm fashionable too. I'm thirteen years old and I have four sisters and two brothers. My hobbies are eating pudding, photographing, watching movies, playing football and listening to pop stars. My best musicians are Brandy *(The Boy is Mine)*, Elton John *(Candle in the Wind)*, and Eric Denison *(This is the Land of My Lord)*. My favourite dishes are chips, matoke and kebabs. Oh gosh! But I hate waking up early. I live near Mathare River which is very dirty. The people of town have learned more about our project through our pictures. I'm so happy because my pictures show people how we live. Most children are happy with Shootback because they are saying that they will be camerawomen and cameramen.

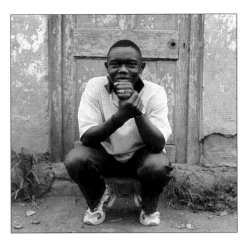

**JOSEPH MULEI**
'Mulei' means 'someone who likes to disagree with people'. I have many friends and only a few enemies and this makes my life satisfying. I am sixteen years old and happy that I am that old. I am the last-born in a family of three and I live with one of my sisters who is married since my parents are dead. I have been a member of MYSA since 1990. I joined MYSA when I saw many of my friends playing football so I decided to join them. I am a good footballer in the making and one day I will be a professional footballer and then the president of Kenya. In Shootback, I am learning how to take pictures of all kinds. I am so happy to be a member of MYSA because I have learned how to make friends and socialize with other people.

**SUSAN MUTHONI**
'Muthoni' in my Kikuyu tribe means 'in-law'. For example, if I marry and my husband has many sisters, they are my sisters-in-law. I am twelve years old. Our city has many slums and I live in Githurai Kimbo zone. I go to school at Moyyo Academy. I come from a family of four members, whereby we are two girls and one brother plus my mother. I have gained a lot from MYSA and Shootback because I know how to use different types of cameras. My hobbies are reading storybooks, taking photos and watching movies. My special interest is to be a journalist.

**JAMES NJUGUNA MWAURA**
I am fifteen and my favourite hobbies are football and being a professional photographer. I also like having haircuts. I play for a team called Sanpadros. I'm the only goalkeeper. We play on a gravel pitch. Almost everybody plays barefooted, but I play with my own boots. Shootback has helped me to know how to focus cameras, use the shutter, write captions, etc. I know I am ready to become a professional. My happiest day was when we went to the museum because my pictures were sharp and displayed on the walls. Many people were looking at and discussing my pictures which made me feel like I was a professional photographer. Now I feel famous because many people saw my name and pictures. Others asked me if I was James and told me how beautiful my pictures were and that I should go on shooting pictures like those.

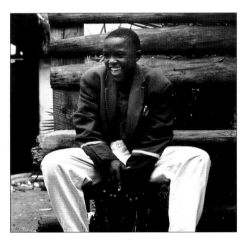

**JULIUS 'RAGOS' MWELU**
I am fourteen years old and my name 'Mwelu' in my tribe means that I was born in the morning. I am the last-born in a family of four. I am living in the slum known as Mathare Phase One, in a room which we use as a bedroom, sitting-room and kitchen. I joined MYSA in 1992. I was approached by my friend who was in the organization at that time so I decided to join. When MYSA introduced Shootback, I sent an application and I was chosen to be a member of the Shootback Team. My other interests are reading storybooks, exchanging ideas, playing football and watching movies. My ambition in life is to be a photojournalist.

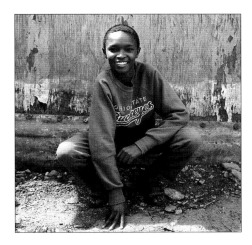

**PETER NDOLO**

'Ndolo' means 'muddy day', that means I was born on a muddy day. I am thirteen years old, black and fashionable. I am a goalkeeper. I finished my primary education in 1997. My mother said she doesn't have money, so no school now. I live with my mother and four brothers and three sisters in a cubic room in Huruma, in a place called Ngei. I thank God and Shootback because I could have been in the street borrowing money, snatching women's bags or sniffing glue but now I know how to take pictures, how to process film and about the Internet. When I get money I can continue to learn and go to secondary school. And when home is boring, I go to my friends like Mathenge and Julius and then we go to search for better pictures and I call it a day.

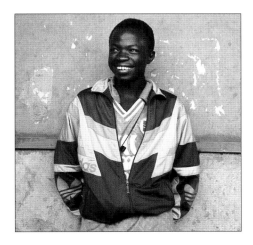

**PAUL 'BEBETO' OCHIENG**

I am fourteen years old. The name 'Ochieng' means that I was born when the sun shines. My nickname is 'Bebeto'. I like this Brazilian footballer because he scores some fantastic goals in each and every match played. I have two sisters and two brothers and I am schooling at Ofafa Jericho High School. Our city is not all that big, but there are some interesting buildings. In our city, there are some slums. The garbage is also thrown anywhere aimlessly. Does your city have slums? And is garbage thrown anywhere in your city? My future life really matters to me so I can't waste time, for time wasted will never be recovered. My ambition for the future is to be one of the best photographers in our country, the best footballer in the world, the best swimmer and other interesting things. Bye bye for now.

**SERAH ODEKE**

I am a Luyha, fourteen years old and the first-born. We are four in our family. 'Odeke' means 'when people are going to church to praise the Lord'. MYSA has helped me in many ways. I have attended the AIDS workshop and coaching course. My team is called Willopex Babes. In Shootback I have learned how to take pictures. My hobbies are exchanging photos, watching movies, exchanging ideas and playing football. I would like to be a special photographer. I like playing with flowers and animals such as rose flower and cat. I like that flower because it smells well and looks pretty too. I like cat because it likes playing around with things and even with people.

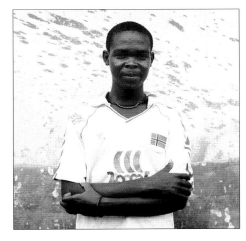

**CHARLES ODHIAMBO**

My second name means evening, so I could have been born in the evening because my tribe always gives newborn babies names depending on the occasion or time after birth. I am fifteen years old and I am the fifth in a family of seven, living in Mathare Valley. I joined MYSA in 1994, whereby I played football from the age of twelve years until now. I joined Shootback in order to learn photography and also meet new friends. I am now familiar with different types of cameras. My special interests include watching videos, taking photos, reading novels and swimming. My dream in future is to become a journalist.
Peer pleasure not pressure.

**HELLEN OKOTH**

I'm sixteen years old and schooling at St. Dominic Savio's. We are eleven people in our family. My hobbies are playing football, watching movies, reading storybooks, novels and socializing. Strangers are friends you don't know. My favourite subjects are social ethics and biology. I'm happy to be among the Shootback Team. The aim of it is to know more about photography.

**COLLINS OMONDI**

I'm seventeen, a handsome young man, Luo in tribe and I can speak fluent English and Kiswahili. My hobbies are making new friends, travelling and adventures. Dislikes: gossipers, pretenders (lions in sheep's skin). Likes: forthright, assertive and ambitious people, beautiful things and people. I'm mentally a billionaire. I own a posh villa in the Nairobi suburbs and a fleet of vehicles ranging from a Rolls Royce limousine to a VW beetle. Due to my mass wealth I have been a victim of armed gangsters but I normally tip them off with a token of 2000 dollars. There is no difference between us and other photographers. The only difference is that they shoot and we shoot back. My ambition in the future is to become a photojournalist and a famous one. Through the motivation of our project leaders, I know I will achieve my dream. Bye and Ciao!

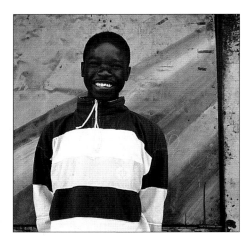

**KENNEDY OMONDI**

I am fourteen and the last-born in a family of five. I live in an estate known as Dandora. I have been a MYSA member since 1994. I like reading novels, playing football, listening to music, watching movies and exchanging ideas. I am a great footballer indeed. As far as Shootback is concerned, I like to take pictures in the slums and in the estates. My first time to touch the camera I did not know much about cameras, how to handle them, focusing and taking of pictures. But nowadays, I can do so. I can take pictures of different views, slums and even of matches. I am interested in learning how to use the fancy cameras. I can be very proud when I will be able to use those big cameras.

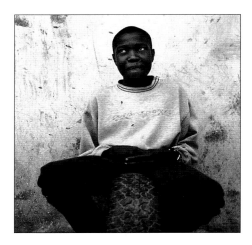

**FREDRICK 'ORECK' OTIENO**

I don't know where I come from, where I was borned I don't know. If you know call the following numbers, 0000MYSA or box number 000 Mathare slums for more details. I must ask God but will I see him? I don't know but I will go to church and ask the pastor. I don't know if he will tell me. But I believe everyone knows the creator of all. May I thank God a lot for creating me in this world. Fredrick likes everybody and he likes jokes. I was born in Mathare slum and I'm fourteen years old. Our family is composed of three members and my mother. My friends told me that there is one big organization known as MYSA which I joined in 1992 whereby I was like a footballer. I really like Shootback actually and the other MYSA activities.

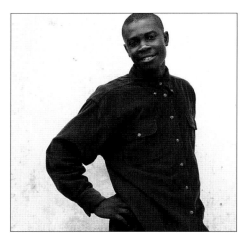

**GEORGE OTIENO**

I am a Luo by tribe (Nilote). 'Otieno' means 'night'; this shows that I was born at night. I am fifteen years old. I am in my final class in secondary school. I am the third-born in a family of six living in a big slum called Mathare Valley. We live in a single room all together. I joined MYSA as a young talented footballer at age ten, playing in the MYSA league for under-twelve boys. Now I am playing in the under-sixteen league. I joined the Shootback project because I wanted to know how photos were made. Now I know how to take good photographs. Apart from taking photographs, I like reading novels, listening to reggae music and watching movies. My main goal is to be a professional photographer and footballer.

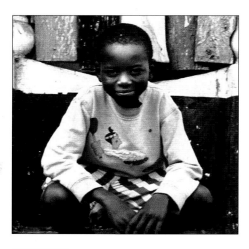

**MOSES OUMA**

I am thirteen years old. I live in a house which is eleven years old. My hair is short and I am one and a half metres short. I like my name 'Moses' because Moses is the man who was given the Ten Commandments by God. 'Ouma' means that I was born when I bent down with my knees to hunt. I come from the Luo community and am black in colour. I like football so much because it is my favourite game. Here in Kenya the environment is very polluted and we don't have enough place to play so we play in half of a playing field. I would like our Shootback Team to improve their skills by taking sharp pictures and writing something good in their composition books. We are supposed to know how to use different types of cameras like the Yashica and Clear Shot. If you know, show others.

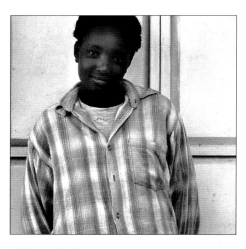

**SERAH WAITHERA**

According to our tribe, 'Waithera' means that I was born during the rainy season. 'Serah' is a Christian name. I come from a family of seven members and I'm fifteen. We are all girls, without any brothers. I'm schooling at Guru Nanak Secondary. Having joined MYSA in 1995, I have achieved a lot. My best achievement so far was being selected to represent MYSA on the under-fourteen girls' team for the Norway Cup tournament last year. I'm also a coach and I coach kids. Apart from football, I have gained knowledge about AIDS. My special interests include playing football, taking pictures and visiting friends. My ambition is to become a professional player. Since I was young, I really dream about being somebody. So aim for the sky before your end of life.

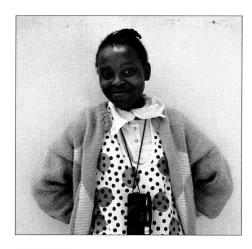

**ANNE WAMBUI**

I am twelve years old. 'Wambui' means that I was born in darkness when the moon was bright. In our language we call it *mbui*. Our home city is Nyeri. In our family we are four people, one brother and three sisters. I joined MYSA when I was small and now I am matured enough. I school at Moyyo Academy in Githurai Kimbo. We are five hundred pupils. I like photography because it makes me to promote our country and know more about our country. In Shootback Lana and Kim are our leaders. I would like to thank them for the good work they have done. From the time we started Shootback they help us by teaching us how to photograph. Even our parents are very happy for the good work. Congratulations Kim and Lana so much. I like photographing so much. I will never leave photography forever and ever.

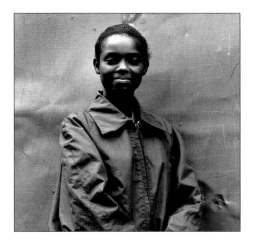

**HELLEN WANGECI**
I am sixteen years old and a Kikuyu by tribe. I don't know
the meaning of my name but I believe it has one, and it
must be a good meaning because 'Wangeci' has a good
ring to it. I started playing football as a hobby at the KCC
ground. Later my team and I started participating in the
MYSA leagues and that is how I ended up playing in MYSA.
I was selected to go to an AIDS awareness workshop and
that is where I handed in my application form for Shootback
and later I was selected. I have really learned a lot from
Shootback. For example, I know how to take pictures using
different types of cameras, which I knew nothing about
before, and I have become more assertive and confident.
I want to study journalism as a profession. My hobbies are
playing football, taking pictures and travelling.

Robbie 'Guru' Bisset

**FRANCIS 'KIM' KIMANZI**
The day I kicked a home-made football in Mathare was the
start of my new life. We all understood the soccer language,
and it gave us a dream to become professional players. MYSA
has made this great desire come true for me and established a
direction in my life. Thanks to MYSA I am a respected member
of the community and a role model for other youths.

**LANA WONG**
I was born in New York and studied photography at Harvard
and the Royal College of Art, London. I moved to Nairobi
in 1996 and will never forget my first walk in Mathare, on
assignment to photograph MYSA. The kids' energy was infec-
tious, and inspired the Shootback process. Throughout our
collaboration, we have opened each other's eyes to new ways
of seeing, and I am now Mathare United's biggest fan.

# MATHARE YOUTH SPORTS ASSOCIATION

MYSA is Africa's largest youth football league with over 14,000 boys
and girls on over 1,000 football teams which are also committed to
community service, AIDS education and gender partnership. Established
in 1987 in Nairobi as a small grass roots project to organize sports and
clean-up activities in the Mathare slums, it is now one of the most
successful development projects in the world which links self-help youth
sports, environmental clean-up and other community service activities.

Young people drive MYSA. Most of the several hundred volunteer
coaches, referees and officials are under sixteen years old. Elected
committees of youth leaders organize the MYSA sports programmes,
weekly clean-up activities and AIDS prevention training. A youth
Executive Council is responsible for the overall management
and budget of MYSA.

MYSA has a Youth Fairplay Code with eleven basic rules, including:
*I will not smoke, drink alcohol or use illegal substances. I will promote
environmental awareness and improvement as healthy athletes need
a healthy environment.*

As youth in Mathare cannot afford to pay fees for sports activities,
all teams participate in clean-up projects instead. Every weekend,
over fifty teams clear the garbage and drainage ditches around their
homes. Teams earn six league points for each completed project.
In addition, over 150 MYSA boys and girls have received special training
and now lead an AIDS prevention and counselling programme in the
Mathare slums. The Mathare youth are also helping to set up a similar
sports and development programme in the Kakuma refugee camp
in northwest Kenya.

MYSA's emphasis on sound minds and bodies has paid off. Since 1990,
MYSA teams usually qualify for the final rounds in the Norway Cup, the
world's largest youth football tournament. Our boys team won
the Cup in 1995 and 1998, and our girls team, the first-ever girls from
Africa to compete, won the silver medal in 1998.

The Mathare United professional team, comprised of young men who
have been playing in the MYSA leagues for a decade, made Kenyan
football history by winning the 1998 Kenyan Moi Golden Cup and by
representing Kenya in Africa's 1999 Cup Winners Cup.

Since 1987, over 40,000 youth in the Mathare slums have benefited
from the MYSA programmes. By 'giving youth a sporting chance'
the young people in Mathare will continue to set and reach new goals
both on and off the field.

**For more information or to help contact:**
Mathare Youth Sports Association
PO Box 69038, Nairobi, Kenya
tel/fax: +254 2 583 055
munro@form-net.com

# SHOOTBACK SPONSORS

## Ford Foundation

The Ford Foundation promotes the visions and voices of women and men working to advance human well-being. In so doing, it is our hope that we can help counter pessimism about people's ability to forge better lives and communities. For over sixty years, the Foundation has provided resources to people and to organizations working for a more equitable future and building a present which nurtures us all. Since 1966, the Foundation has supported such efforts in East Africa. Throughout this time, individuals and organizations in the region have demonstrated exceptional creativity and perseverance in the face of daunting political and social problems. The Mathare Youth Sports Association is one such organization, for eleven years giving young people in one of Nairobi's poorest areas a chance to work with pride and determination to contribute to their communities, and in so doing, change the course of their own lives. The Shootback project trusted the voice and vision of young people to teach us about the world in which they live, so that we could share in their work toward a better future. We at the Ford Foundation are proud of the beauty they have created and the brave realities they have portrayed, and look forward to seeing MYSA continue to grow from strength to inspiring strength.

Susan V. Berresford
President, Ford Foundation

The power unleashed when we celebrate is contagious. It attracts, just as beauty attracts. Just as music elicits something marrow-deep in us, causing us to tap our feet or melt imperceptibly from the inside out, the photographs in this book have touched something in those who have seen them in a way that a tour of the slums of sprawling Mathare Valley would never do. I believe this is because they are celebrations of a community, true to both the stark shapes of its poverty and the hopeful laughter of its youth. Truth, too, attracts us.

In East Africa we are well aware of the fact that our collective futures rest in the hands of our youth, far too many of whom are growing up in increasingly threatening worlds with decreasingly adequate support systems to help them navigate the contested terrain to adulthood. Stories of mob violence, AIDS deaths, drug use, political and economic insecurity are everywhere the stuff of front page stories about young people in our region. All these are true enough — but the images captured by the Shootback Team are closer to the truth because they also depict the unconquerable human spirit and our unquenchable thirst to express ourselves.

Whenever I lose my usually-strong tether on optimism, all I have to do is glance above my desk at my collection of MYSA photographs. They never fail to help me find that tether, even though one is a picture of children playing on a garbage dump. For those images capture a process that has been all about celebration and about truth, a process which has helped to turn once-shy inarticulate kids into diplomats, proud of who they are, where they come from, and what they can do. This is the stuff of which hope is made.

As has been the case with most of the best work I have been involved in over the years, this was a project that started on a vision, a gulp, and a shoestring. Lana Wong and Francis Kimanzi believed in the kids of Mathare Valley and the value of the stories they could tell if given a chance to do so. As photographers themselves, they knew the power of images for reflecting many truths at once. Still, none of us expected the attention and excitement that the Shootback project would create. Nor dared we anticipate the talent and thoughtfulness of the young photographers when they gingerly held cameras for the first time or wrote their first tentative journal entries. Sometimes stumbling, sometimes as fleet of foot as the soccer teams which had earlier brought fame to MYSA, the Shootback Team and the Shootback project have far outrun our initial hopes and dreams. In part this is thanks to the support that parents, coaches, teachers and community members have given to these young people as they walked the paths of their villages, pointing their cameras at what they saw. We must first thank those many unnamed contributors, especially the families of the photographers whose work is included in this very special book. We must also thank Lana and Kim whose unrelenting spirits, playschool sense of the immediate, and willingness to tramp bootless into the unknown have brought a new sense of the possible to the young lives they have touched. For her enthusiastic help with our web page and much else, we thank Lisbeth Levey. At the Ford Foundation, we thank Melvin Oliver, Ginger Davis Floyd and Katharine Pearson for their belief in this project and their patience with my proclivity to make programmatic decisions from the heart even when the mind knows we cannot be wholly certain of the outcome.

For they understand as I do that the justice we all strive for must recognize the joy, pain and power of stories told by those closest to them.

Mary Ann Burris
Ford Foundation, East Africa

## Netherlands Development Assistance

Thank you to Netherlands Development Assistance (NEDA) for their generous support of *Shootback*, and their commitment to the young people of the Mathare Youth Sports Association.

## United Nations Environment Programme

For more than a quarter of a century, Nairobi has been host to the headquarters of UNEP, the United Nations Environment Programme. The provocative pictures in this book, taken by the youth of Mathare, are of a city we share but show a side that is often hidden from view. They give a warning of the immense urban problems before us but also a sense of optimism about what can be achieved through inspired community-led development.

At the 1992 Earth Summit in Rio, the Mathare Youth Sports Association received the UNEP Global 500 Award for environmental innovation and achievement. MYSA stood out in their efforts to combat poverty — the most toxic substance in the world. Today, this innovation continues and the young Shootback photographers have brought to life the fundamental linkages between poverty eradication, environmental protection and social justice better than any United Nations document could ever hope to do.

The message in these poignant images, which attest to the enormous source of energy and creativity amongst the impoverished youth of the world, is a universal one — the desire to lead a full and productive life in a healthy environment. The challenge for all of us is to listen, to share this aspiration and by our actions, turn this hope into reality.

Klaus Töpfer
Executive Director, United Nations Environment Programme

## Acknowledgements

A heartfelt thank you to the following people and organizations whose moral support, financial and technical assistance, expert advice, creativity, care, dedication and unwavering belief in SHOOTBACK have made this book a reality:

Mary Ann Burris and the Ford Foundation

Francis Kimanzi, Bob Munro and the MYSA family

Robbie Bisset, Tore J. Brevik, Steve Jackson, Naomi Poulton, Marceil Yeater and the staff of the Communications and Public Information Branch of UNEP; a special thanks to UNEP for providing office and darkroom facilities

Jelte van Wieren and the Royal Netherlands Embassy

Runyon Hall and Karen Wong

Vicky Hayward for her editorial vision, Edward Booth-Clibborn and Booth-Clibborn Editions

Alan Beechey and Derek Smith of D. A. Associates Photographic Laboratories, London

Bobby Pall, Sylvanus Omollo, Karanja and Vanguard Colour Lab, Village Market, Nairobi

Masud and Kamraan Quraishy and Photomural Kenya

Stromme Foundation, Norway

Fiona Bailey and Paul Wombell and The Photographers' Gallery, London

Hans Goosens and the National Museums of Kenya

Carol Beckwith, Susan Scull-Carvalho, Angela Fisher, Jody Friedman, Chad Hall, John Hare, Peter James, Alex Kamweru, Lisbeth Levey, Damien Lewis, Susan Meiselas, Magali Moreau, Kate Mundle, Elisabeth Paulson, Maria Pavlopoulos, Steve Van Basten, Barney Wan, Nicky Weinstock, Jo Weinberg, Chien Jen and Milly Wong

EDITOR Lana Wong
EDITED BY Runyon Hall, Karen Wong, Lana Wong
DESIGNED BY Runyon Hall, Karen Wong

First published 1999 by Booth-Clibborn Editions
12 Percy Street
London W1P 9FB
info@internos.co.uk
www.booth-clibborn-editions.co.uk

ISBN 1 86154 132 5

Printed and bound in Hong Kong

All royalties from this book will go directly towards school fees
for the Shootback Team and MYSA .

COVER PICTURE Beldine Achieng, 14  WORDS Peter Ndolo, 13

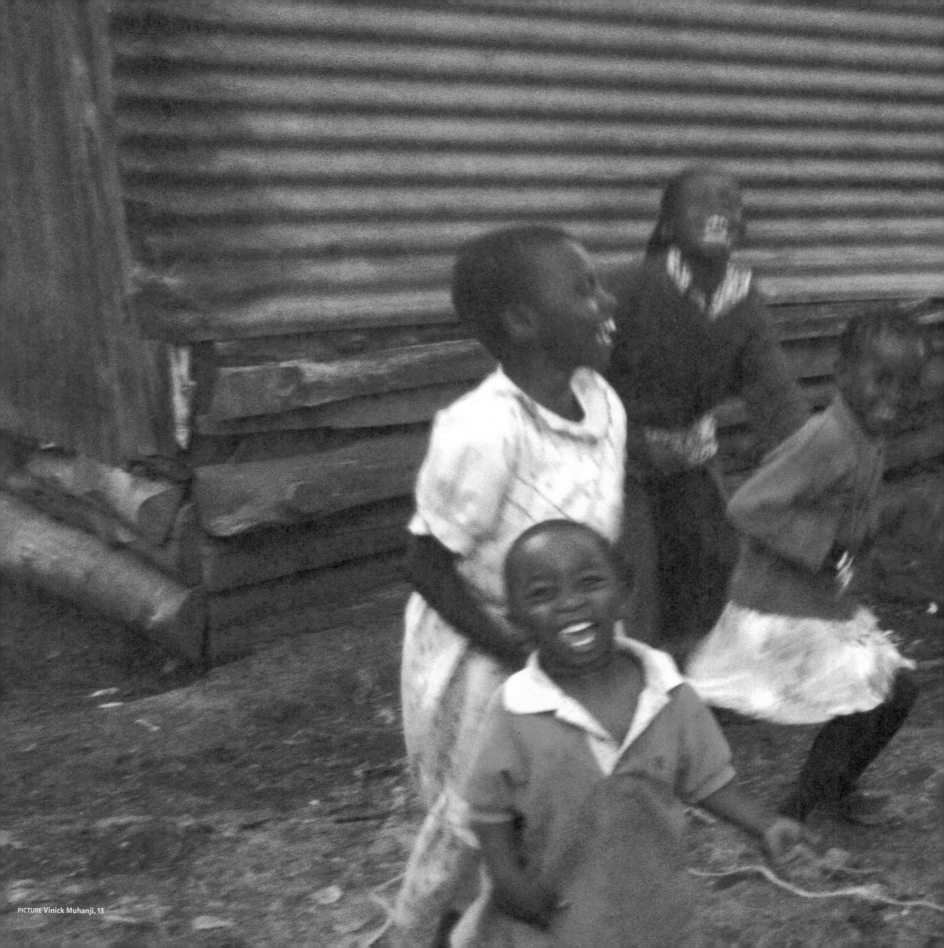